painting *peaceful* country LANDSCAPES

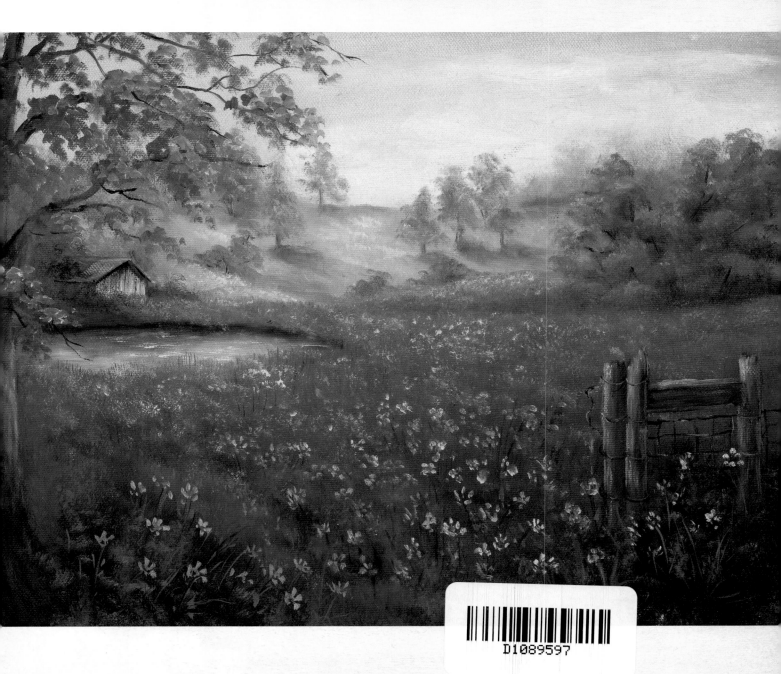

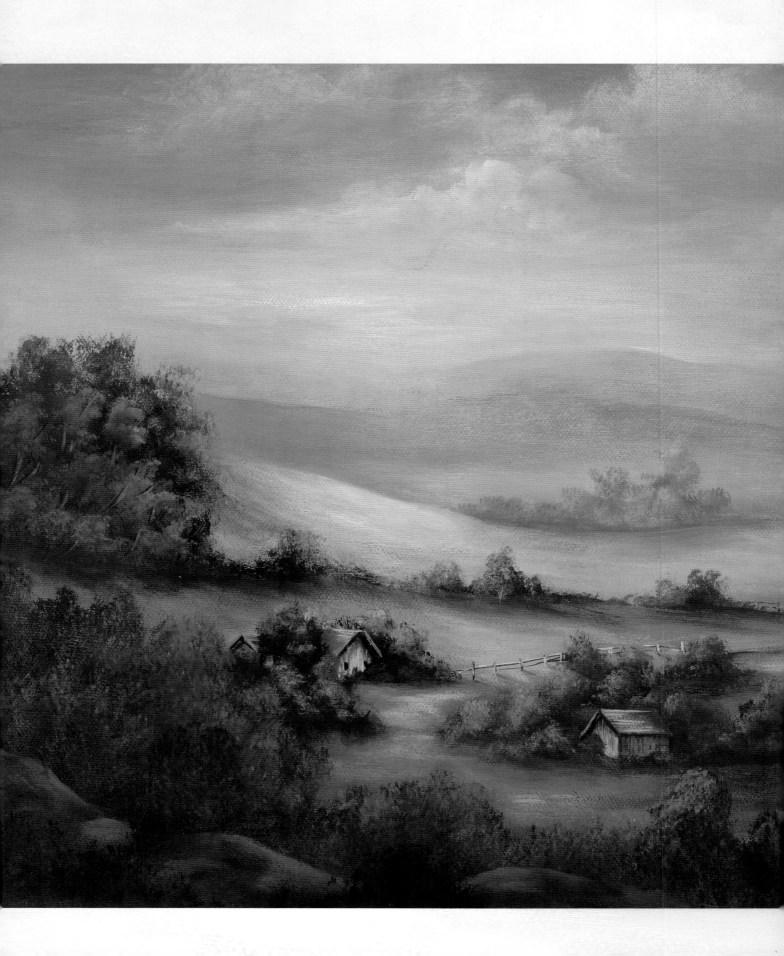

painting *peaceful* country
LANDSCAPES

Annette Dozier

NORTH LIGHT BOOKS
CINCINNATI, OHIO
www.artistsnetwork.com

fw
F+W PUBLICATIONS, INC.

Other fine North Light Books are available from your local bookstore, art supply store or direct from the publisher.

11 10 09 08 07 5 4 3 2 1

DISTRIBUTED IN CANADA BY FRASER DIRECT
100 Armstrong Avenue
Georgetown, ON, Canada L7G 5S4
Tel: (905) 877-4411

DISTRIBUTED IN THE U.K. AND EUROPE BY DAVID & CHARLES
Brunel House, Newton Abbot, Devon, TQ12 4PU, England
Tel: (+44) 1626 323200, Fax: (+44) 1626 323319
Email: postmaster@davidandcharles.co.uk

DISTRIBUTED IN AUSTRALIA BY CAPRICORN LINK
P.O. Box 704, S. Windsor NSW, 2756 Australia
Tel: (02) 4577-3555

Library of Congress Cataloging in Publication Data
Dozier, Annette.
 Painting peaceful country landscapes / Annette Dozier.
 p. cm.
 Includes bibliographical references and index.
 ISBN-13: 978-1-58180-910-7 (pbk. : alk. paper)
 ISBN-10: 1-58180-910-7 (pbk. : alk. paper)
 1. Landscape painting--Technique. I. Title.
ND1342.D69 2007
751.45'436--dc22
 2006024360
Edited by Holly Davis and Jacqueline Musser
Cover design by Clare Finney
Interior design by Terri Schmitt
Interior layout by Kathy Gardner
Production coordinated by Greg Nock
Photography by Christine Polomsky

Metric Conversion Chart

To convert	to	multiply by
Inches	Centimeters	2.54
Centimeters	Inches	0.4
Feet	Centimeters	30.5
Centimeters	Feet	0.03
Yards	Meters	0.9
Meters	Yards	1.1

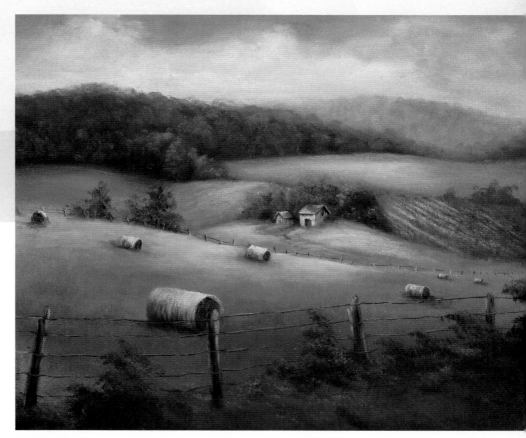

Bales of Hay

ABOUT THE AUTHOR

Annette Dozier has been painting landscapes for more than 23 years and has spent many years travel-teaching around the country. She studied with Dorothy Dent in the 1980s and has since developed her own painting style and techniques. She is the author of four successful books on landscape painting published by Eas'l and is at work on a fifth one. She has also had articles published in many of the painting magazines including *The Decorative Painter.* She is a member of the Society of Decorative Painters and Artistic Friends Club of St. Louis. She has been active in the craft market, both retail and wholesale, since her first store opened in 1974. She now teaches in her home studio and travels throughout the United States teaching in both oil and acrylic.

ACKNOWLEDGMENTS

To the staff at F+W, thank you, thank you. You were so understanding during a difficult time. Both Dave and I appreciate your help and kindness. I want to thank Kathy Kipp for considering me and for honoring me by asking me to do this book. Holly Davis, you were great to work with and I wish you success in your new position with F+W. Kathy, thanks for stepping in and helping with the completion of this book. Christine Polomsky, you made it so easy for me as you clicked photo after photo. A great staff, beautiful, informative books and a blessing to the artist.

DEDICATION

There is a special man in my life to whom I would like to dedicate this book, David, my husband of 47 years. During the painting and designing of the canvases in *Painting Peaceful Country Landscapes,* he had to do double duty. This last year has required much from him, and I appreciate all his help and comfort.

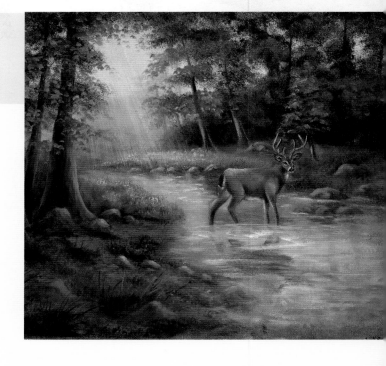

Landscape Paintings in Acrylics

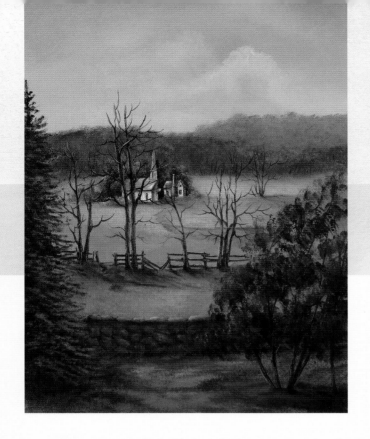

LANDSCAPE PAINTINGS IN OILS

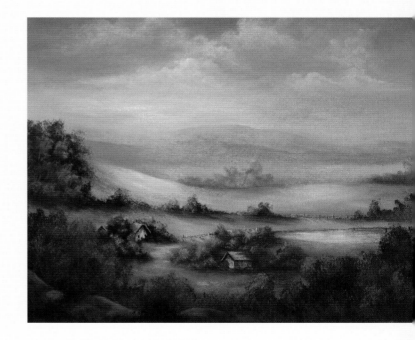

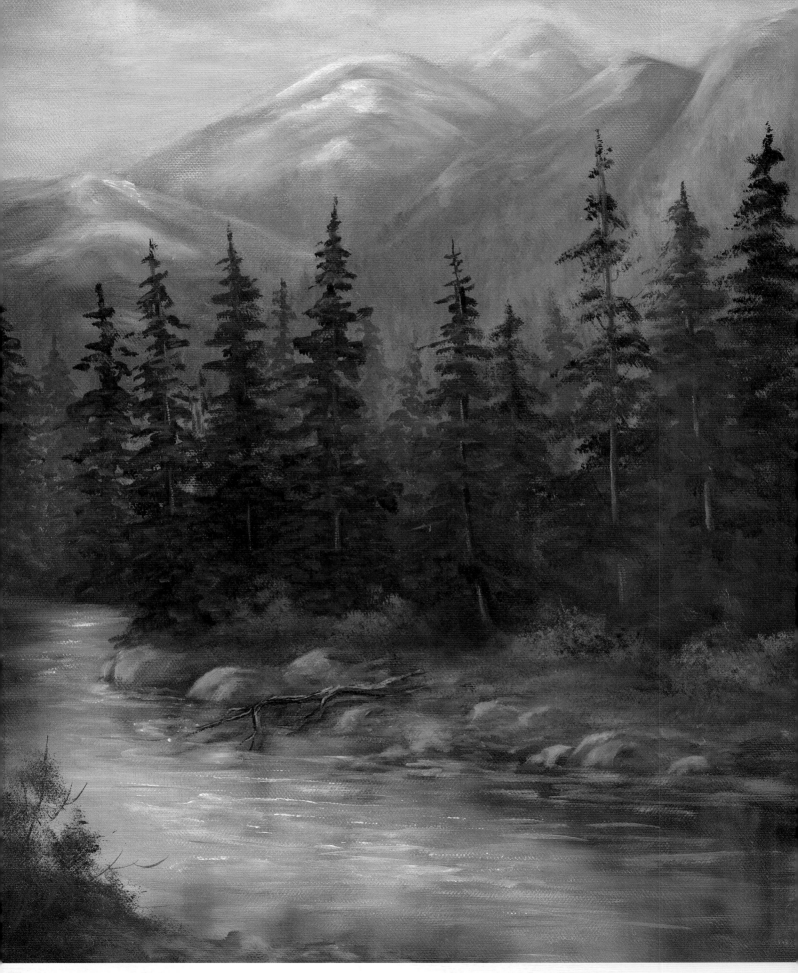

INTRODUCTION

For years, I only painted other artists' patterns, always yearning to try a painting all my own. I did not feel I could draw or produce something other people would like. Many of you may feel the same way, or you just do not know how to start. My goal with this book is to encourage you and to provide information on how to start if you just feel hopeless with a pencil and paper.

Painting from photos gives the artist a head start. Not every painting has to be created from an idea in your head. Patterns are included in the book, and they will help you to paint the scenes. Copying patterns of different artists and using their instructions is a good learning experience. You cannot trace a pattern without learning something about form and perspective. When you are comfortable in your painting, begin to venture out by painting from your own photos. This book explains several different methods to help you transfer a photo idea to canvas. Utilize a palette from one of the paintings in this book to paint your own composition. Not every idea or pattern will create a lovely picture, but the more we practice, the better we become.

There are five acrylic projects and five oil projects in this book, but there also is an acrylic/oil colors conversion chart included. With this chart, you can select your preferred medium and paint all ten projects in this book with the same medium. It's difficult for me to decide which medium I prefer, oil or acrylic. Both mediums have their own special qualities. I have always thought of landscapes as being oils and decorative painting projects as acrylic. However, the painting principles remain the same — using values correctly and keeping perspective in the drawing. Only the painting techniques vary from medium to medium.

Each photo chosen for this book, with the exception of *Mountain Pines*, was from a special trip that my husband and I took. *Mountain Pines* was a photo from a good friend who travels and takes hundreds of photos wherever she goes. I appreciate her loaning me her photos to use in this book. As I painted from our photos, some wonderful memories came back to me and they have made this an extra special book. I hope it becomes a special painting book for you as well.

Mountain Pines

ACRYLIC PAINTS

Five landscapes in this book are painted with acrylic, and five are painted with oil. You may paint the projects in their designated mediums or use the acrylic/oil conversion chart (see page 140) to paint the project in your preferred medium. The next few pages are an overview of materials you will need to complete the projects in the book, organized by medium.

PAINTS

The acrylic projects in this book are painted with DecoArt Americana paints. I find these paints are readily available in most places and on the Internet. The colors are consistent and come in a wide variety of hues. It is easier to paint on the canvas if you use more paint in the brush. Since I do not use water in my brushes, I need the extra paint to be able to work wet-into-wet.

WET PALETTE

I prefer to use a wet palette with acrylics. Masterson's makes a nice wet palette, Sta-Wet Painter's Palette, which has a yellow lid. Remove the sponge that is included and replace it with four layers of Blue Shop Towels that are wet. Lay a piece of deli wrap paper or Maureen McNaughton wet palette paper on top. The wet palette keeps your acrylic paint workable for a long time. When painting on canvas, I do not like my acrylic paint to become too wet. You may want to try painting on a regular palette without the wet palette. Depending on the humidity at your location, the need for a wet palette will vary.

EASY FLOAT MIX

Easy Float is a medium from DecoArt that you add to your floating water to help make nice, graduated floats. For this book, I use the medium not only to float, but as a glazing medium, a medium to thin the paint when loading a liner brush and also to dress the brush when floating. You will find the term Easy Float Mix throughout the book.

Easy Float Mix: Fill a clean, 2 ounce (57g) bottle halfway with Easy Float. Fill the remaining half of the bottle with water. In some drier areas of the country, you might try 2/3 water and 1/3 Easy Float. If you find the paint drying too quickly on your palette, you need to add more Easy Float to the mix. This allows the paint a little bit more open time to make blending easier. Use a small mop brush and stipple up and down where the float ends to help blend into the background. Easy Float does not thin the color enough to make line work transparent.

*DecoArt Americana
Acrylic Paints*

Easy Float

ADDITIONAL MATERIALS

- **Brush Basin:** Used to hold water. Look for a basin that has three wells for water and is deep enough to hold lots of water. This keeps you from having to replenish the basin too often. One well can always be kept clean and ready to use for floating.

- **Canvas Gel:** When working with DecoArt Americana paint on canvas, I like to use a thin layer of DecoArt Canvas Gel on the surface so the paints will blend easily.

PAINTS

Winsor & Newton Artists' Oil Colors is my brand of choice for oil paints. They have wonderful pigment and a good line of colors. These paints are rich and creamy and not so thick as to make painting difficult. Blending and glazing medium helps when you need to thin the paint for line work, washes and glazing.

Instead of using white oil paint, I use Winsor & Newton Alkyd Titanium White. Alkyd colors are compatible with oil. Since alkyds dry quickly, any area where you are using alkyd white by itself or in a mix will dry much quicker than oil. The alkyd allows me to add more highlights and sometimes glaze sooner. If you cannot find the alkyd in your area, use regular Titanium White oil paint.

Liquin

Winsor & Newton Oil Paints

BLENDING AND GLAZING MEDIUM:

Blending and glazing medium reduces the consistency of the oil paint and is used when painting fine line work, washes or glazes. When working with blending and glazing medium, place a small amount in a palette cup.

The medium slows the drying process. If time is an issue, consider using Liquin for glazing. Liquin does not thin the paint well for line work. I do not use turpentine to thin my paints due to health reasons.

PALETTE

Use a good quality waxed palette to hold your oil paints. Since I mix using a brush, I need a large palette. The small palettes do not give me the room I require.

BRUSHES AND SURFACES

If you paint in both mediums, it is necessary to have separate brushes for each. I prefer to work with Royal and Langnickel brushes. I especially like the Royal Sable brushes when using acrylics on canvas. They are longer lasting and have more body to the brush. The Aqualon and Golden Taklon series of liners, filberts and mops that I use are typically only used for acrylics, but I also use them with oils. You may use other brands of brushes as long as they are the correct materials and sizes. Experiment and decide which brands work best for you.

Canvas is rough and hard on your brushes, so you need good quality brushes to do your best work. Having good brushes and taking care of them will help your painting skills develop and aid in creating beautiful artwork. Buy the best brushes you can afford, as they are the main tool you will use. Old, flared brushes will not produce the best work and only cause frustration by making the painting process more difficult.

Aqualon Liner, nos. 5/0, 1, 4 and 6

Aqualon Script Liner, no. 2

Aqualon Filbert, nos. 2, 4 and 6

Aqualon Wash, 1-inch (25mm) and 3/4-inch (19mm)

Royal Sable fan blender, no. 8

ACRYLIC BRUSH CARE

Acrylic brushes may be cleaned with DecoMagic Brush and Jewelry Cleaner. Rinse the brushes in clean water before you put them away. To make your brush long-lasting, you can dip the acrylic brush in Loew-Cornell One-Step for Oils cleaner and conditioner and reshape the bristles before putting it away. You must clean the One-Step from the brush with soap before using it again.

When you clean your brush, it is best to let it lay on the table until dry and then put it away in your brush container. Letting the wet brush stand on end while it dries allows water to run into the ferrule and can cause the bristles to flare.

OIL BRUSH CARE

Clean the oil brushes with Pink Soap or Loew-Cornell One-Step for Oils brush cleaner and conditioner. I like to dip my brushes in Loew-Cornell One-Step for Oils and reshape the bristles before putting them away. You do not need to clean the oil brushes that have cleaner in them before you start to paint.

Brush Cleaners

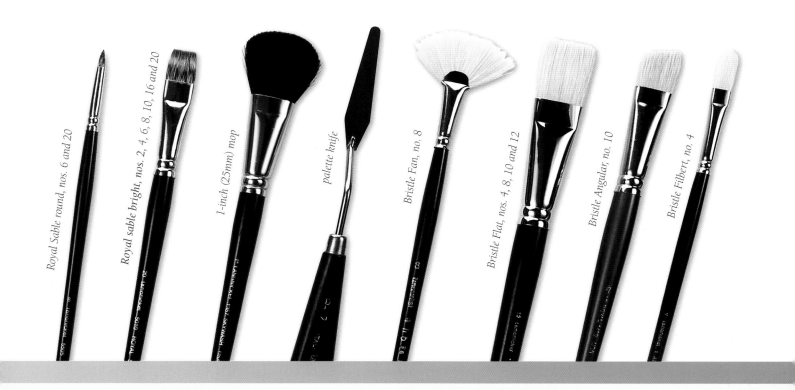

Royal Sable round, nos. 6 and 20

Royal sable bright, nos. 2, 4, 6, 8, 10, 16 and 20

1-inch (25mm) mop

Palette knife

Bristle Fan, no. 8

Bristle Flat, nos. 4, 8, 10 and 12

Bristle Angular, no. 10

Bristle Filbert, no. 4

SURFACES

In this book, I have used 11" × 14" (28cm × 36cm) and 12" × 16" (30cm × 41cm) surfaces. You can enlarge the patterns and use larger sizes should you desire.

I only use Fredrix Blue Label stretched canvas. I feel the smoothness of the Blue Label makes painting much easier. The beauty of oil canvas painting is no prep! Simply transfer the pattern and you are ready to paint.

ACRYLICS ON CANVAS

You need an acrylic base when painting on canvas with acrylics. You can use acrylic paint or gesso to base the canvas. Use at least two coats of paint, applied with a large brush. Sand and then wipe with a damp paper towel or cloth between the coats of paint. When preparing a canvas, I prefer to use an acrylic color that can show through the other paints. Painting the canvas with white will make your finished painting brighter.

Canvases & Sand Paper

MATERIALS

Palette Knife: I do not like to use plastic palette knives. A good quality, flexible knife is an important painting tool. The three knives that I use that are available from Royal Brush are: P-16, good for mixing; K-4, for palette knife mountains and water lines; and P-5 for transferring paint from area to area, spattering edges and general painting.

Stylus: Used to transfer patterns to any surface with the aid of transfer paper. I also use a stylus to etch into wet oil paint when needed (see page 15). Look for a double-ended stylus. Check the ballpoints and look for a stylus that has a large and small point.

Paper Towels: I prefer the Blue Shop Towels available from many of the mass merchandisers. They are usually found in the automotive department. These are very absorbent and do not leave lint when wiping over a canvas or project piece. Whatever paper towel you choose, be sure it is soft and absorbent. Rough paper towels are like sandpaper to your brushes.

Round Synthetic Sponge: Used to make foliage, clouds and background trees. Be sure to wash it in clean water as soon as you are finished sponging. For small areas, I like to cut the sponge into halves or fourths.

Kneaded Eraser: Used to remove art masking fluid.

T-square: Used to ensure straight vertical and horizontal lines, especially on buildings in landscape painting.

Art Masking Fluid: Used to block an area of the canvas that you do not want to get paint into or where you want a background color to show through. Apply the fluid with an old brush and then remove it with a kneaded eraser when you have completed the painting around the masked-off area.

Graphite Paper: Also known as transfer paper and available in white, gray or black. This is used to transfer the traced pattern onto the painting surface.

Red Acetate: Used to check the values in a painting. It may be purchased in most art supply stores.

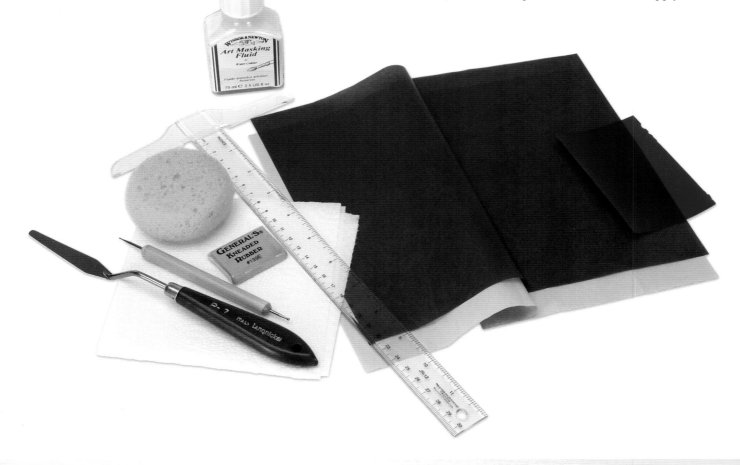

TRANSFERRING A PATTERN

It is best to copy your pattern onto a piece of tracing paper the size of the canvas. You may use a pencil or felt pen to trace the pattern. Lay the tracing on top of the canvas and slip a piece of white or gray transfer paper between the tracing and the canvas. Check to be sure you have the graphite side facing the canvas. Use a stylus over the tracing, transferring the design to the canvas. Before removing the tracing, check to be sure you have the entire pattern on the canvas.

When painting with acrylics, I like to complete the background and then add the detail or outline of people, animals, small buildings and other subjects. Lay the tracing over the painted canvas and slip your transfer paper between the tracing and the dry canvas and reapply the pattern.

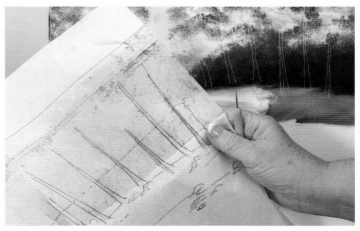

Etching Pattern Lines on Wet Oil. Sometimes it's more helpful to trace a portion of the pattern onto the canvas after you've painted the background, but oils take a while to dry. To transfer the pattern while the canvas is wet, simply lay the pattern over the canvas and etch the desired pattern lines into the wet paint with a stylus, as shown here.

RESIZE AN ELEMENT

1

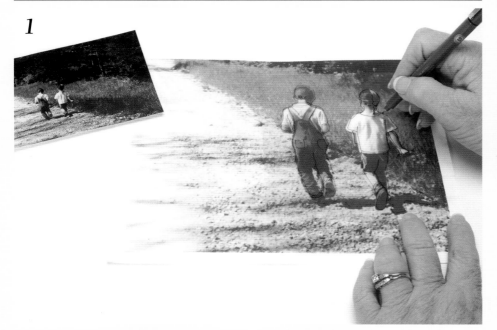

2

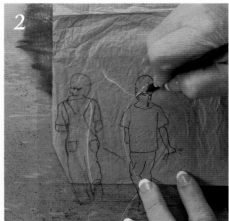

Step 2: Trace image from acetate. Your acetate tracing becomes a pattern you can use to place the desired element into your composition.

Step 1: Use copier to enlarge image. Sometimes you have an element in one photo that you want to add to your composition, but the size is too big or too small. Use a photocopier to bring the original to the right size. Place clear acetate over the resized photo and trace the element you desire.

TECHNIQUES

The next few pages offer an overview of brush loads, strokes and techniques used in the book. Depending on your experience level, you may want to practice these on a blank canvas before attempting them in a painting.

Double Load (Oil & Acrylic)

This load can save you time when you're painting a fence rail or tree trunk. It is used in both oil and acrylic painting.

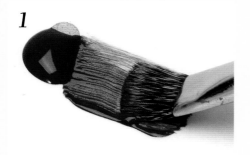

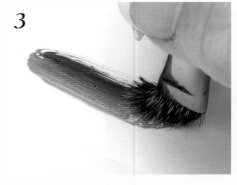

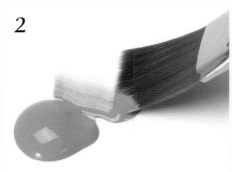

Step 1: Load Dark Color Create a loading zone by pulling a little paint from the puddle with your brush. Load one flat surface of the brush in the first color.

When loading the brush in oils, you need to thin the first color of paint with a little blending and glazing medium. With acrylics, you do not need to thin the paint.

Step 2: Load Lighter Color Turn the brush and swipe through the lighter color once. When double-loading oil paint, do not thin the lighter, second color. Typically your palette will contain a light color that is spread on the palette from prior use. If the paint that is going to be used for the highlight is still in a puddle, spread the paint out on the palette with a palette knife so you have a thin layer of paint to load the brush.

Step 3: Work into Bristles Hold the brush on the chisel with the lighter color facing toward the light source and stroke. This gives you the dark, medium and light colors at once. You can then refine them.

Corner Load

This load is used with both oils and acrylics for touches of color or for highlight.

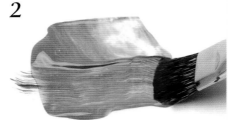

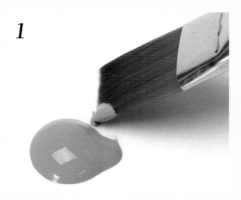

Step 1: Grab paint Pick up paint from puddle on one corner.

Step 2: Work into Bristles Stroke the brush to blend the paint into the bristles.

SIDE LOAD

This load is used for floating shadows.

1

2

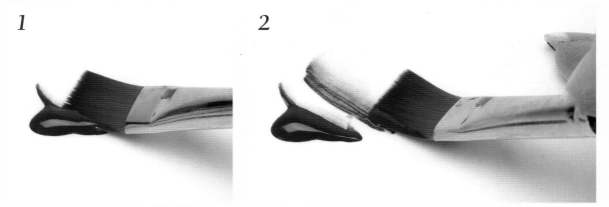

Step 1: Load Run one side of the brush through the edge of a paint puddle.

Step 2: Work into Bristles Blend on the palette so the color goes from color to nothing. Do not let the color travel across the entire brush.

LINER LOAD

Always thin your paint before loading a liner. When working with oils, use blending and glazing medium or turpentine to thin the paints. With acrylic, thin with Easy Float mix (see page 10) or water. To best load a liner, your paint needs to be an ink-like consistency.

1

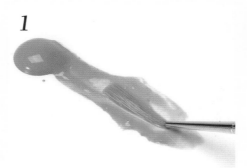

Step 1: Load Create a loading zone and fill the brush to ferrule.

2

Step 2: Create a Point After loading, roll the brush to a point.

3

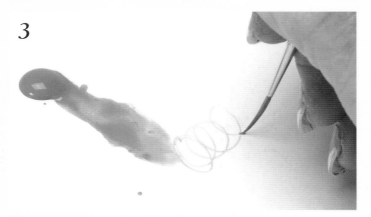

Step 3: Check Load The brush is loaded correctly if you can scribble with it. This load is used to line tree branches, fence wires, grass — anything that needs a thin line.

4

Step 4: Loading for Highlights If loading for highlights, don't dilute the paint. Pick up a heavy dab on the point. When you apply the paint to canvas, the paint will break instead of giving a continuous line. This technique creates the brightest highlights on tree branches, deer antlers and hay bales.

STIPPLING

Stippling is mainly used to create foliage. I also use stippling in this book to create foam in water and to suggest weeds and flowers. I always use an old, scruffy brush for this technique, but if you do not have such a brush you can use an angular bristle brush.

Step 1: Load Dark Color Load the darker color by tapping on the palette to flare the bristles. Load just the toe.

Step 2: Stipple Canvas Pounce (stipple) color on canvas.

Step 3: Double Load Stipple To apply two colors at once, load the heel of the brush with the dark value and the toe with a light value. Tap once on the palette and then stipple on the canvas. You now have two values, dark and medium.

Step 4: Add Highlights Load just the toe with highlight color and stipple on highlight.

SPATTERING

Spattering is useful for adding spotty textures, such as falling snow or a suggestion of gravel. It can be done with a toothbrush, but a fan brush gives me more control.

Step 1: Load Dampen the brush with water (acrylic) or blending and glazing medium (oil). Pull out some paint from the puddle to create a "soupy" loading zone. Load one side of the brush.

Step 2: Scrape Brush Scrape the brush across a palette knife for a spatter.

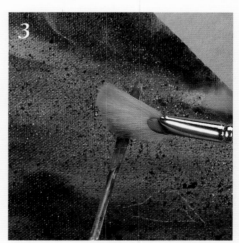

Step 3: Use Easel or Lay Flat You can spatter with the canvas flat or on an easel, but most people prefer to have the canvas flat. Cover areas you wish to keep clean with a paper towel.

SPONGING

Sponging is sometimes used to create foliage. It can also be used to create clouds, although it is not used in that way in this book. This technique typically is not used with oils, however I have successfully used it with that medium. With oils, I usually use a little blending and glazing medium on the canvas and sponge on top of the medium.

Step 1: Dampen Sponge If working with acrylics, dampen the round synthetic sponge with water and blot out the excess dampness in a paper towel.

Step 2: Pick up Paint Squeeze the sides of the sponge together to create a rounded surface on the flat side. Dab the rounded surface into the paint.

Step 3: Pounce to Disperse Paint. Pounce the sponge on the palette to disperse the paint into the sponge.

Step 4: Tap on Canvas Tap painting surface, pointing sponge in different directions.

Step 5: Load Second Color Turn the sponge to a clean spot and load as you did in steps 2 and 3.

Step 6: Tap on Second Color Tap second color onto the painting surface.

MOPPING

Mopping is used for blending parts of the painting together, such as clouds into sky or sky into the top of a hill.

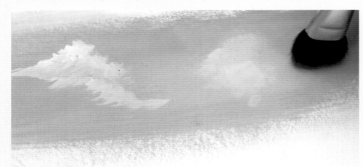

Acrylic: The cloud on the left hasn't been mopped, while the cloud on the right has. Acrylic mopping is stippled — or tapped — onto the surface.

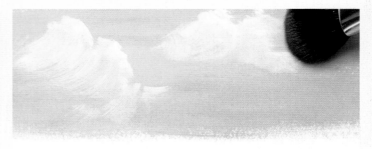

Oil: The cloud on the left hasn't been mopped, while the cloud on the right has. To mop oil, sweep over the paint with a light touch.

Brush Mix

You can achieve many different values and colors when you brush mix. Since you typically cannot brush mix the exact same color every time, the technique provides a wider variety of colors in the painting.

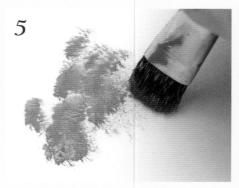

Step 1: Pick Up Color Pick up first color (either light or dark).

Step 2: Work in Paint Tap once or twice on palette.

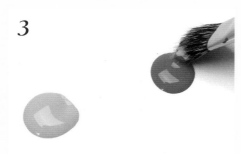

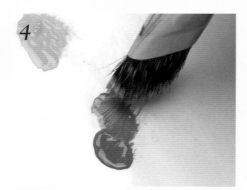

Step 3: Add a Second Color Pick up the second color.

Step 4: Tap on Palette Again, tap once or twice on palette. Do not over mix. If you mix two colors until they are well blended, you could have used a palette knife instead.

Step 5: Tap on Canvas Tap the mix onto your painting surface — in addition to the mixed color, both colors come out at once. The brush mix works well for grass and foliage.

Palette Knife Mix

Mixing paint with a palette knife produces what I call "dead color." The color doesn't provide the spontaneous variations and commingling of colors that add so much to a painting — although sometimes the dead color is necessary for the task. I use palette-knife mixing more with oils, because there are so many colors already manufactured for acrylics.

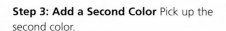

Step 1: Load First Color Scrape the designated portion of the first color in the mix onto the palette knife.

Step 2: Add Additional Color Clean the palette knife and scrape up the next color. Continue to clean the palette knife after scraping up each color.

Step 3: Mix the Colors Then mix the two or more colors together. The resulting color should be solid with no streaks.

Dry-brushing

Use dry-brushing to add tints and highlights. The highlights on the children's clothing in *Down a Country Lane* (page 46) was applied with the dry-brush technique. Use this technique any time you want to have a broken look, as with highlights or shading.

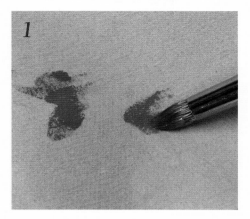

1

Step 1: Load Brush Load brush well and then wipe the outside bristles on a paper towel.

2

Step 2: Move Brush in Circle Lay the brush on its side and move it in a circular motion. This technique is used to apply highlights to rocks, roofs, clothing and other items.

Glazing

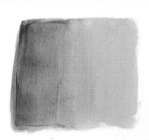

Apply Medium Glaze Glazing is a transparent layer used over dry paint. First put medium on dry paint. Then glaze. Here you see a blue base (right) with a Black Plum glaze (left). Among other things, I use glazing to deepen shadows.

Wash

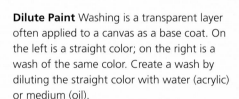

Dilute Paint Washing is a transparent layer often applied to a canvas as a base coat. On the left is a straight color; on the right is a wash of the same color. Create a wash by diluting the straight color with water (acrylic) or medium (oil).

Checking Values

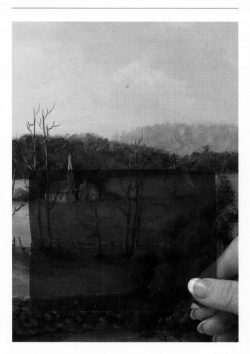

Using Red Acetate You can check the values in your painting by using red acetate. The red acetate blocks the colors and lets you view the painting in gray tones. This makes it much easier to see your values and to correct the painting should values be missing or need to be corrected.

WATERFALL WITH POOLED WATER

Two painting projects in this book have waterfalls. These instructions break down the steps more than the project step-by-step.

Step 1: Load and Dry-Brush The dark strokes are the based rock ledge. For the fall itself, you can use a fan, rake or old scruffy brush (my preference). A flat also works, but it's harder to use. To begin the fall, load with the color used for the water and then wipe out the back (dry-brush). With the paint on top, pull the brush straight down, allowing the paint to break over the ledge.

Step 2: Use the Chisel Edge Use the brush's chisel edge where the water breaks over the falls to make the water more opaque and hide the edge of the rock line.

Step 3: Load Dark Color Water pooled at the base of a fall is painted with the same technique as water in a pond or lake. First, load dark color in the brush and pull straight down from the rock ledge or bank. Pull some strokes farther than others.

Step 4: Fill Pool with Vertical Strokes Fill in the pool with a brush and thin paint. Start the light color in an unpainted area above the dark area and catch the edge of the dark colors as you pull down. Use vertical strokes.

Step 5: Blend Blend horizontally with a dry bristle fan brush.

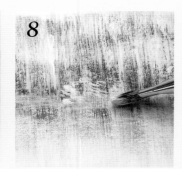

Step 6: Add White to Waterfall Now return to the waterfall. Load the brush with white and pull down falls again as you did in step 1.

Step 7: Create Sheeting You can create a sheeting effect with the brush chisel and white. Use vertical strokes.

Step 8: Add Foam To create the foam at the bottom of the fall, corner load brush with white and stipple appropriate area.

PINES

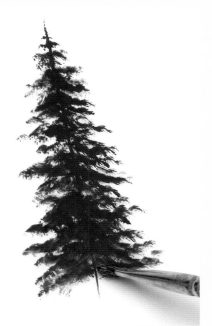

Corner load and Tap Start a pine by painting a spine with a liner. This is just a reference for the center of the tree. Don't worry if it becomes covered in paint. Corner load a flat brush and turn it so the paint is on top. Tap in the branches with the brush corner, creating an irregular outside edge.

ROCKS

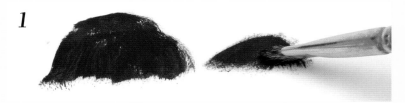

Step 1: Base coat Rock Paint rocks with any flat brush. Load the brush with rock colors and base coat the rock.

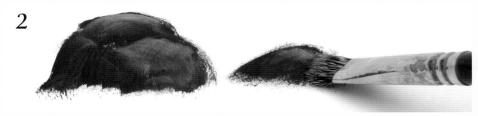

Step 2: Create Form with Highlights Corner load the brush with your first highlight color and create form, facets, and edges.

Step 3: Highlight Cool Side Continue to add highlights and reflected lights. Give the cool side (the one facing away from the light source) bluish colors.

Step 4: Highlight Warm Side Give the bright side (the one facing toward the light source) warm colors.

GRASS

Step 1: Corner Load First Color To paint grass in oil, use a fan brush; to paint grass in acrylic, use a fan or flat. Load only one corner of the brush and then turn it so the paint is away from you. Stroke only with the corner in short, downward, overlapping strokes.

Step 2: Avoid Arches If you load the whole fan brush and use the middle bristles to stroke, you'll makes undesirable arches.

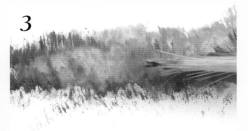

Step 3: Corner Load Second Color When you've finished with the first grass color, corner load the next color and lay it over the first in short, downward strokes.

COMPOSING FROM PHOTOS

There are a number of reasons to let photos inspire a painting. Photos capture shadows and preserve exact lighting, which is constantly changing when painting on location, also known as plein air. When I plan to paint on location, I take a photo before I start, and this photo helps me complete the painting later in my studio.

Using photos, cards, magazines and reference books is a wonderful way to learn more about colors and other specific elements that will help your painting, but remember published materials are copyrighted and cannot be copied. Your own photos are the best help you can have in designing a painting.

SELECT THE RIGHT PHOTOS

When deciding which photos I am going to paint from, I like to have several strips of black construction paper that I can lay over the photo to crop parts of the image. You can place the strips to see the different elements in the photo, determining the most interesting and cropping out the remaining parts. It is unusual to have the perfect photo from which to paint. Sometimes the composition requires two or three photos put together to make the scene you wish to paint. The *Bales of Hay* project on page 90 is a combination of two photos.

When choosing images, remember your painting will need a center of interest. The center of interest is the place you want the viewer's eye to look first. It could be a building, or group of buildings, a large tree, a person or an animal. To properly place your center of interest, divide your canvas into quarters. You will want to place your center of interest in one of the squares just off center.

NOTES ON PHOTOGRAPHY

■ Digital cameras allow you to view your picture and make changes right away.

■ I like to take photos from 10 A.M. to 11 A.M. and from 2 P.M. to 4 P.M. The shadows are much more interesting during these times.

■ Take the picture as if you were looking at a painting.

■ Take several pictures from different positions. Many times I will change my mind about what I thought looked good once the photos are printed. Having several views from which to choose is helpful.

■ Be sure the subject is appealing to the market.

■ Is the perspective achievable in the painting and if not can you change it?

Transfer the Image

Once you've selected your subject matter, you can transfer it to the canvas. So many of my students who want to paint from photos are concerned about their drawing skills, but masterful drawing techniques are not required. There are many ways to transfer subject matter from the photo to the canvas.

In *Down a Country Lane* (page 46), I sketched on the background and painted it. Then, I enlarged the photo of the children on my copy machine, making it the size I wanted on the canvas. I placed a piece of clear acetate over the enlargement and traced the outline of the children with a fine-point permanent marker. I used this pattern to transfer the image onto the canvas using black or white transfer paper.

You can also use grids to help improve your drawing. Divide your photo and your canvas into 16 sections. Draw the lines on the canvas or tracing paper with a pencil and on the photo with a permanent marker. Take each section and draw what you see in it. If you are drawing a building, use a T-square to insure the vertical lines are straight. Drawing within small sections is much easier than trying to draw the entire scene.

Another method of getting the photo onto the canvas is with the aid of a projector. There are several machines on the market at many different prices. All are a great help in transferring the photo to a canvas, wall or any painting surface. Keep in mind a camera lens is curved and will distort the lines of a building. If you are enlarging a photo or using a projector, know that you must correct the perspective. There are several books on perspective available and I suggest you purchase one for reference. *Perspective Without Pain* by Phil Metzger can give you a good start in working with perspective.

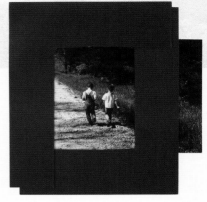
photo with croppers

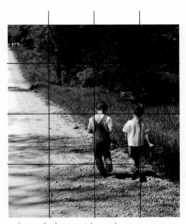
enlarged photo with grid

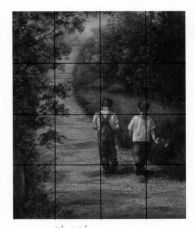
canvas with grid

Combine photos

If you want to combine several photos into one, you can use a copy machine to help assemble the new image, as I did in the *Bales of Hay* project. That painting is a combination of three photos. I enlarged the two photos to about 200 percent on a copy machine and then cut the copies apart and taped the sections together the way I wanted them. (The third photo was just for reference for the field.) Now I had a crude rendition of the picture and a visual concept of the scene. Draw the scene, changing it as you want it to appear on the canvas.

Change the season

Sometimes you may want to change the look of a photo. Say you have a summer scene with lots of greens and you want to make it a winter scene with lots of blues. Study some pictures from your reference material, decide on colors, check shadows, determine how snow lies on tree branches and accumulates next to objects. Then, you can easily change seasons.

Value Scale Snow Scene

I f you have ever photographed a snow scene of just trees and snow, you know that the photos look as if they were taken with black-and-white film. The pictures are great for value studies since they allow you to see relative light and dark without the distraction of color.

Learning to recognize the different values helps you to be a better painter. Brush mixing is much easier when you can recognize and understand how to use the different values. This painting will teach you much about values, and should you desire, you can color wash the finished painting, adding your choice of colors. The values are already there with the black-and-white gray scale.

Brushes:

nos. 8 and 16 Royal Sable brights
no. 2 Golden Taklon liner
no. 10 angular bristle
1-inch (25mm) Aqualon glaze/wash

Other Materials:

medium-grit sandpaper
sponge
red acetate
Canvas Gel
palette knife (for spattering)
pattern (see page 28)
Easy Float Mix
paper towels

Surface:

11" × 14" (28cm × 36cm) portrait-grade canvas

DecoArt Americana Acrylic Paints:

| Lamp Black | Grey Sky | Ultra Blue Deep | Snow (Titanium) White |

REFERENCE PHOTOS AND GRAY SCALE

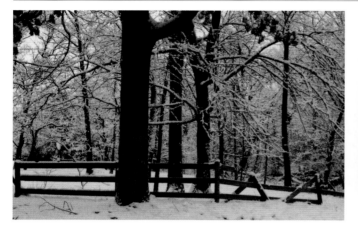 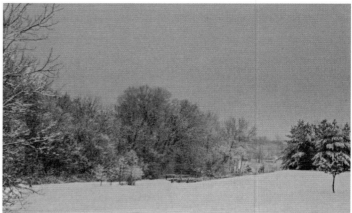

PATTERN

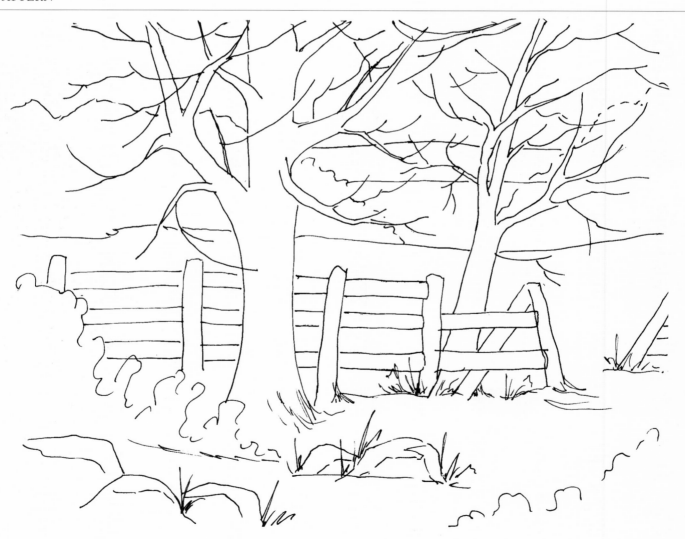

This line drawing may be hand-traced or photocopied for personal use only. Enlarge at 100% to bring it up to full size.

Gray Scales

You can purchase a gray scale from your local art supplier. It is good to have one of these on hand, but it also is important for you to learn to mix one yourself.

Here, you see a full-value scale painted in black and white and a 5-value scale. The full-scale was painted in black and white only. The 5-value scale was painted with a dot of Ultra Blue Deep added to Ivory Black. You will use the 5-value scale for this painting.

Value 9	*Value 8*	*Value 7*	*Value 6*	*Value 5*	*Value 4*	*Value 3*	*Value 2*

Highlight (value 5)	*Light*	*Middle*	*Dark*	*Low Dark (value 1)*

Step 1: Create Values Mix at least four values for the painting. Your fifth value will be pure Snow (Titanium) White. It is best to mix these colors with a palette knife. Start by adding a little Ultra Blue Deep to the Lamp Black paint, simply to have a nicer looking black. This is your darkest value (Low Dark). Create the remaining four values out of this Low Dark value.

First add a little Snow White; the color should look gray, not blue. If it looks blue, add a little more black. Test the color against the 5-value scale. Continue mixing your five values, laying them in order on your palette from Low Dark to Dark to Middle to Light to Highlight.

Step 2: Preparation Paint the canvas with two coats of Grey Sky and a 1-inch (25mm) glaze wash, sanding and wiping with damp paper towels between coats.

Transfer the background to the canvas. (You'll trace the large trees, fence and rocks later.) Apply a thin layer of canvas gel to the sky area with a paper towel.

Throughout the rest of the value painting, do not clean your brush unless the instructions tell you to, and work wet-into-wet as much as possible. With a no. 16 sable bright, apply Light Value, starting at the top of the sky. Add Highlight Value toward the center of the canvas.

Step 3: Background Hill Base the back hill with the same brush and Light Value. Shade the bottom of the hill with Middle Value. Use Highlight Value at the top.

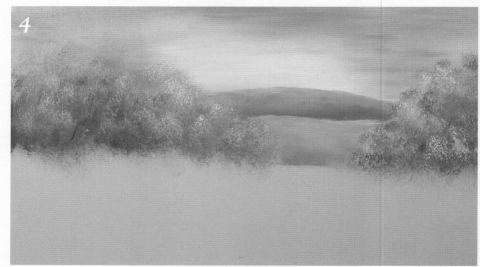

Step 4: Snowfield and Foliage Paint the far snowfield with Light Value + Highlight Value. Shade the bottom with Light Value. Go lighter at the top with Highlight Value.

Sponge Light Value (see page 19) on the foliage on the right and left side of the canvas. Pick up a Middle Value as you move down.

Then turn the sponge to a clean area, pick up Highlight Value, tap out the excess and apply on the trees.

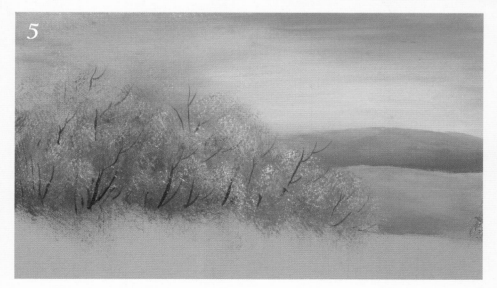

Step 5: Trees Use a no. 2 liner to add tree trunks and limbs to the left foliage with Middle Value and Light Value. Afterwards, you can add a bit more Highlight Value to the foliage with a sponge if necessary.

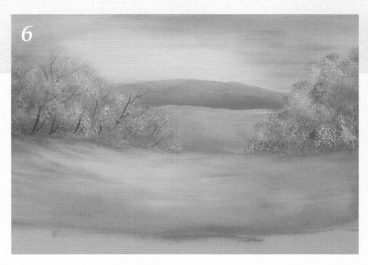

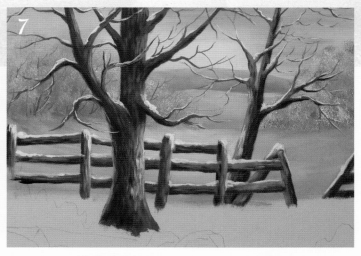

Step 6: Snow-covered Ground Apply Canvas Gel to the midground snow down to the base of the fence (see finished painting, page 35). Use a no. 16 sable bright and Light Value to paint in the snow, angling the brush with the lay of the slope. Add Highlight Value for the drifts.

Since you're working wet-into-wet, adding the Highlight Value on the Light Value will give you a value between the two. Go lighter toward the middle. Add shading with Middle Value from the base of the tree and along the base of the field.

Let paint dry to the touch before proceeding.

Step 7: Large Trees and Fence Trace on the rest of the pattern. For the trees and fence, mostly use the nos. 8 and 16 sable brights, depending on the size of the area you're painting. Paint the smallest branches with a no. 2 liner.

Base the trees and fence with Middle Value + Dark Value. A touch of water makes the paint flow more easily. Then apply the first shading with Dark Value and the second shading with Low Dark Value. Chop these values in on the vertical chisel of the brush. Chop in highlights with Light Value.

Tap snow on the branches, trunks and fence first with Light Value + Highlight Value. Then add Highlight Value highlights.

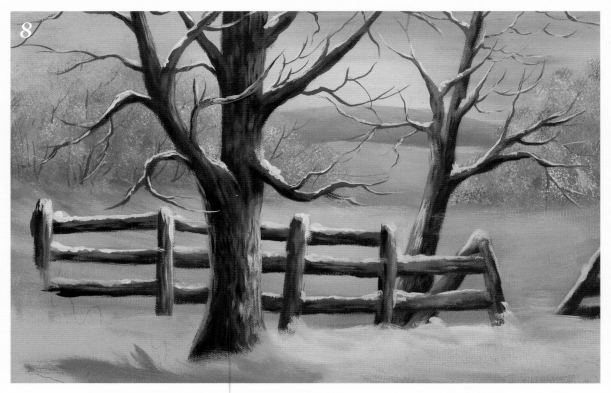

Step 8: Snow-covered Ground Apply Canvas Gel to the snow area in front of the fence. With a no. 16 sable bright, base the snow with Highlight Value. Pick up Light Value to blend with the snow by the broken fence area. As you descend to the bushes on the right, pick up Light Value.

Continue to work lower on the canvas, both to the right and the left, picking up Middle Value, Dark Value and Low Dark Value consecutively.

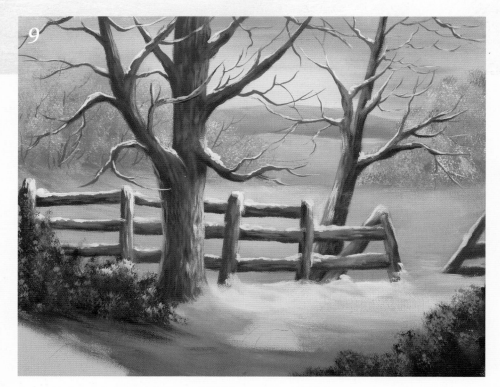

Step 9: Bushes Use the no. 10 angular bristle to tap on the lower bush foliage with Low Dark Value. Highlight with Middle Value + Dark Value.

Apply second highlights with Light Value, perhaps adding a bit of Highlight Value. Using a no. 16 sable bright, pick up Dark Value + Low Dark Value to pull out shadows from the bushes.

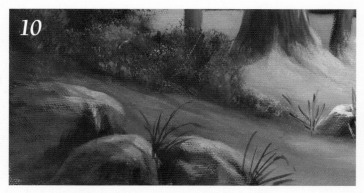

Step 10: Rocks Using a no. 16 sable bright, base the rocks with Dark Value and shade in the front faces with Low Dark Value. Highlight with Middle Value and then with Light Value.

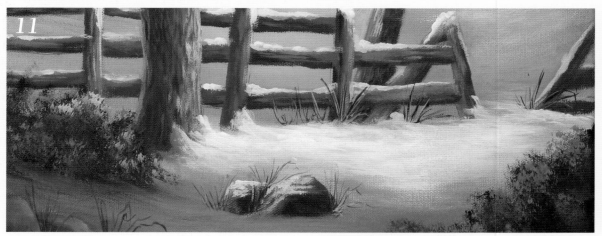

Step 11: Grass Paint the grasses with a no. 2 liner, making some Dark Value, some Middle Value and some Highlight Value.

Using clean nos. 8 and 16 sable brights (depending on the size of the area you're painting), apply pure Snow White to create the brightest highlights on the snow on the fence, trees and ground in the focal area. Chop this value in the snow to create texture, and use very thick paint on the fence and trees.

Step 12: Check Values with Red Acetate

When the painting is dry, look through a sheet of red acetate and check the values. Deepen any that need to be darker and highlight anything that needs to be lighter.

Highlights tend to sink in as they dry, so you may have to apply them three or four times.

In the photo at left, the red acetate shows the fence needs a mid-value.

In the photo at right, the red acetate reveals the need for more highlights on the rocks.

Step 13: Color Wash When the canvas is dry and the values are correct you can color wash over the black-and-white painting. Use transparent colors. Paint labels sometimes list colors as transparent. If you need to use an opaque color, adding Easy Float will make an opaque color translucent.

With a 1-inch (25mm) wash brush, apply a layer of Easy Float Mix (see page 10) to the sky. With a no. 16 sable bright, pick up Ultra Blue Deep and add the blue tones to the sky. Use a mop brush and stipple stroke to smooth the color. Add Lemon Yellow + a dot of Cadmium Red to tint the sky. Wash some of the tint color on the top of the hill. Add more blue tones to the field of snow. A little Lamp Black may be added to the Ultra Blue Deep to gray the color for the shadow areas.

Wash Dark Chocolate, Ultra Blue Deep, Evergreen or Black Green in the sponged trees. If you lose too much of the highlights, tap some more Highlight Value in the trees.

You'll need to glaze several layers before the colors build to the right level. Here you see the first layer of glazing on the left side of the canvas and across the sky.

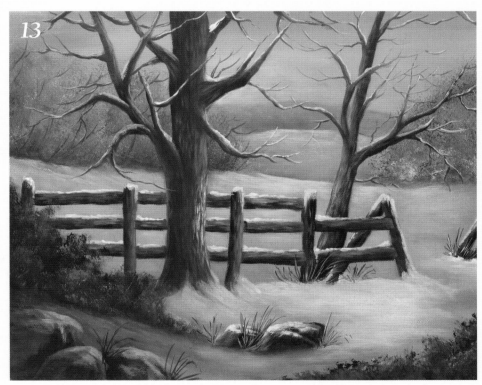

GLAZING A VALUE PAINTING

The values must be adjusted before you add color glazing. Glazing is transparent and cannot correct values.

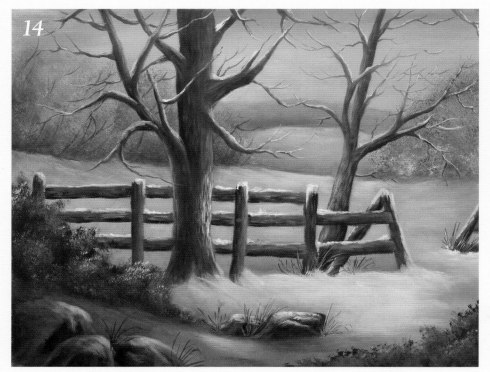

Step 14: Glazing and Color Wash Continue to glaze in layers, letting the paint dry between applications.

Add the blue tones to the snow, Soft Black and Dark Chocolate to the trees and Alizarin Crimson + Ultra Blue Deep in the shadows.

Highlight the trees with Lemon Yellow and Cadmium Red. You can add Black Green to the foliage area.

Rocks can have a variety of glazes: Ultra Blue Deep + Highlight Value, Alizarin Crimson + Soft Black + Snow White. Highlight with Snow White + Yellow Light + Cadmium Red.

Add more Snow White snow where needed. Here you see the painting fully glazed in several layers on the left and across the sky. The right has been left mostly as a value painting without any glazing.

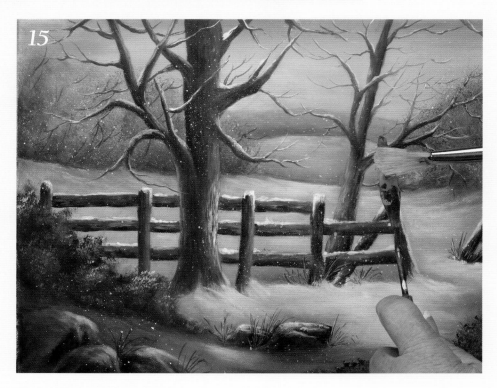

Step 15: Spattering snow Once the entire canvas has been completely glazed, you can spatter snow (see page 18) with Ultra Blue Deep + Snow White. Then repeat with Snow White.

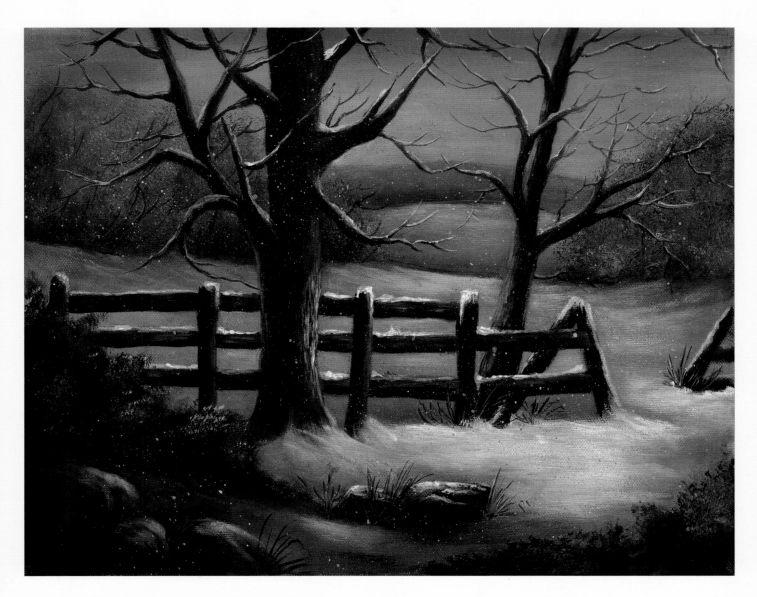

VALUE SCALE SNOW SCENE

Finishing Touches: The color washes on this final painting are very subtle. You may wish to add more color by not thinning the colors as much. Use the value scale painting to know where to place your more opaque colors.

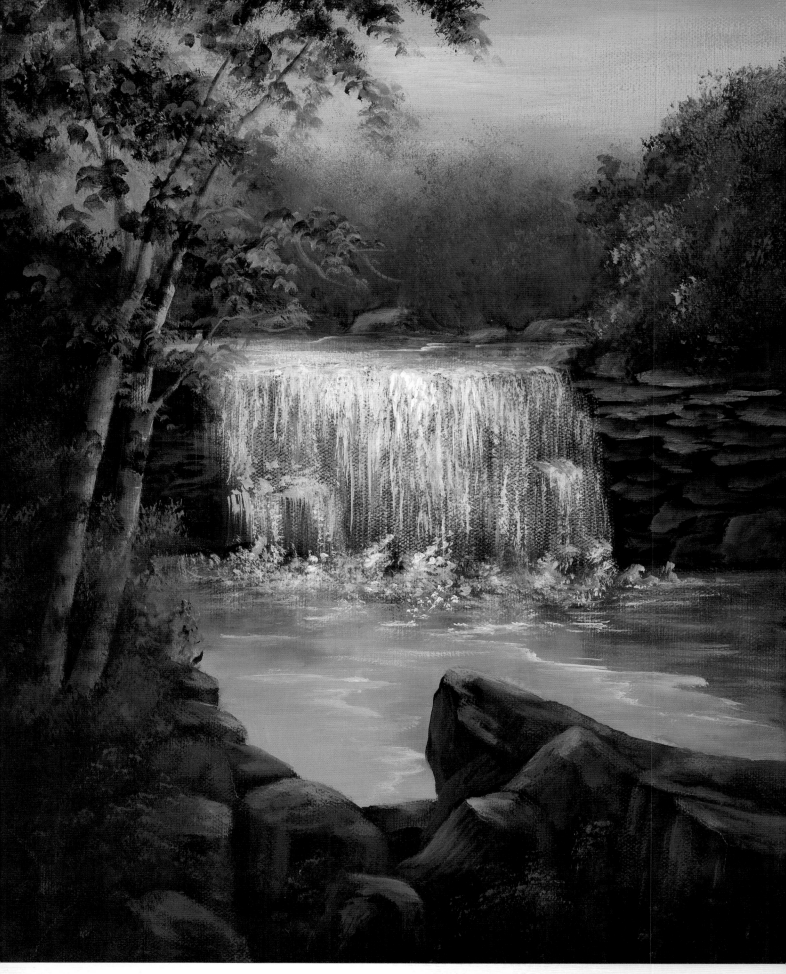

Cumberland Falls

As my husband and I travel, we have three things we always must stop and photograph: waterfalls, mills and covered bridges. Cumberland Falls is a beautiful, photogenic area located in Kentucky. It is early spring; large falls with spring runoff and lots of rocks complete the scene.

In this project, concentrate on learning to paint rocks and rock ledges. In the photo, you will see lots of small trees and bushes that were eliminated in order to see the falls at a better advantage. You could simply draw this scene with a pencil or thin down Ultra Blue Deep with water and sketch with a liner brush. If the paint does not flow off the brush easily, you need to add more water.

DecoArt Americana Acrylic Paints:

Yellow Ochre	Arbor Green	Lamp Black	Black Forest Green
Black Green	Black Plum	Burnt Sienna	Burnt Umber
Cadmium Orange	Cadmium Yellow	Deep Midnight Blue	Evergreen
Hauser Dark Green	Hauser Light Green	Hauser Medium Green	Ice Blue
Plantation Pine	Slate Grey	Soft Black	True Ochre
Ultra Blue Deep	Warm White		

Brushes:

3/4-inch (19mm) and 1-inch (25mm) Aqualon glaze/wash

no. 10 angular bristle

nos. 6, 8, 10 and 16 Royal Sable bright

no. 6 Golden Taklon liner

no. 6 Aqualon filbert

Other Materials:

Canvas Gel

medium-grit sandpaper

paper towels

Easy Float Mix – 1/2 Easy Float + 1/2 water

Round synthetic sponge

Pattern (see page 38)

Surface:

11" × 14" (28cm × 36cm) portrait-grade canvas

REFERENCE PHOTOS

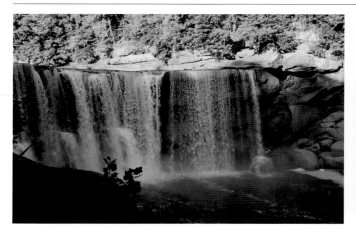 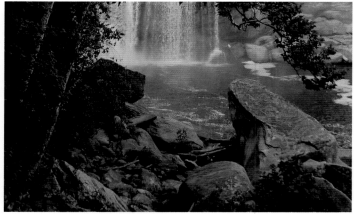

PATTERN

This line drawing may be hand-traced or photo-copied for personal use only. Enlarge at 111% to bring it up to full size.

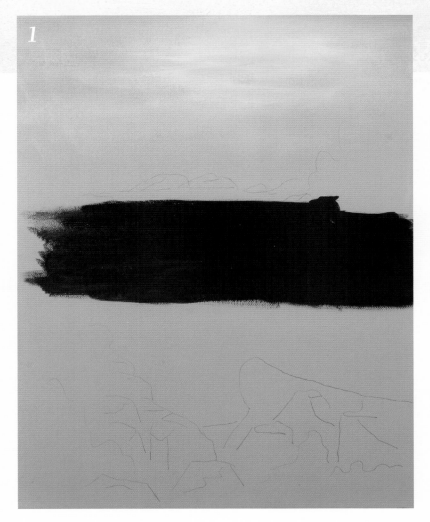

Step 1: Preparation Base the canvas with two coats of Ice Blue and a 1-inch (25mm) wash, sanding and wiping between coats. Transfer the pattern onto the canvas.

Paint the rocks and fall area with Lamp Black and a 1-inch (25mm) wash.

Dip a paper towel in a pile of canvas gel and work the gel into the sky and foliage area down to the rocks. Use a 3/4-inch (19mm) wash loaded with lots of Warm White + a bit of Ultra Blue Deep + a touch of Black Plum to paint in the sky, adding more Warm White toward the center of the painting.

Paint down to the back horizon. Add a tiny bit of Cadmium Orange into some Warm White and add sunshine to the sky. A bit of streakiness is fine.

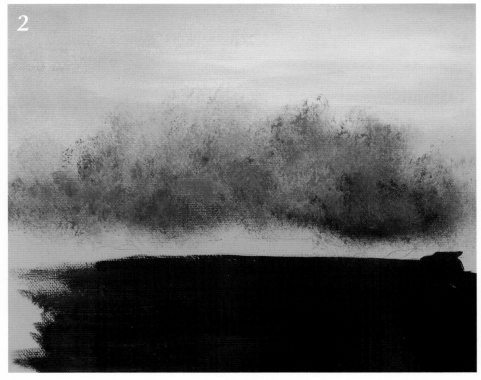

Step 2: Background Trees Load a round synthetic sponge (see page 19) with Ice Blue + Arbor Green and tap in the first layer of trees. Add Plantation Pine, getting darker as you get closer to the rocks.

Then stipple (see page 18) darker values with a no. 10 angular bristle brush and Black Forest Green. Do the same with Black Green for darkest values.

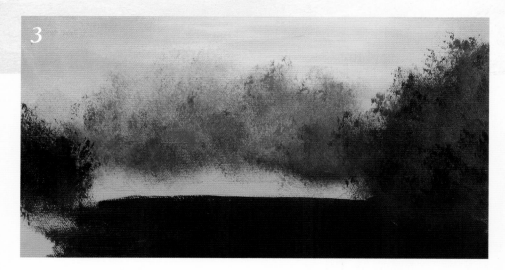

Step 3: Bushes Stipple the large bush on the right rock ledge and the bush on the far left with the no. 10 angular bristle brush loaded with Ultra Blue Deep + Plantation Pine and Ultra Blue Deep + Black Green.

Step 4: Highlight Foliage Clean the brush and add highlights on the large right foliage with Hauser Medium Green. Highlight the foliage on the right with Hauser Light Green.

Keep layering highlights from darker to lighter. You can use Evergreen, Hauser Dark Green + Hauser Medium Green + Warm White, Hauser Light Green, Hauser Light Green + Cadmium Yellow + Warm White and Cadmium Yellow + Warm White.

Work wet-into-wet to mingle the colors and remember to stay soft and hazy. Don't highlight the bush on the far left.

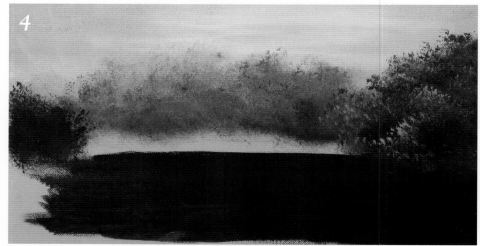

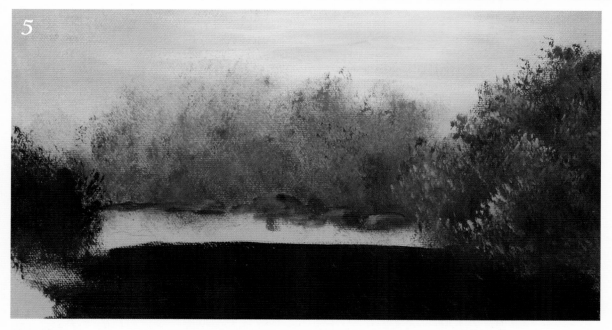

Step 5: Rocks Wash in the background rocks with a no. 6 sable bright and Black Plum + a touch of Soft Black. Highlight with True Ochre + Warm White + Cadmium Orange. On the shadow side add touches of light blue from the sky and some foliage greens.

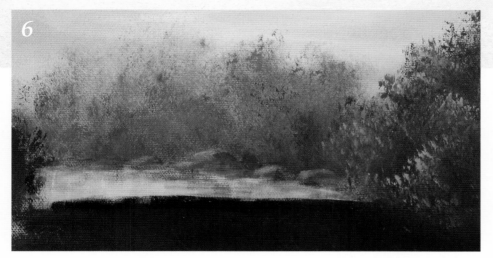

Step 6: Rocks and Water Apply Canvas Gel to the water above the falls. Using a no. 6 sable bright, pull down dark colors from the rocks (Soft Black, Ultra Blue Deep and Black Plum). Then fill in the water with Warm White, Hauser Light Green + Warm White and Ultra Blue Deep + Warm White, pulling down and then stroking horizontally.

Step 7: Rocks For the rock wall on the right, double load a no. 10 sable bright with Soft Black and True Ochre + Cadmium Orange. With the lightest color on the bottom, place the chisel on the canvas and slice in the edge of a rock. Continue, varying the colors in the double load, sometimes using Burnt Sienna and Cadmium Orange + Burnt Sienna. As you work into the shadows on the left, include Ultra Blue Deep + a smidgen of Warm White.

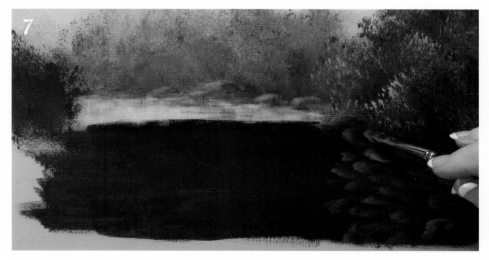

Step 8: Rocks
Double load a no. 10 bright with Lamp Black and highlight colors. Remember to vary the colors, using True Ochre + Cadmium Orange + Warm White, True Ochre + Burnt Sienna + Warm White.

Float the colors and keep the rocks a little lighter toward the top of the ledge and darker toward the bottom.

Using the chisel of the same brush, drybrush in soft ledges of True Ochre, Burnt Sienna and a touch of Lamp Black.

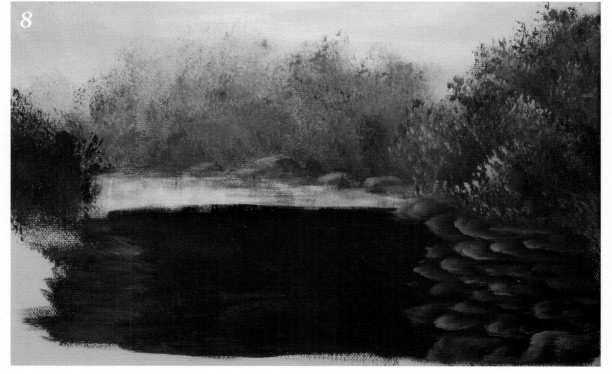

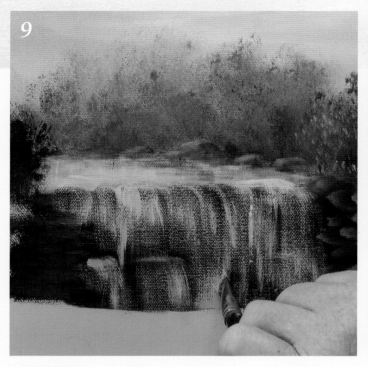

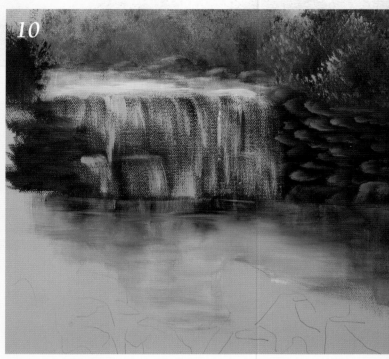

Step 9: Falls Using a no.16 sable bright and Warm White + Ultra Blue Deep + Hauser Medium Green, pull the first layer of water. To indicate the levels of falling water formed by rocks, stop pulling part way down and then begin the falling water again. The color is heavier at the top of the falls. For a sheeting effect, go back in with the chisel edge held vertically and pull down in a few places.

Step 10: Water Apply a thin coat of Canvas Gel to the bottom water area. Still using a no. 16 sable bright, pull any dark colors from your palette (Deep Midnight Blue + Lamp Black, Deep Midnight Blue + Burnt Umber, Plantation Pine, Evergreen) straight down from the top edge of the water.

Clean the brush and then fill the water area with vertical strokes of thin Warm White + a dot of Hauser Medium Green and Warm White + Ultra Blue Deep. Blend horizontally.

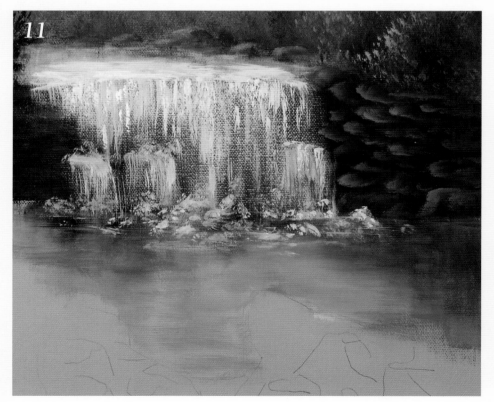

Step 11: Water Continue with the no. 16 sable bright. Load one side of the brush with Warm White and sweep highlights and foam to the falls with the color on the bottom of the brush. Sometimes use Warm White + a dot of Hauser Medium Green. Turn the brush on the vertical chisel for the sheeting effect. Using Warm White + Ultra Blue Deep on the brush corner, tap foam at the bottom of the falls. Then tap in Warm White foam.

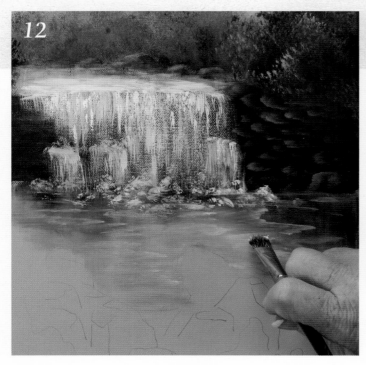

Step 12: Water For the water movement lines, load the no. 16 sable bright with Easy Float mix and then side load Warm White. Hold the paint on the right of the brush, and float in the lines. For the shadowed area to the right, you can pick up some Ultra Blue Deep.

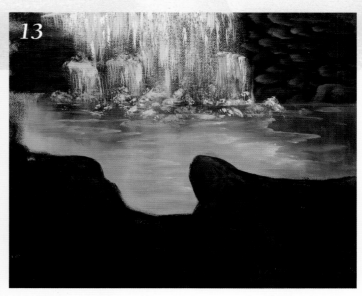

Step 13: Foreground Rocks Still using the no. 16 sable bright, undercoat the foreground rocks with Lamp Black + Burnt Umber + Black Plum, varying the colors by adding Burnt Umber, Deep Midnight Blue + Lamp Black and Soft Black. Don't worry about losing the pattern lines; you can trace them back later.

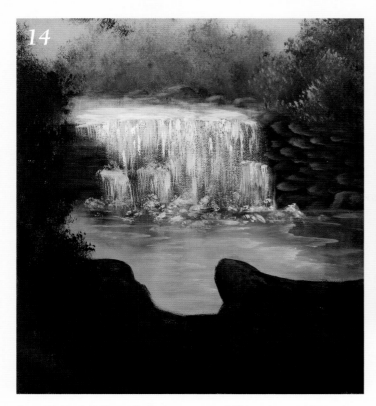

Step 14: Dark Foliage (Left, bottom, top) Using the no. 10 angular bristle and Black Green, stipple the foliage along the left edge of the canvas. Do the same for the grass and weeds at the bottom and the dark tree foliage at the top of the canvas.

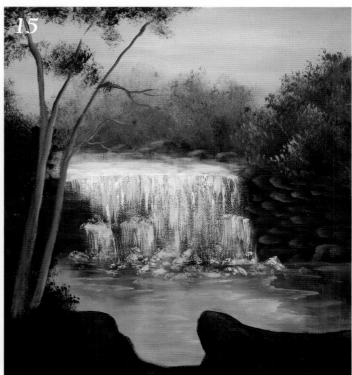

Step 15: Dark Foliage (Left, bottom, top) Double load a no. 8 sable bright with Slate Grey and Lamp Black. With the Lamp Black on the left and Slate Grey to the right, pull in the birch trunks. Start at the top of the tree and pull down, adding pressure to the brush to widen the trunks.

You can also pull in the branches with the brush chisel. Pull in the thinnest branches with no. 6 liner, flattening the bristles for the double load.

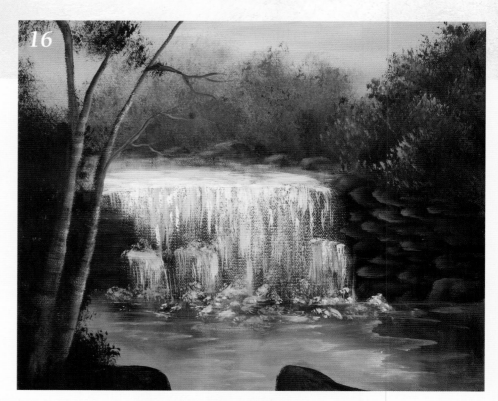

Step 16: Highlight Tree Trunks Load the no. 8 sable bright with Lamp Black and darken the left side of the tree, occasionally pulling across the trunk in a C-stroke to create texture. Highlight the right edge of the trees with True Ochre + Warm White. Add some Warm White + Plantation Pine or Ultra Blue Deep + Warm White in the cool areas.

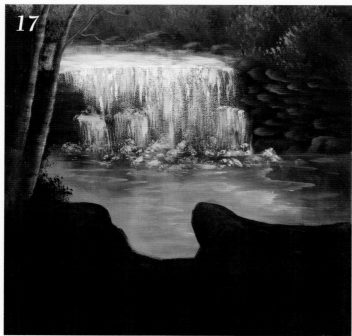

Step 17: Foreground Rocks Retrace the pattern lines for the foreground rocks with light graphite paper. Using a dry no. 8 sable bright and scant Yellow Ochre + Cadmium Orange + Warm White, place the first layer of highlights on the surfaces closest to the light. Occasionally add some Burnt Sienna.

Use Black Plum + Ultra Blue Deep on the shadow side. Also work in some Burnt Sienna + Warm White, some of the greens and Deep Midnight Blue + Warm White in the shadowed areas.

Step 18: Dark Foliage (Left, bottom, top) Finish the birch foliage and foliage around the birches by layering in ever-lighter colors, tapping them in to create leaf clusters. Using a no. 6 filbert, start the middle values with Evergreen. Add Hauser Medium Green to the dirty brush and continue. Then add a highlight with Hauser Medium Green + Cadmium Yellow. Next add touches of Ultra Blue Deep + Cadmium Yellow + Warm White. With a clean brush, apply the lightest highlights with Yellow Ochre and Cadmium Yellow. When painting highlights, I sometimes clean the brush by simply wiping it on a paper towel, depending on how much color is left in the dirty brush.

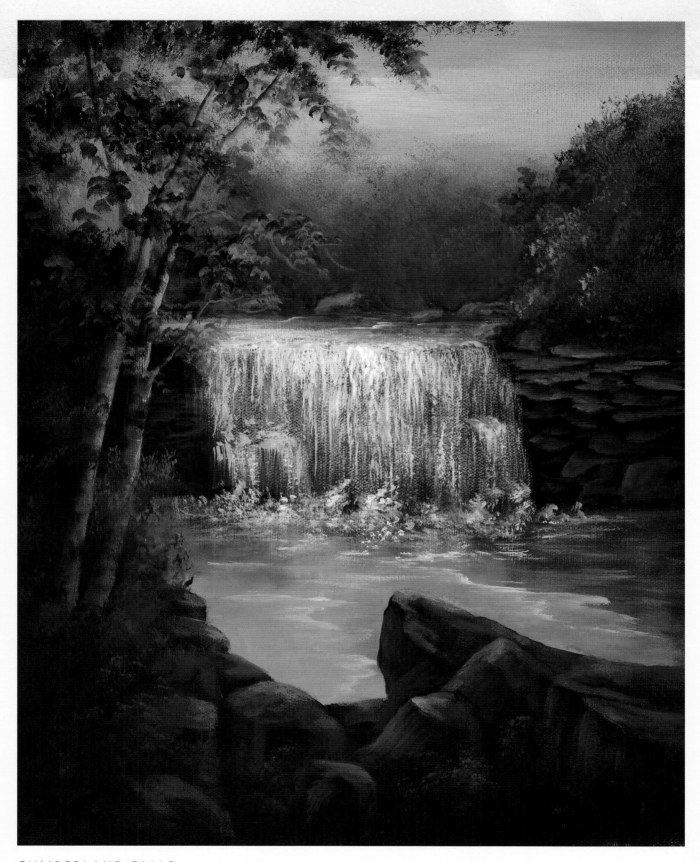

CUMBERLAND FALLS

Finishing Touches: Reinforce highlights and add other finishing touches as needed.

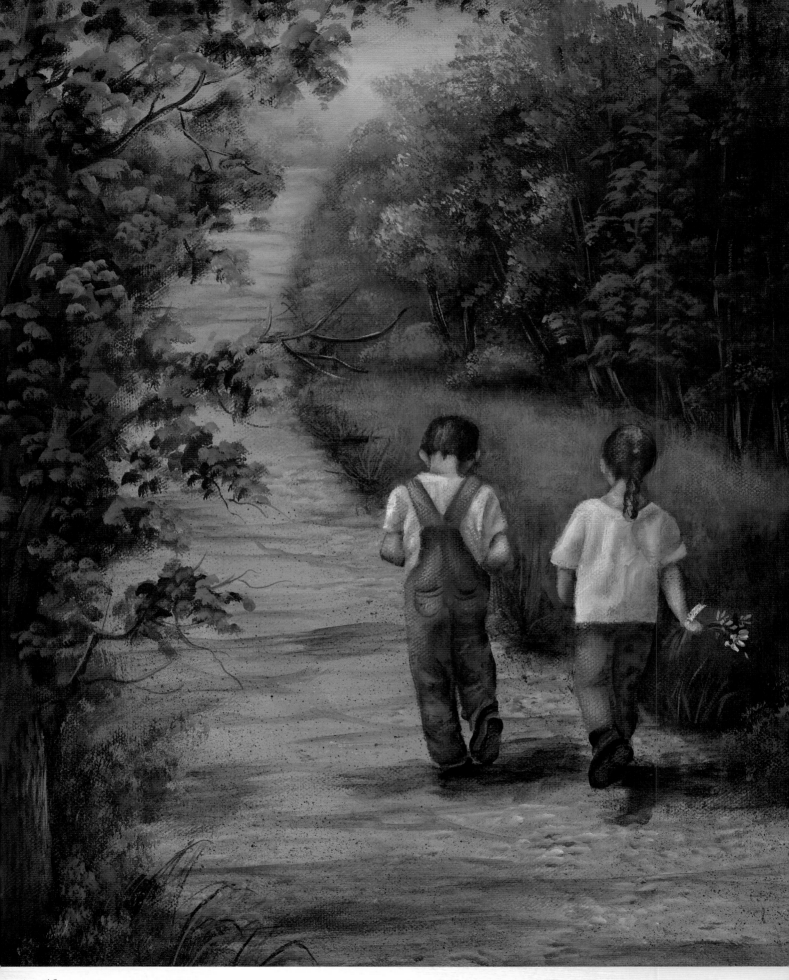

Down a Country Lane

The children in this painting are two of my grandchildren, Katie and Chip. From this view, they could be anyone's children. The photo has always been a favorite of my husband's, and he suggested I use it in this book. Photos and paintings with people, children or animals appeal to a wide market. Keep your market in mind if you are planning to sell your art.

This is a relatively easy painting and teaches dry-brushing, glazing shadows and how to paint gravel. I enlarged the photo of the children to the size I wanted in the painting. I traced the enlargement onto a piece of clear acetate. The tracing allowed me to play with the children's placement within the painting.

DecoArt Americana Acrylic Paints:

Avocado

Black Forest Green

Black Green

Burnt Sienna

Cadmium Yellow

Camel

Dark Chocolate

Deep Midnight Blue

Dioxazine Purple

Evergreen

Base Flesh

Hauser Dark Green

Hauser Light Green

Hauser Medium Green

Hi-Lite Flesh

Khaki Tan

Light Buttermilk

Light Cinnamon

Midnite Green

Oxblood

Payne's Grey

Pineapple

Salem Blue

Shading Flesh

Soft Black

Ultra Blue Deep

Warm White

Brushes:

3/4-inch (19mm) Aqualon glaze/wash
1-inch (25mm) Sky-Wash
no. 10 angular bristle
no. 8 bristle fan blender
nos. 4, 6, 8 and 10 Royal Sable brights
nos. 2 and 6 Golden Taklon liners
3/8-inch (10mm) Aqualon angular
no. 6 Royal Sable round
no. 6 Aqualon filbert

Other Materials:

Canvas Gel
medium-grit sandpaper
palette knife
Easy Float mix – 1/2 Easy Float
 + 1/2 water
pattern (see page 48)

Surface:

11" × 14" (28mm × 36mm) portrait-grade canvas

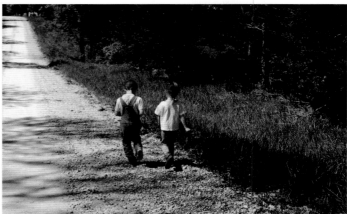

PATTERN

This line drawing may be hand-traced or photocopied for personal use only. Enlarge at 112% to bring it up to full size.

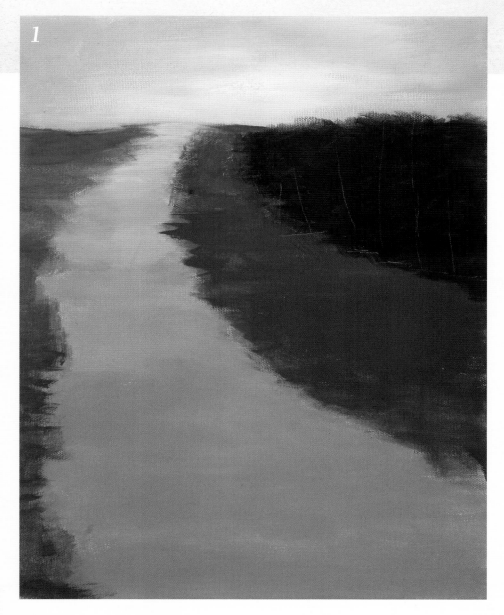

Step 1: Preparation Trace on the background pattern. Use a 3/4-inch (19mm) wash for all basing. Base the sky with Salem Blue, the grass with Avocado, the road with Khaki Tan, and the dark tree area with Midnite Green. Let dry.

Sand and repeat the base coats with the following variations: on the second sky base coat, create a light area by adding Light Buttermilk to the Salem Blue. Add Warm White and again lighten the sky just above the horizon. A little Canvas Gel rubbed into the canvas will help the paint blend (see page 11).

Lighten the Khaki Tan for the road's second base coat by adding Light Buttermilk toward the horizon.

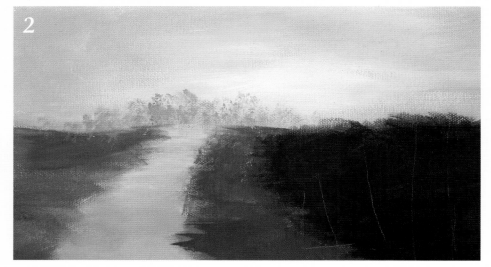

Step 2: Distant Trees Tap on some distant trees with an old scruffy brush or a no. 10 angular bristle and Salem Blue + Light Buttermilk + Evergreen, adding a little Ultra Blue Deep in the mix from time to time. Keep this area very light and hazy.

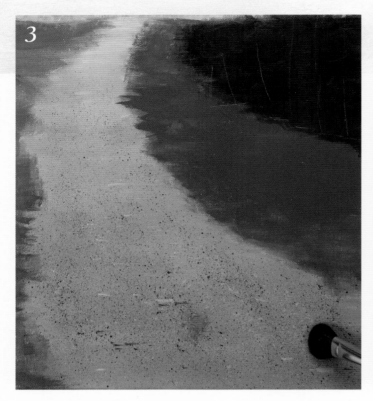

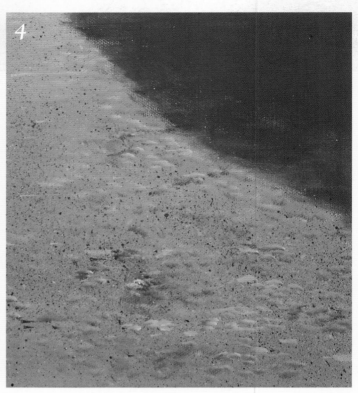

Step 3: Road Cover the sky with a paper towel and spatter the road with a no. 8 fan blender and a palette knife (see page 18), using Burnt Sienna, Dark Chocolate, Soft Black, Khaki Tan + Light Buttermilk, and Camel, loading each color or mix for a separate spattering.

Try to make the spatters finer in the background and heavier as you move forward. Let the spatters set up just a little and then mop across the spatters horizontally with a 1-inch (25mm) Sky-Wash brush. You may need to mop in stages. Don't worry if the spatters get into the grass — the area will be painted over.

Step 4: Road Double-load a no. 4 sable bright with Soft Black and Warm White + a touch of Camel. Set the brush corner down on the canvas with the dark on the bottom and push off little rocks and gravel. Sometimes use Dark Chocolate on the dark side. Make the rocks different sizes and a variety of colors. Let them run together. You may be able to use some smeared paint spatters to help create gravel.

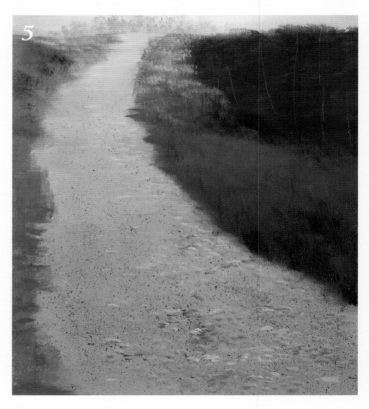

Step 5: Grass and Foliage Rub some Canvas Gel onto grass areas with a paper towel. Paint the grass with corner loads on a no. 8 fan blender. Use short downward strokes, darkening the colors as you move toward the foreground. Start at the top with Avocado and add light areas with Avocado + Pineapple + Warm White + a dot of Salem Blue.

As you move down, deepen the grass color by adding more Avocado + Evergreen + Ultra Blue Deep. The very darkest green in the front shadow area is Midnite Green and Black Green + Ultra Blue Deep.

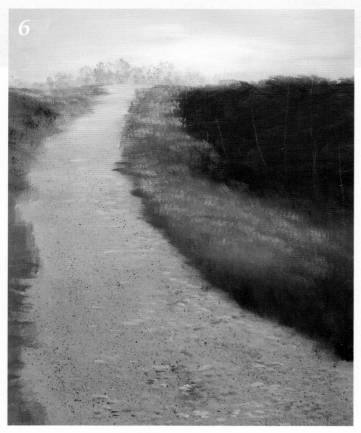

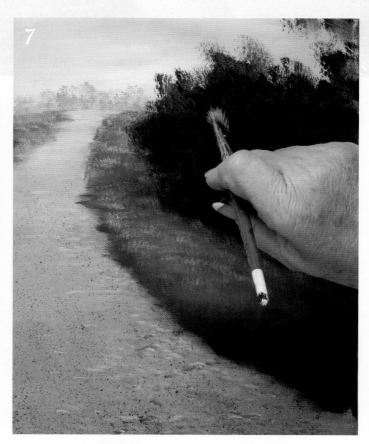

Step 6: Grass and Foliage Add color variety to the grass by layering some areas with Hauser Medium Green and Hauser Light Green. Highlight in the sunlit area with Hauser Light Green + Pineapple and again with Warm White added to the previous brush mix.

Step 7: Grass and Foliage Using a no. 10 angular bristle and Midnite Green, tap in tree foliage on the upper right, letting it feather into the sky.

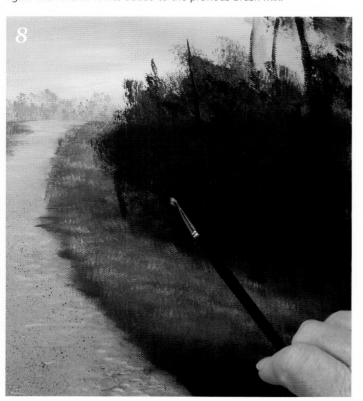

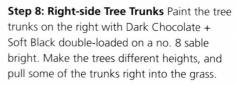

Step 8: Right-side Tree Trunks Paint the tree trunks on the right with Dark Chocolate + Soft Black double-loaded on a no. 8 sable bright. Make the trees different heights, and pull some of the trunks right into the grass.

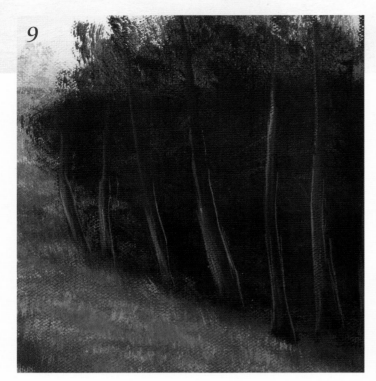

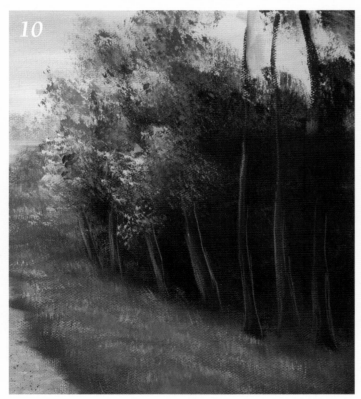

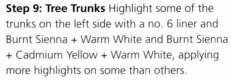

Step 9: Tree Trunks Highlight some of the trunks on the left side with a no. 6 liner and Burnt Sienna + Warm White and Burnt Sienna + Cadmium Yellow + Warm White, applying more highlights on some than others.

Add reflected light on the right side of the trunks with Ultra Blue Deep + Warm White.

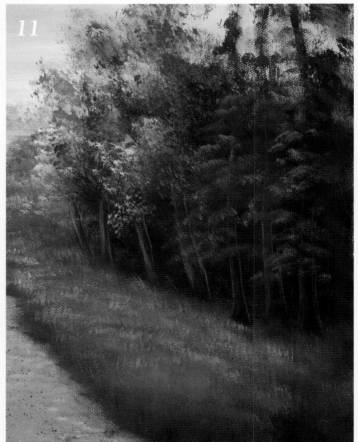

Step 10: Leaves Using an old scruffy brush or the no. 10 angular bristle, tap in the leaf highlights in layers. (The two trees closest to the right canvas edge will not be highlighted until the next step.)

Keep the trees closest to the light source lighter and brighter. Start with Hauser Medium Green and continue through progressively lighter colors — Hauser Light Green, Cadmium Yellow + Light Buttermilk and Cadmium Yellow + Warm White.

Step 11: Leaves The two trees closest to the right edge of the canvas are highlighted to look like firs, so change to a blue-green and use a corner-loaded no. 8 sable bright.

Start with Black Forest Green + a bit of Black Green and work through progressively lighter colors — Hauser Dark Green + Hauser Light Green, Ultra Blue Deep + Hauser Light Green and Ultra Blue Deep + Black Forest Green + Light Buttermilk.

Apply the darkest colors only to the trees on the far right.

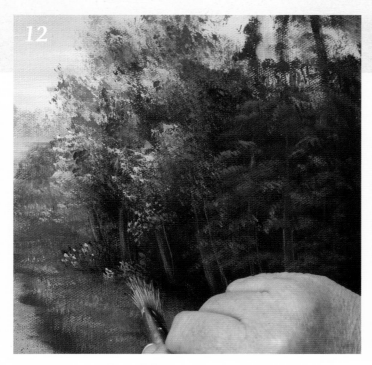

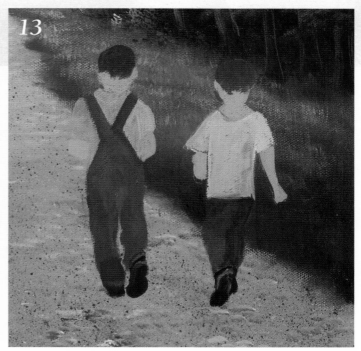

Step 12: Leaves Using a no. 10 angular bristle and Midnite Green, start tapping in foliage to hide the trunks of the deciduous trees left of the pines. Highlight with Hauser Medium Green and Hauser Light Green + a bit of Cadmium Yellow.

Let the paint dry to the touch before proceeding.

Step 13: Children Trace on the pattern of the children using dark graphite paper on the light background and light graphite paper on the dark background.

As you base in the children, use a no. 4 and a no. 6 sable bright, depending on the size of the area you're painting.

Use Ultra Blue Deep + Light Buttermilk for the shirts; Deep Midnight Blue + Soft Black + Light Buttermilk for the overalls; Ultra Blue Deep + Dioxazine Purple + Light Buttermilk for the girl's pants.

Use Base Flesh for the skin, Light Cinnamon for the girl's hair, Dark Chocolate for the boy's hair, and Soft Black for the boots, with Oxblood trim.

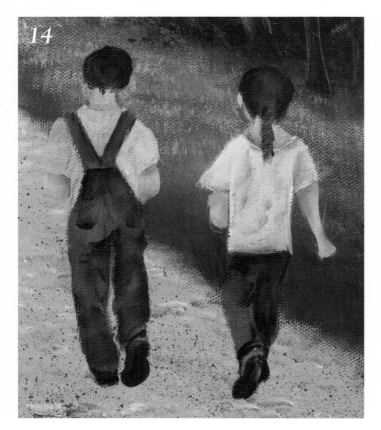

Step 14: Children Float shading on the children with a 3/8-inch (10mm) angular brush.

On the overalls use Payne's Grey + Soft Black.

On the shirts use Ultra Blue Deep + Warm White. Add a little Dioxazine Purple to the girl's shirt. You'll continue highlighting and shading the shirts in the following step.

For the flesh areas, shade with progressively darker colors, starting with Shading Flesh and going on to Burnt Sienna and then Payne's Grey.

Shade the girl's hair with Dark Chocolate + Soft Black and the boy's hair with Payne's Grey.

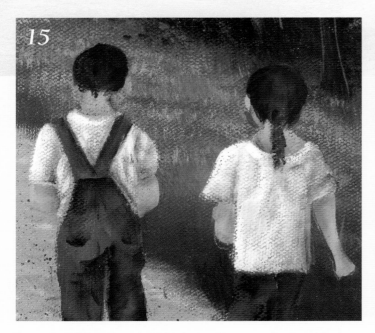

Step 15: Children To create folds in the shirts, move back and forth between highlighting and shading. Start highlighting with Light Buttermilk on a no. 6 sable round.

Wipe the brush with a paper towel and drybrush highlights, letting the blue base coat leave shadows. Return to the 3/8-inch (10mm) angular and Ultra Blue Deep + Warm White and Dioxazine Purple to work the shading again.

Keep going back and forth with the shading and highlighting on the shirts until you have the effect you want. You can use a bit of Payne's Grey to deepen shadows. Final shirt highlights are Warm White.

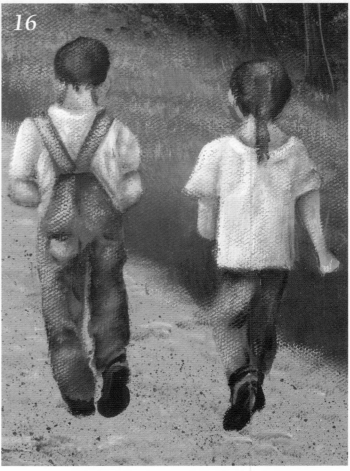

Step 16: Children Continue the dry-brushed highlighting of the children with a no. 6 sable round. For the overalls use Ultra Blue Deep + Dioxazine Purple + Light Buttermilk (base mix) + more Light Buttermilk. Highlight again using Warm White.

Highlight flesh areas with Hi-Lite Flesh, the hair with Burnt Sienna + Warm White + Cadmium Yellow and the black of the boots with Soft Black + Light Buttermilk.

When the highlights are complete, apply final shading as needed with Payne's Grey.

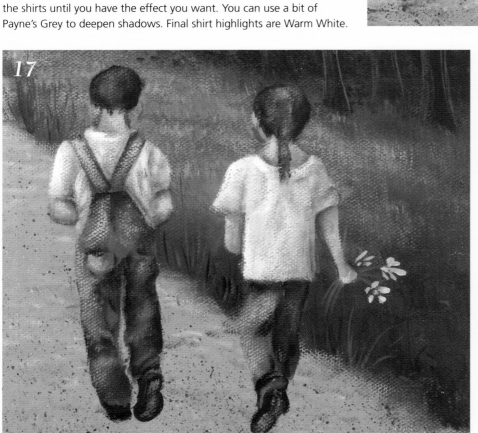

Step 17: Flowers Paint the flowers in the girl's hand with a no. 2 liner. Stems are Hauser Medium Green; petals are Hauser Medium Green + Warm White. Stroke more white on the lower right petals. Touch in the centers with Cadmium Yellow.

Stroke in some roadside grasses near the children with Hauser Medium Green, Black Green and a brush mix of the two, adjusting colors so they show up on the background grass.

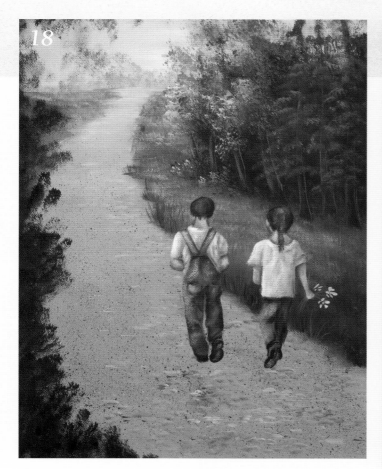

Step 18: Left tree Using an old scruffy brush or a no. 10 angular bristle, tap Payne's Grey foliage on the upper right side of the tree on the left. Then tap in Midnite Green along the right side of the canvas. Pull the foliage into the road at the bottom, creating a small bush.

Step 19: Left tree Base the left trunk with a no. 10 bright and Dark Chocolate, working in a little Soft Black as you move to the left edge. Switch to a no. 6 liner to pull in the branches.

Highlight the trunk and branches with the liner and Light Buttermilk + Burnt Sienna.

Step 20: Left Tree Tap in the foliage on the left tree with a no. 6 filbert, layering colors with the dirty brush. Start with Black Green and go to Hauser Dark Green, then Hauser Medium Green and then to Ultra Blue Deep + Hauser Medium Green + a little Light Buttermilk. Add a few Cadmium Yellow leaves in the upper sunlit area. Switch to the no. 10 angular bristle and Black Green + Hauser Medium Green and tap dark highlights on the foliage at the base of the tree.

Step 21: Road Shadows Dress a 3/4-inch (19mm) wash with Easy Float Mix and glaze Soft Black in horizontal strokes from the right edge of the road.

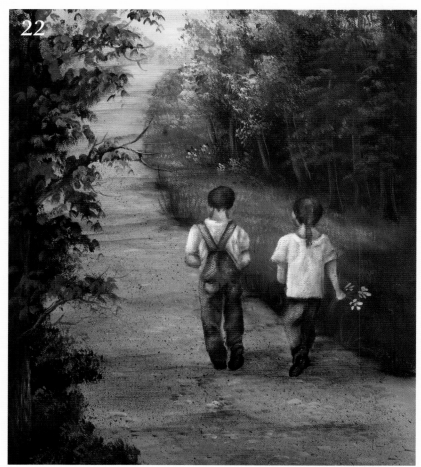

Step 22: Road Shadows Prepare the road for the shadows by stroking it over with Easy Float Mix on a 3/4-inch (19mm) wash, going right over the children. (You may want to break the road down into sections to ensure that the area doesn't dry.)

Then glaze in cast shadows from the children and the tree with Payne's Grey, applying several layers. Shadows in the foreground and from the children are darkest. Let the values fade as you go up the road.

Here you see the first stage of the glazed shadows. Refer to the finished picture for the results after all the layering is done.

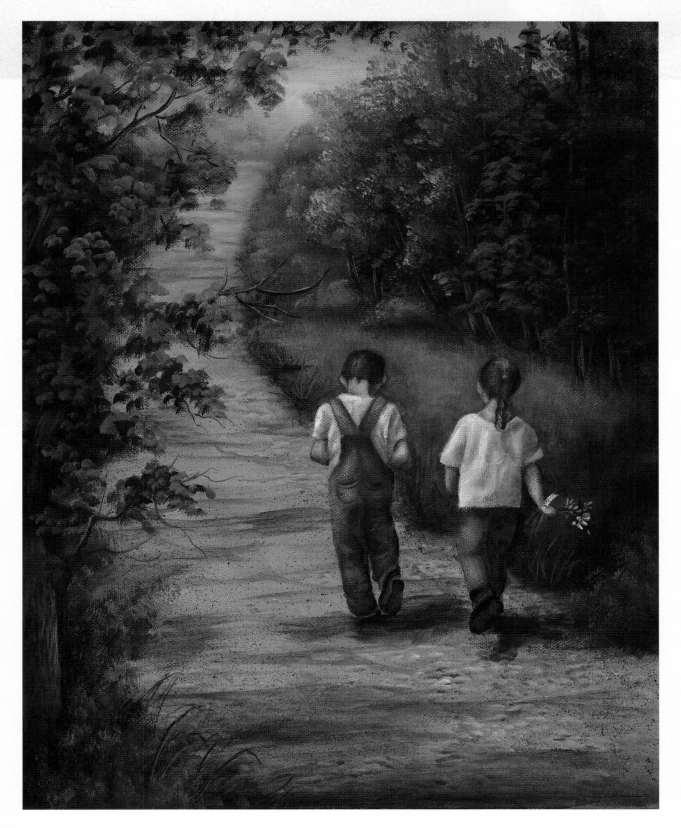

DOWN A COUNTRY LANE

Finishing Touches: The finished picture has been glazed several times to deepen the shadows. Notice how dark the shadows are under the children. White tends to sink in and disappear, so more highlights have been added to the shirts. Be sure to let shadows fall right across anything in their paths.

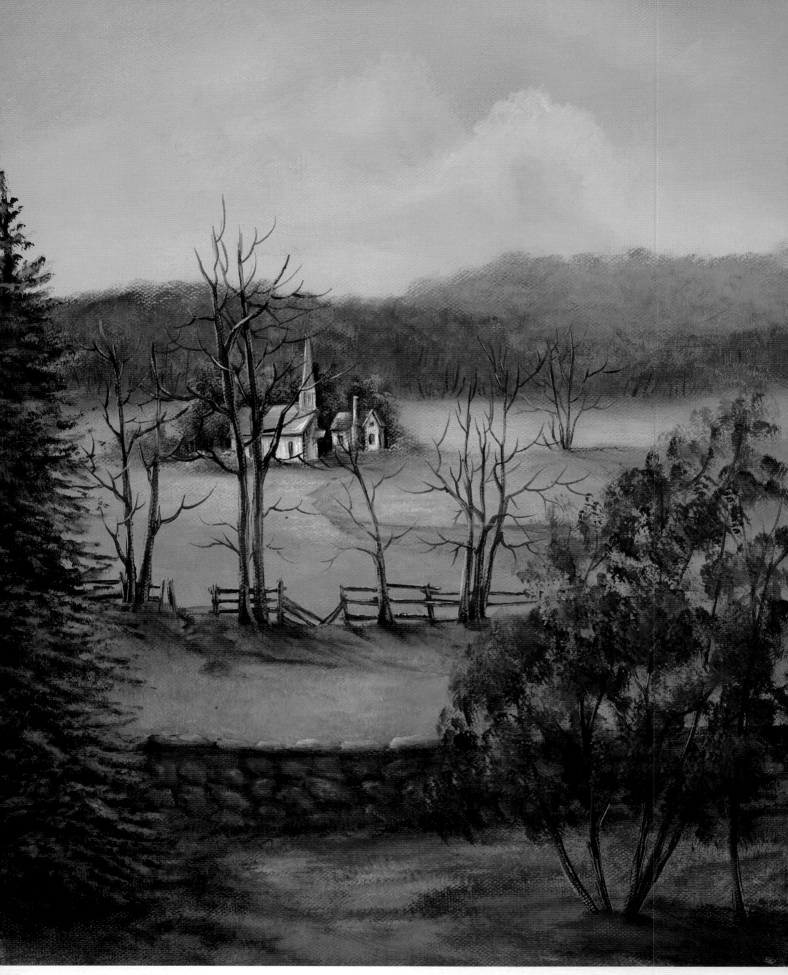

Church in the Valley

A country scene of church and parsonage is typical of almost every state. Even while touring in Europe, you would see a scene such as this one. This particular scene is behind the Daniel Boone home in Missouri. There is lots of perspective in the scene. Concentrate on the colors and misty look to create this perspective. This scene also would make a lovely snow scene. You could try changing the season.

I enlarged the original photo that inspired this painting to see if I would like the composition. You can project the photo onto a canvas and then draw the scene. If you do not have a projector, enlarge the picture on a copier and transfer the scene. Another way to transfer the scene would be to draw a grid on the photo and the canvas and draw each section of the photo grid onto the canvas. It is unusual to have a photo that I did not want to change, but I feel this photo tells a good story as it is. Interesting shadows play on the ground and the pine tree is painted differently from those in the *Mountain Pines* painting on page 78.

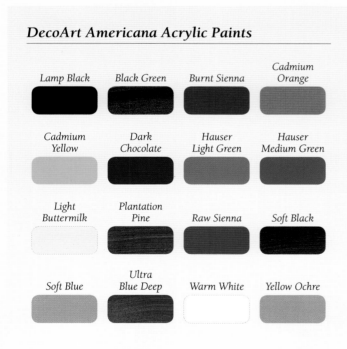

DecoArt Americana Acrylic Paints

Lamp Black	Black Green	Burnt Sienna	Cadmium Orange
Cadmium Yellow	Dark Chocolate	Hauser Light Green	Hauser Medium Green
Light Buttermilk	Plantation Pine	Raw Sienna	Soft Black
Soft Blue	Ultra Blue Deep	Warm White	Yellow Ochre

Brushes:

1-inch (25mm) Aqualon glaze/wash
1-inch (25mm) Sky-Wash
no. 4 bristle filbert
no. 10 angular bristle
nos. 4, 10, and 16 Royal Sable bright
nos. 5/0 and 2 Golden Taklon liner

Other Materials:

Canvas Gel
medium-grit sandpaper
paper towels
Easy Float Mix – 1/2 Easy Float + 1/2 water
pattern (see page 60)

Surface:

11" × 14" (28cm × 36cm) portrait-grade canvas

REFERENCE PHOTO

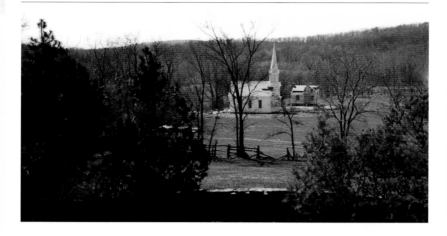

PATTERN

This line drawing may be hand-traced or photo-copied for personal use only. Enlarge at 100% to bring it up to full size.

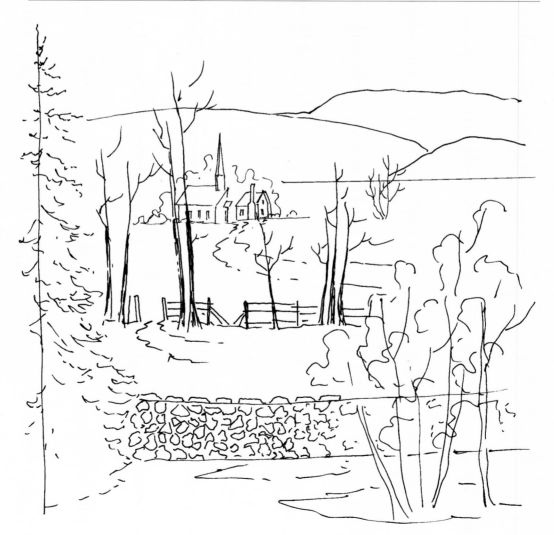

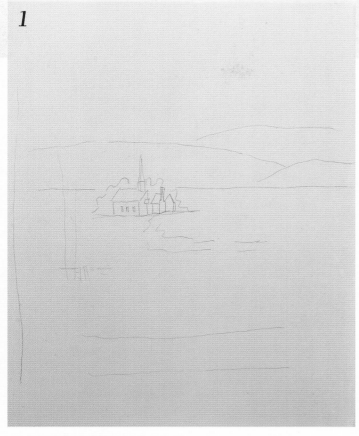

1

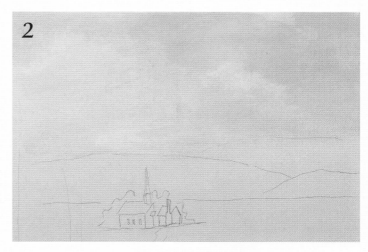

2

Step 2: Preparation Rub the sky area with a small amount of Canvas Gel applied with a soft paper towel.

Glaze the sky with a 1-inch (25mm) wash and Soft Blue to moisten the paint. Then add Ultra Blue Deep to the dirty brush to lightly deepen the sky across the top and on the corners of the canvas. Streak a little of the same color in toward the center of the painting. Wipe the brush, corner load Warm White and fluff in the clouds.

Mop with a 1-inch (25mm) Sky-Wash brush to blend. If the canvas begins to dry, add a tiny amount of Canvas Gel to the brush.

Step 1: Preparation Base the canvas with a 1-inch (25mm) flat and two coats of Soft Blue, sanding between base coats. Remove the dust with a damp paper towel. Transfer the pattern to the canvas.

3

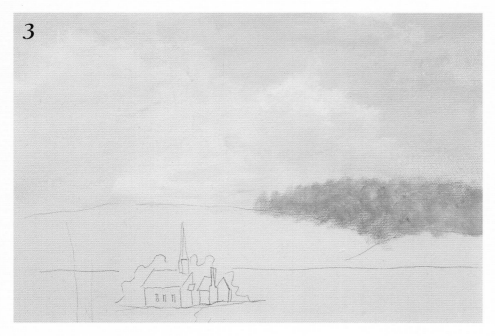

Step 3: Background Hills Apply a little Canvas Gel to the background hills. With a no. 4 bristle filbert, pick up Ultra Blue Deep + Soft Blue + a dot of Soft Black + Light Buttermilk and, using short downward strokes, add the treetops on the most distant hill. Keep this area soft and light.

As you paint, add touches of Dark Chocolate and Plantation Pine in the dirty brush. If this area becomes too dark, add some Ultra Blue Deep + Soft Blue + a dot of Soft Black on top to soften.

4

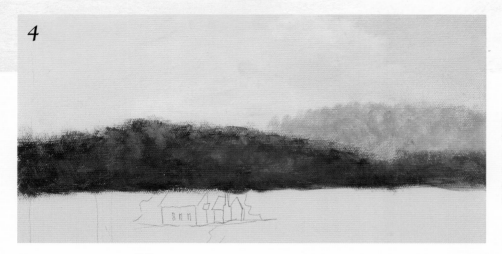

Step 4: Background Hills Paint the next hill with the same brush, loaded with Ultra Blue Deep + Soft Black. Keep the top of the hill soft and hazy and darken the hill as it approaches the horizon line with more Soft Black in the mix.

5

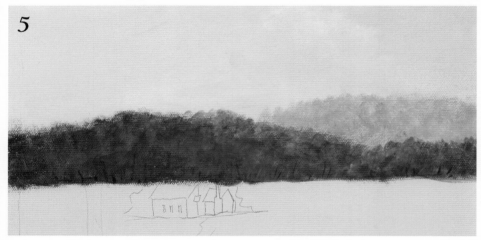

Step 5: Background Hills Switch to a no. 4 filbert and tap in highlight touches of Raw Sienna, Burnt Sienna and Raw Sienna + Light Buttermilk to create the texture and color of fall foliage. The lightest areas are above and to the right of the house.

Paint right over the steeple. Add a few trunks with a no. 5/0 liner and Soft Black.

6

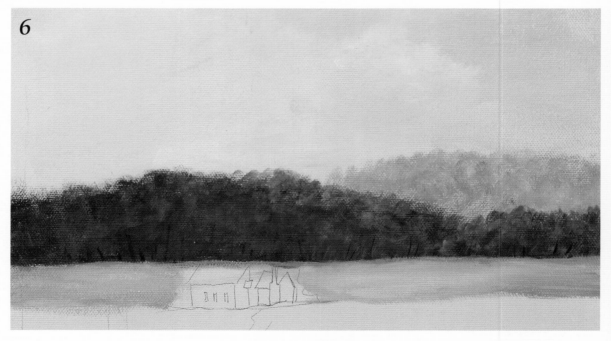

Step 6: Fields Apply a small amount of Canvas Gel to the distant field with a paper towel. Using short vertical strokes, paint this field with a no. 10 sable bright and a soft blue-green mix of Warm White + Cadmium Yellow + Soft Blue + Ultra Blue Deep. Blend up into the background hills. Add Warm White + Cadmium Yellow in the center light area of the field.

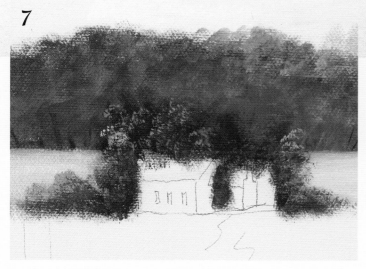

7

8

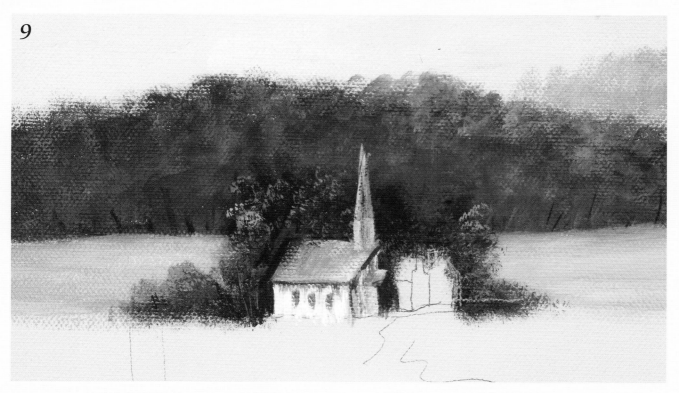

9

Step 7: Buildings and Foliage Still using the no. 10 sable bright, tap soft foliage around the buildings with Soft Black, Dark Chocolate and Ultra Blue Deep. Don't clean the brush between colors. Then tap on some fall colors with a scrubby old brush or no. 10 angular bristle and Cadmium Orange + Cadmium Yellow, Yellow Ochre, Raw Sienna, and some Hauser Light Green + Soft Blue.

If you lose some of the buildings, let the area dry and transfer the buildings once more.

Step 8: Buildings and Foliage Paint the bare tree to the right of the buildings with a no. 5/0 liner and Soft Black + Dark Chocolate + Soft Blue thinned with Easy Float Mix. Be sure the paint is of an inky consistency, and hold the brush straight into the canvas. Highlight the limbs and trunk with Cadmium Orange + Light Buttermilk.

Use this same mix to add trunks in the dark foliage by the buildings.

Step 9: Buildings and Foliage Retrace the pattern lines for the buildings. Paint both buildings with a no. 2 liner. Base the church and steeple roofs with Ultra Blue Deep + Soft Blue + Cadmium Yellow and shade with the same mix + a little more Ultra Blue Deep. Highlight with Warm White + Cadmium Yellow. Fill in the church with Light Buttermilk. Add shading on the front with some of your blue mixes from the roofs. Highlight the side with Warm White + Cadmium Yellow and then Warm White. Float shading under the roof line with Lamp Black + Ultra Blue Deep. Paint the windows Lamp Black + Ultra Blue Deep.

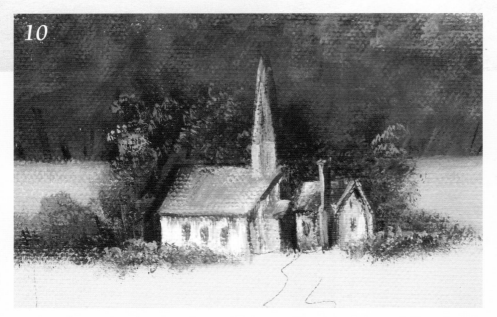

Step 10: Buildings and Foliage Use the no. 4 bright to base the house with Cadmium Orange + Warm White. Add highlights of Warm White and Warm White + Cadmium Yellow. Paint the chimney Burnt Sienna with smudges of Dark Chocolate and Soft Black. You may need to use the no. 2 liner in the smaller areas. Highlight with Cadmium Orange + Warm White and again with Warm White + Cadmium Yellow. Base the house roof with Burnt Sienna and highlight with Warm White + Cadmium Yellow.

Tap in the bushes around the buildings with the corner of a scrubby old brush or a no. 10 angular bristle and Plantation Pine. Highlight with Hauser Light Green and then with Hauser Light Green + Light Buttermilk + Cadmium Yellow.

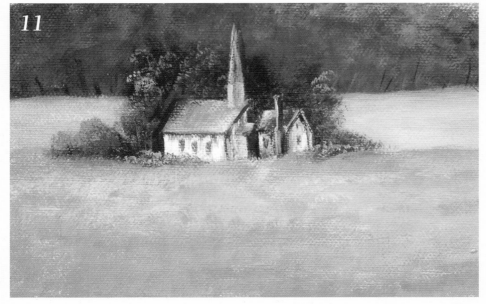

Step 11: Field in Front of Buildings Paint the field in front of the buildings with a no. 16 sable bright and the same basic colors and technique as you used for the field in step 6. Deepen the tone with a little Ultra Blue Deep to help delineate from the back field.

In the tree-shadow area, add a bit of Lamp Black. As you paint further into the field, add Hauser Medium Green to the dirty brush. In the highlight area add Light Buttermilk + Cadmium Yellow. If there is a lot of dirty color in the brush, clean it with a paper towel before adding highlights.

Allow the paint to dry to the touch before proceeding.

Step 12: Field in Front of Buildings Trace the remaining bare tree and the rail fence onto the canvas with dark graphite paper. Wash in the path with a sideloaded no. 10 sable bright and very thin Dark Chocolate, stroking horizontally.

Add Light Buttermilk highlights and deepen the edges of the path with a little Burnt Sienna + Dark Chocolate.

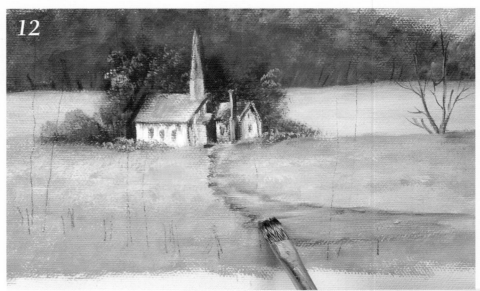

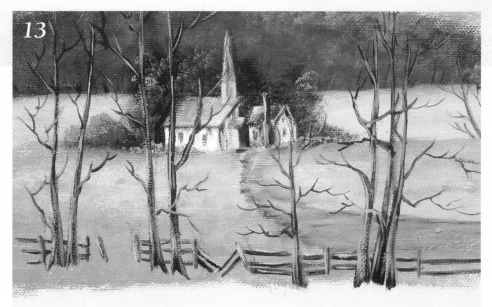

Step 13: Mid-plane Trees and Fence Paint the fence and trees with a no. 2 liner, using the same colors for both. Base with Dark Chocolate + Soft Black. Pull the trunks from the top, adding more pressure as you go downward to broaden the bottom.

Highlight with Cadmium Orange + Warm White and Cadmium Yellow + Warm White. (Highlights help the trees stand out against the distant foliage.) Add reflected light to the right side of the fence and trees with Ultra Blue Deep + Warm White.

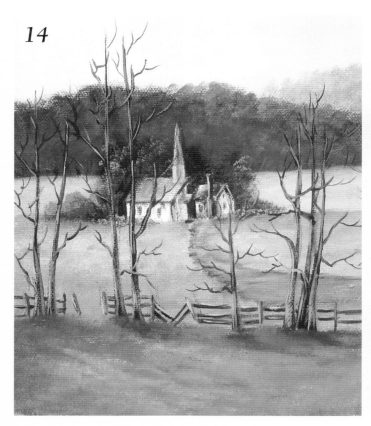

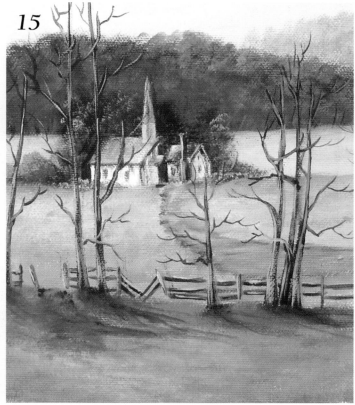

Step 14: Mid-plane Trees, Fence and Ground Paint the grass in front of the rail fence with a no. 16 sable bright and Hauser Medium Green + Plantation Pine + Hauser Light Green. Use short vertical strokes, and go darker under the trees, near the fence and toward the sides of the canvas.

Highlight with Hauser Light Green + Light Buttermilk + a little Cadmium Yellow. Apply cast shadows with Ultra Blue Deep + Soft Black, thinned to a glaze and applied over the dry grass.

Step 15: Mid-plane Trees, Fence and Ground Make sure the grass is dry and then give the bare trees shadows with a no. 2 liner and a glaze of Ultra Blue Deep + Soft Black.

Add a path with a no. 10 sable bright and Burnt Sienna. Shade with Dark Chocolate + a bit of Soft Black. Highlight with a bit of Cadmium Orange + Warm White. Tap in a bit of the grass color over the road edges using colors from step 14.

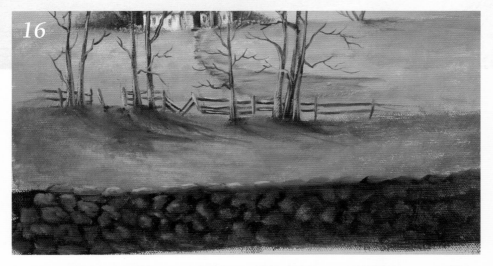

Step 16: Rock Wall, Grass and Ground
Apply Canvas Gel to the rock wall area with a paper towel. Pick up Soft Black + Ultra Blue Deep and base in the wall area with a no. 16 sable bright. While this area is still wet, use a no. 4 sable bright and a dirty white that has blue tones to add the rocks.

Then paint tones down over the wet dark base, creating a suggestion of rocks. Highlight the rocks on top of the wall with dirty white. Highlight again with Warm White + Cadmium Orange and Warm White + Cadmium Yellow.

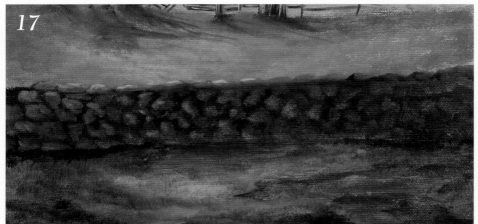

Step 17: Rock Wall, Grass and Ground
Using a no. 16 sable bright, base the foreground dirt area with Burnt Sienna, sometimes adding Dark Chocolate for shading. Start the grass next to the wall with Plantation Pine + Ultra Blue Deep, adding a little Black Green in the shadow areas. Thin the paint slightly and use horizontal strokes to set the grass into the bare ground. Highlight with Hauser Light Green + a touch of Cadmium Yellow.

Step 18: Fir Tree Paint the fir tree with Black Green using the chisel of a no. 16 sable bright. Add Hauser Medium Green highlights. Highlight once again with a little Hauser Light Green.

Step 19: Trees and Ground Paint the limbs and trunks of the small tree on the right as you did the trees in step 13. Add foliage to the tree with a no. 10 angular bristle or an old scruffy brush and Dark Chocolate, Burnt Sienna, Raw Sienna, Burnt Sienna + Cadmium Orange and Cadmium Orange + Light Buttermilk.

With the same brush and Dark Chocolate + Soft Black, add some tree shadows.

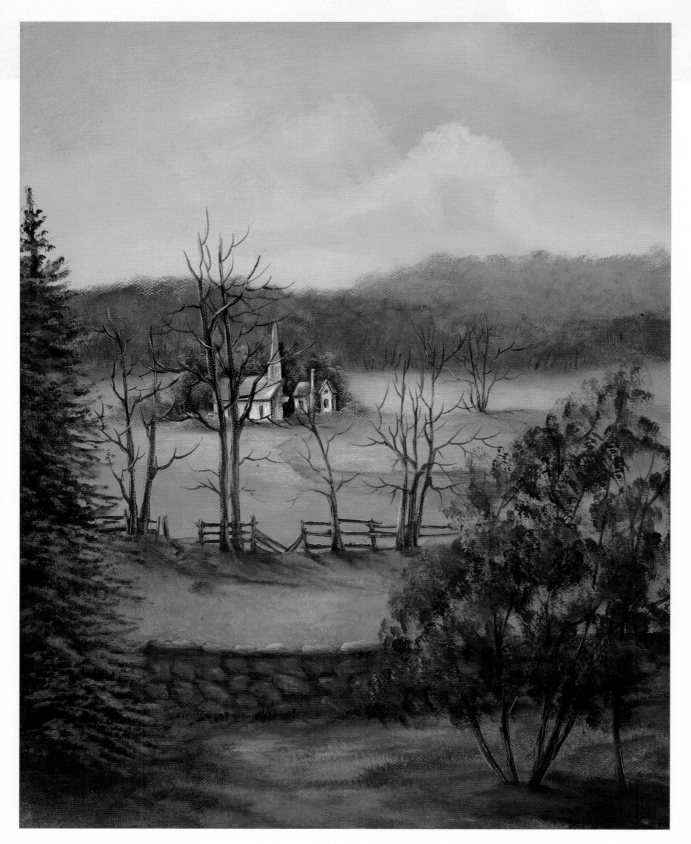

CHURCH IN THE VALLEY

Finishing Touches: Reinforce the shadows as needed by glazing with Ultra Blue Deep. Black Green also may be used for glazing shadows. Add any additional highlights with thicker paint and have some Cadmium Yellow or Cadmium Orange in the Warm White.

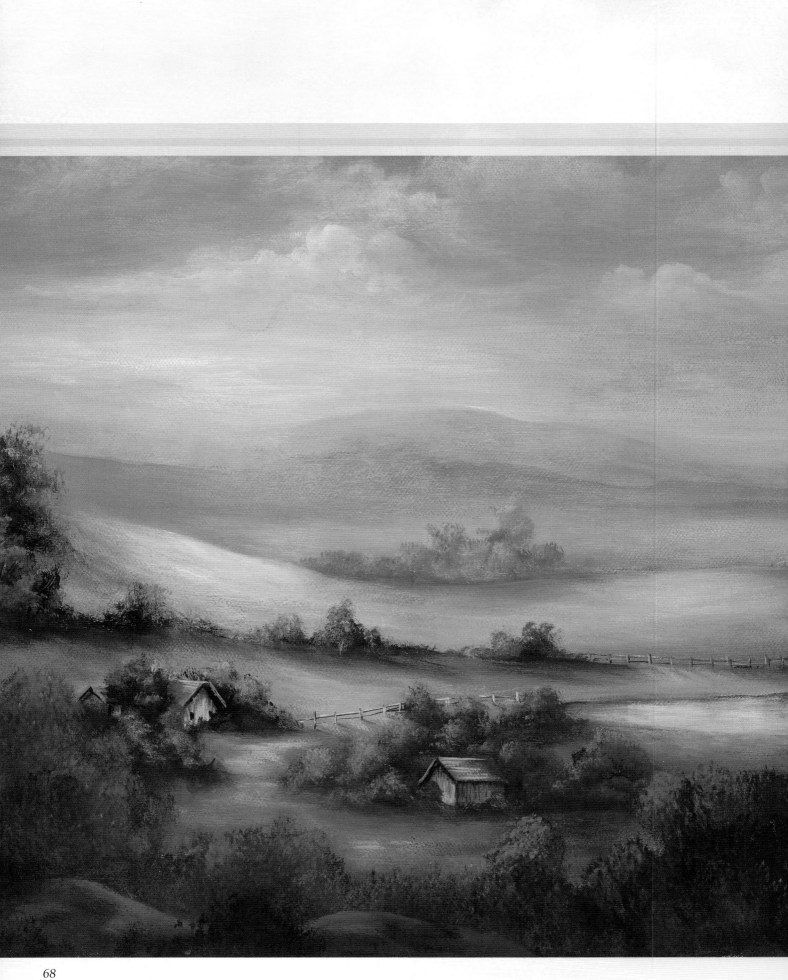

The Valley Below

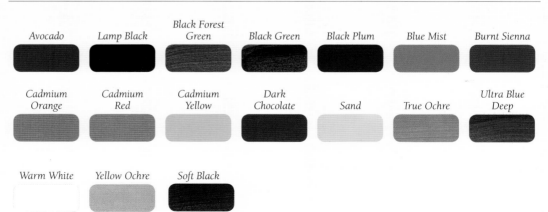

How many times have you been driving in the country and come across a peaceful country scene such as this one? This view is from a spot not far from our home.

I chose to paint more sky than the photo showed and to eliminate some fields and create a canvas for the beginning artist. Even though the scene is simpler than the photo, it is still interesting and readily achievable. Create distance with color, soft hills and light sky. Keep soft edges to the clouds and notice how the sky has little to no clouds close to the top of the hills. This also helps to create distance. Most of the paintings in this book have simple, easy skies, but I chose to add fluffy clouds to this project. The light source is from the left, just above the hill. Notice the shadows of the fence posts and trees on the ground. The darker foreground creates drama and frames the scene. Try to capture lots of sunlight on the ground near the buildings. We want the viewer to see this area first, before seeing the rest of the picture.

Brushes:

1-inch (25mm) Aqualon glaze/wash
1-inch (25mm) Sky-Wash
nos. 4, 6, 8, 10 and 16 Royal Sable brights

no. 10 angular bristle
no. 1 Aqualon liner
no. 2 Golden Taklon liner
no. 20 Royal Sable round

Other Materials:

medium-grit sandpaper
Canvas Gel
paper towels
index card cut down to 2" × 3" (5cm × 8cm)
pattern (see page 70)

Surface:

12" × 16" (30cm × 41cm) portrait-grade canvas

DecoArt Acrylic Paints:

| Avocado | Lamp Black | Black Forest Green | Black Green | Black Plum | Blue Mist | Burnt Sienna |

| Cadmium Orange | Cadmium Red | Cadmium Yellow | Dark Chocolate | Sand | True Ochre | Ultra Blue Deep |

| Warm White | Yellow Ochre | Soft Black |

Reference Photos

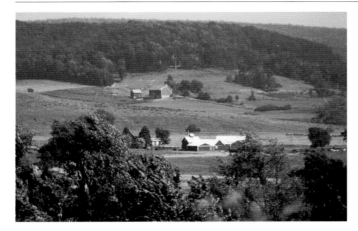
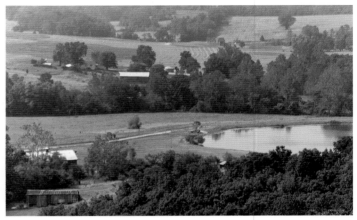

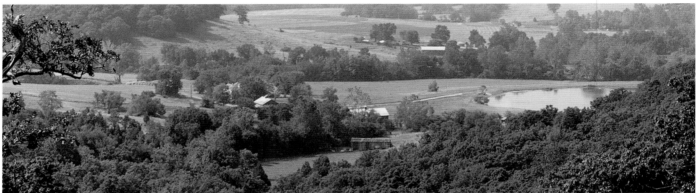

Pattern

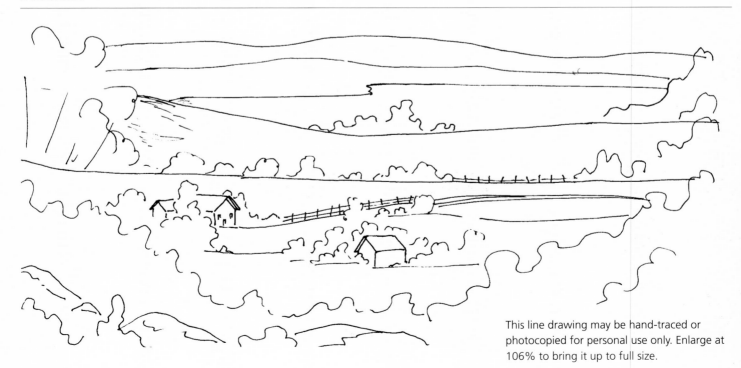

This line drawing may be hand-traced or photocopied for personal use only. Enlarge at 106% to bring it up to full size.

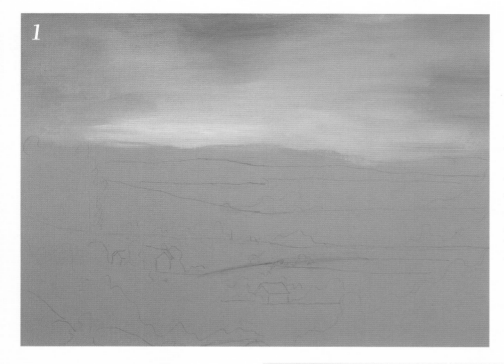

Step 1: Preparation Base the canvas with a 1-inch (25mm) Aqualon glaze/wash and two coats of Blue Mist, sanding between coats. Transfer the pattern. Apply a thin coat of Canvas Gel to the sky with a paper towel. With the 1-inch (25mm) flat, add sky color with Blue Mist + Ultra Blue Deep + a dot of Black Plum. Make this darker at the top and edges. As you work down, use Blue Mist + Warm White, making the area where the sun will be lightest.

Step 2: Preparation Let dry and then reapply Canvas Gel. Add clouds with a no. 16 sable bright corner loaded with Sand, keeping the paint toward the upper left. Turn the brush to the unloaded side and blend the bottom of the clouds into the sky. You might want to mop the clouds with a 1-inch (25mm) Sky-Wash.

Add a little Cadmium Yellow for sun glow above the hills on the left. Add a tiny amount of Cadmium Red and streak in for a peachy tone.

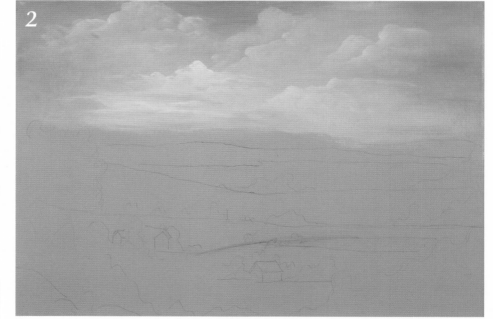

PAINT AT YOUR OWN SPEED

If you don't feel you can paint the whole sky before it dries, do half at a time.

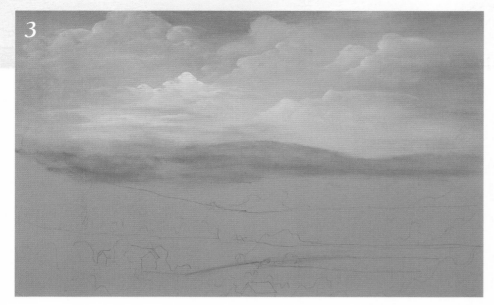

Step 3: Background Hills Apply Canvas Gel. Deepen the sky color (Blue Mist + Ultra Blue Deep + a dot of Black Plum) and use this new color to paint the farthest hill with a no. 16 sable bright. The hill on the far right should be closest in color to the sky.

Drybrush a little Cadmium Yellow + Sand on the bright spot of the hill, sometimes adding a touch of Cadmium Red.

Add a little more Ultra Blue Deep + a dot of Lamp Black to your deepened sky color and paint the next hill. Keep the colors very soft. Drybrush in some Black Plum, keeping it soft and hazy.

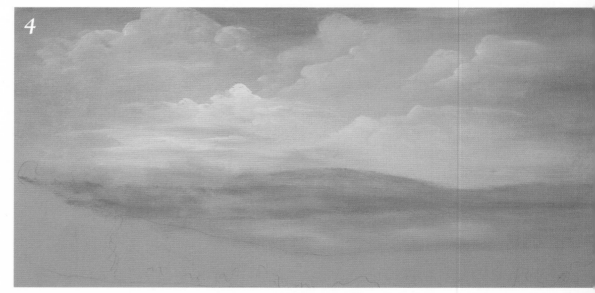

Step 4: Grass Using a no. 16 sable bright, paint the grass with Blue Mist + Cadmium Yellow + Ultra Blue Deep + Warm White.

Deepen the color with a touch more Ultra Blue Deep, and perhaps a dot of Lamp Black along the base of the field.

Clean brush with water and dry well. Add Sand + Cadmium Yellow highlights.

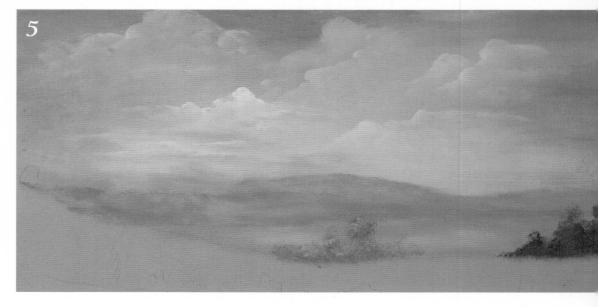

Step 5: Grass Using the same brush, tap in the distant trees with corner loaded Ultra Blue Deep + Blue Mist + Sand + a touch of Lamp Black, darkening a little at the base of the trees. Highlight with Cadmium Yellow + Sand.

Paint the far foliage on the right with Black Forest Green + Ultra Blue Deep + a bit of Black Plum adding some Black Green toward the base. Highlight with Black Forest Green + Cadmium Yellow.

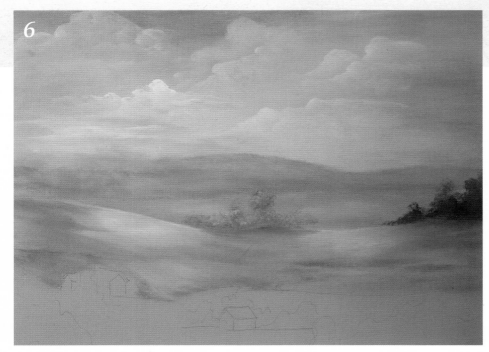

6

Step 6: Golden Fields Apply Canvas Gel on the golden hill area and paint the area with a no. 16 sable bright and Yellow Ochre, True Ochre + Burnt Sienna, and Yellow Ochre + Warm White, applied in horizontal strokes. Angle the brush in keeping with the lay of the land.

Keep the fields darker toward the bottom, on the edges and in the tree-shaded areas. Lighten the fields towards the top of each. Make the bottom field a little darker than the others.

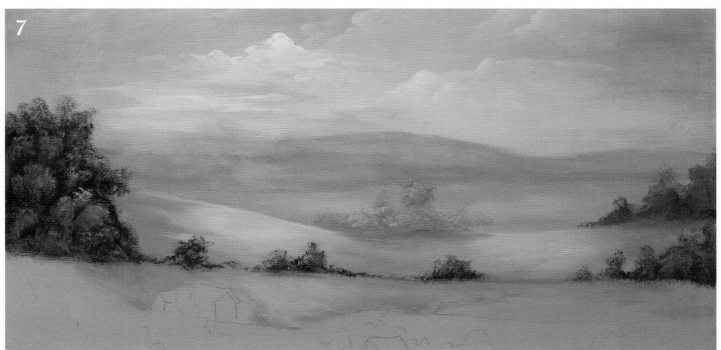

7

Step 7: Midground Trees Base the midground trees with a corner loaded no. 16 sable bright and Black Forest Green + Black Green. Work mostly on the corner of the brush, but as you come to the grass, turn to the chisel.

In the center of the painting, add Blue Mist to the base color to lighten the green.

To darken the trees on the right, add a bit of Black Plum. Highlight with a no. 10 angular bristle and Black Forest Green + Warm White + Cadmium Yellow. Then highlight again on only the left trees with Avocado to create a front layer of foliage.

Make the final highlights on all trees with Yellow Ochre and True Ochre + Warm White.

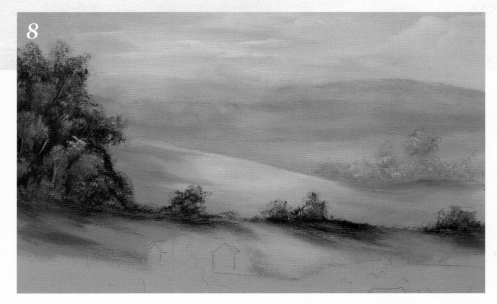

Step 8: Midground Trees Pull branches into the foliage on the left with a no. 2 liner and Soft Black. Highlight with Yellow Ochre.

Paint all the tree shadows with a no. 4 sable bright and dry-brushed Burnt Sienna and Ultra Blue Deep. Add in a few tree foliage colors. When the shading is complete, pick up True Ochre and drag the tree shadows into the golden field. Add Yellow Ochre in the lightest areas.

Step 9: Lake Using a no. 8 sable bright, pull Warm White + Ultra Blue Deep and Black Plum vertically from the far bank into the water. Clean the brush and fill in the rest of the water with thin Warm White + Blue Mist + a bit of Ultra Blue Deep, stroking vertically. Blend horizontally. Add a little Warm White + Cadmium Yellow in the water for highlights, pulling down and then blending horizontally.

Using the chisel edge, line the back of the lake with Lamp Black + Black Plum.

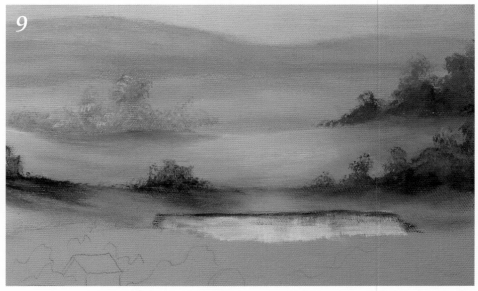

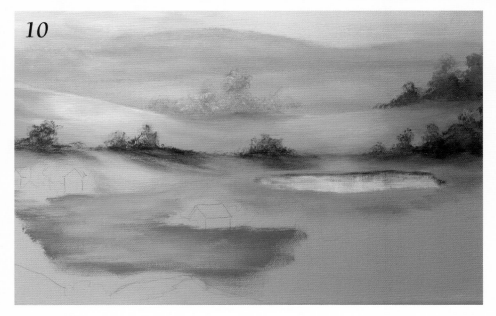

Step 10: Green Field Using a no. 16 bright, base the closest green field with Blue Mist + Warm White + Cadmium Yellow and a dot of Lamp Black (don't forget the strip of grass behind the left side of the lake).

In the shadowed areas, add Avocado, Black Forest Green and touches of Ultra Blue Deep. Highlight the field with the dirty brush and True Ochre + Warm White.

Add a second highlight of Cadmium Yellow + Warm White.

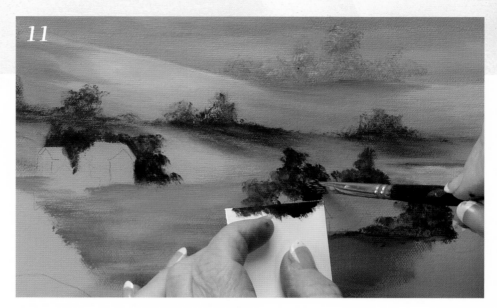

Step 11: Trees and Green Field Use an index card cut down to about 2" × 3" (5cm × 8cm) to mask the buildings.

Using a no. 10 sable bright, base the foliage around the buildings with Avocado + Black Green.

The trees between the two houses on the left will be painted later.

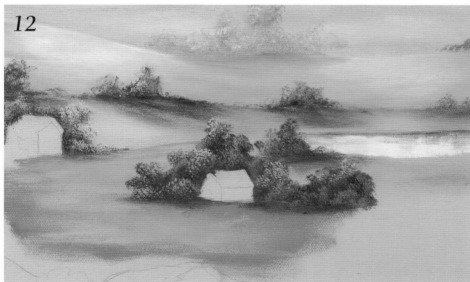

Step 12: Trees and Green Field Highlight the foliage with a no. 10 angular bristle and Avocado + Cadmium Yellow and Avocado + True Ochre.

Step 13: Buildings Use a no. 6 sable bright to base all of the buildings with Warm White. Shade under the roof line with corner loaded Ultra Blue Deep + Lamp Black.

Take a no. 1 liner, water down some Lamp Black and add a few board lines. Also paint the undersides of the roofs and windows.

Highlight the buildings on the left with Sand. Using the no. 4 sable bright, paint the roof on the house Blue Mist + Ultra Blue Deep and highlight with Cadmium Yellow + Warm White. Make the shed roofs Burnt Sienna shaded with Dark Chocolate and highlighted with Cadmium Orange + Warm White. Then add a few Cadmium Yellow + Warm White horizontal streaks.

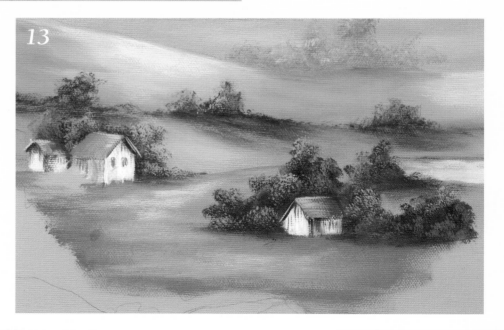

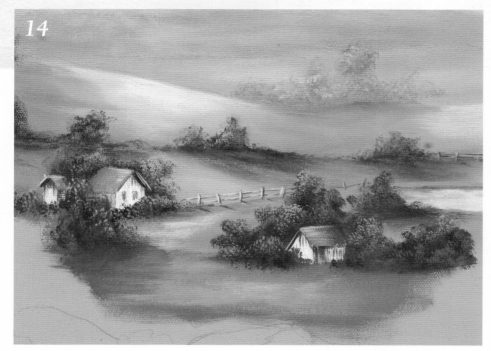

Step 14: Foliage and Fences Nestle the buildings in foliage with a no. 10 angular bristle and Black Green + Avocado. Highlight with Cadmium Yellow + Sand.

Paint the fence nearest the house with a no. 2 liner and thinned Soft Black.

Use the same brush and thinned Soft Black + a little Blue Mist for the farther fence.

Pull fence post shadows with Soft Black. Highlight both fences with Cadmium Yellow + Warm White.

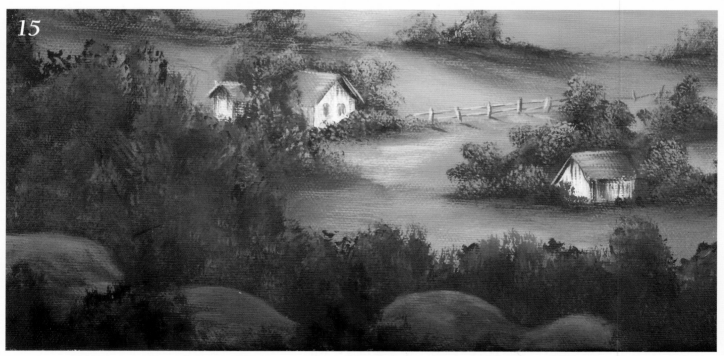

Step 15: Foreground Foliage and Rocks Using a no. 10 angular bristle, base the foreground trees with Black Green, adding Ultra Blue Deep here and there.

Highlight with Avocado and Avocado + True Ochre. Use the dirty brush + Ultra Blue Deep + Sand to add touches of blue-green.

With a no. 16 sable bright, base the rocks with Lamp Black + Ultra Blue Deep and Black Plum. Highlight with a side load of Cadmium Orange + Sand to establish shape and facets of the rocks.

Using a no. 10 sable bright, add touches of Ultra Blue Deep, Yellow Ochre + Burnt Sienna, Black Plum + Ultra Blue Deep + Warm White and Ultra Blue Deep + Warm White + Lamp Black. Keep the cooler colors to the left of the canvas and go into the warmer ones as you move right.

Use a no. 10 angular bristle and Ultra Blue Deep + Lamp Black and Soft Black + Black Plum to add dark foliage next to rocks.

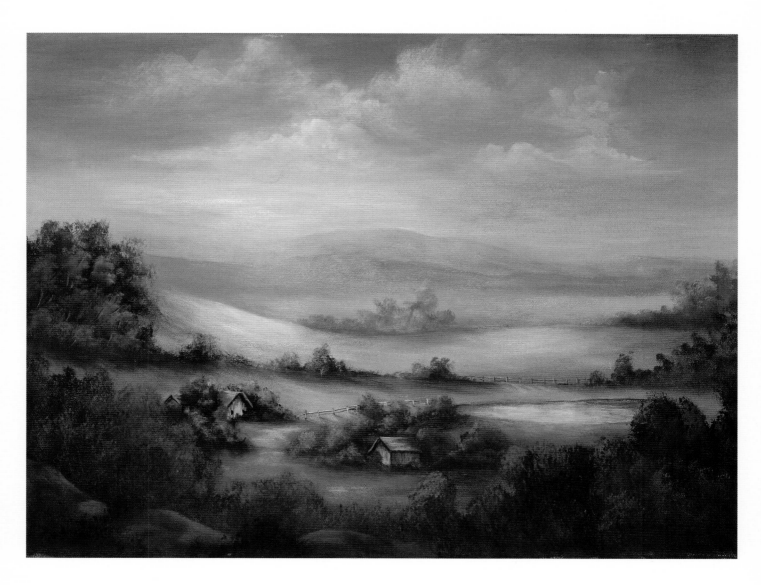

THE VALLEY BELOW

Finishing Touches: Use a no. 20 sable round to haze the distant hills with dry-brushed Cadmium Orange + Warm White and then with Ultra Blue Deep + Warm White. With a no. 1 liner or the chisel edge of a no. 4 sable bright, add Cadmium Yellow + Warm White highlights by filtering through the rail fence and strengthen any highlights that need to be brighter.

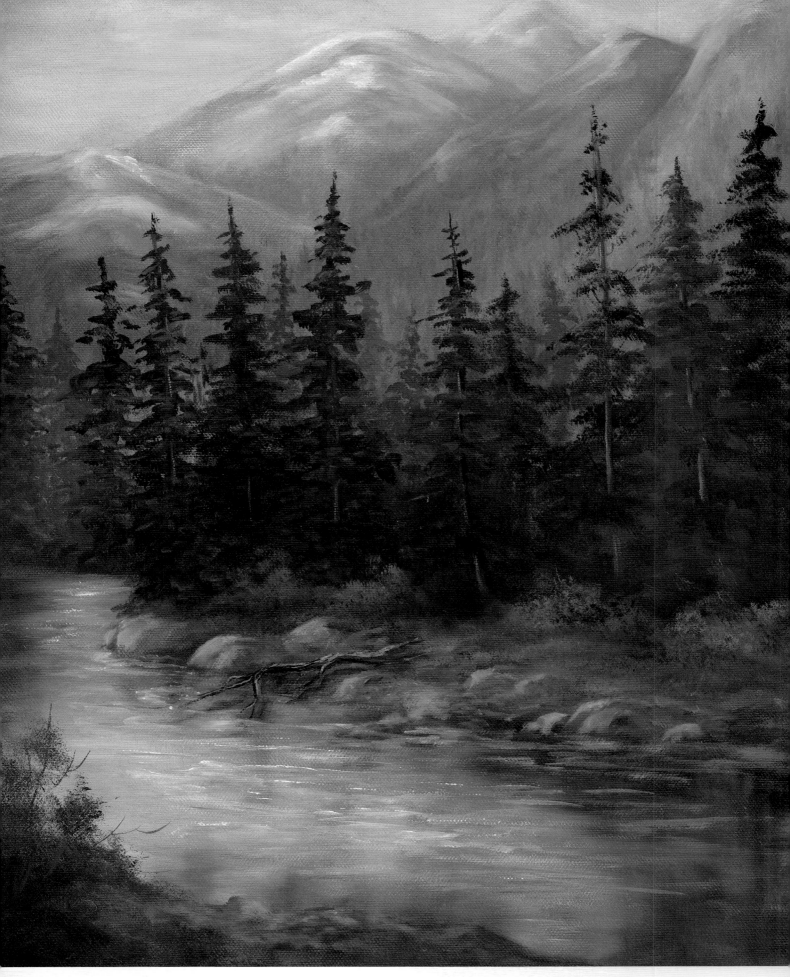

Mountain Pines

Mountains are one of my favorite subjects to paint. I have always loved the snow-topped, rugged peaks. My dream of a special place to live would be at the foot of the Rockies, having coffee each morning as I view the sun rising from behind a mountain peak and watching the shadows play on the mountains.

Don't be afraid to paint mountains. The secret is to use very little paint and move the brush slowly, letting the facets of the rocks just happen. Once the basic shape is achieved, go back and add shadows and highlights to the facets, creating interesting peaks and shapes. Heavy paint will hamper you by not letting you play with the shadows and highlights without some drying time. Whether you are painting tall mountains or rocks, the process is the same — a play between darks and lights.

There are plenty of pines in this composition to allow lots of practice in learning to paint them. The water also allows a good lesson in shadows and movement of water. This is a good beginning painting that has plenty of pines, simple mountains and lots of water.

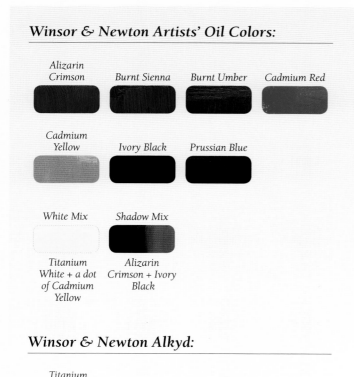

Winsor & Newton Artists' Oil Colors:

Alizarin Crimson

Burnt Sienna

Burnt Umber

Cadmium Red

Cadmium Yellow

Ivory Black

Prussian Blue

White Mix

Titanium White + a dot of Cadmium Yellow

Shadow Mix

Alizarin Crimson + Ivory Black

Winsor & Newton Alkyd:

Titanium White

Brushes:

no. 10 Supreme Bristle Flat
nos. 4, 8, 16 and 20 Royal Sable brights
no. 10 angular bristle
no. 8 Royal Sable fan blender
no. 2 Golden Taklon liner
1-inch (25mm) Sky-Wash

Other Materials:

Blending & Glazing Medium
palette knife
pattern (see page 80)

Surface:

12" × 16" (30cm × 41cm) portrait-grade canvas

REFERENCE PHOTOS

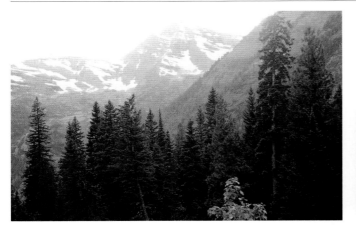

PATTERN

This line drawing may be hand-traced or photo-copied for personal use only. Enlarge at 130% to bring it up to full size.

1

Step 1: Sky Using a no. 10 bristle flat, corner load Titanium White + Prussian Blue + a smidgen of Ivory Black and begin painting the sky. Add White Mix to the brush as you paint down to the mountains. If the brush gets dirty, wipe it out.

Deepen the corners and across the top of the canvas with a little darker sky mix. Don't put a lot of time into painting the sky since it is not the main focus. If you wish, add a bit of the Shadow Mix in the corners.

Mop with the Sky-Wash brush.

2

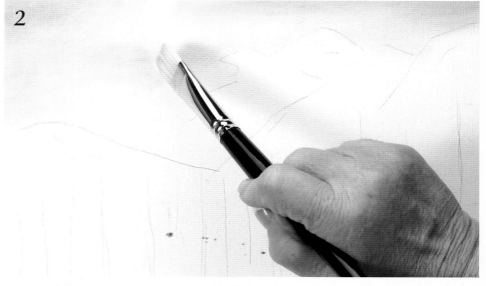

Step 2: Sky Clean the no. 10 bristle flat, dry well and tint the sky with White Mix + Cadmium Red and White Mix + Cadmium Yellow for sun glow.

3

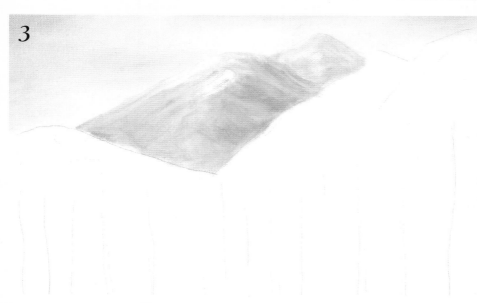

Step 3: Mountains Starting with the sky-mix blue from step 1, add a touch of Burnt Umber with a no. 4 sable bright and paint the shadows on the farthest mountain. Scuff on a small amount of paint with a no. 10 angular bristle. Lay in shadows on the right side of the next closest mountain, deepening the color a little by adding some of the Shadow Mix along with the blues. Occasionally pick up a little Ivory Black and Burnt Umber to vary the color.

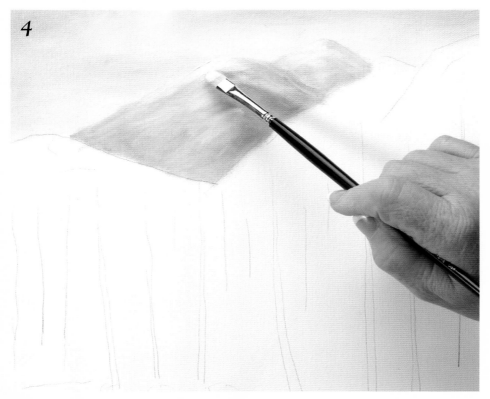

Step 4: Mountains Wipe the brush and pick up some of the light blue mix from the sky to highlight the sunny sides of the mountains. Blend where the shadow side and the light side meet.

Break up any large light areas with a darker color. Use White Mix for the lightest highlights.

If the paint doesn't stick or stay light, go back in later, after the undercoat has time to set up.

Step 5: Mountains Paint the two next closest mountains on the right side with brown tones. Scuff Burnt Sienna + White Mix on the left side of both mountains with a no. 4 sable bright. For darker areas, add Shadow Mix and a tiny bit of Burnt Umber, varying colors for interest and mountain separation.

To create distance, keep the mountains soft and hazy — avoid dark, rich colors in this area.

Paint the remaining mountains (on the left side) with Burnt Sienna + White Mix + extra Shadow Mix. Then add a little Prussian Blue on the right mountain, near the canvas edge. Be sure to paint mountain color into the tree area so it will show behind the trees.

Add a bit of Prussian Blue + White Mix to the right side of the left mountain to start to establish lighter areas.

Mop with the Sky-Wash brush to soften.

Use a no. 16 sable bright to blend where the front left mountain lays against the back mountain.

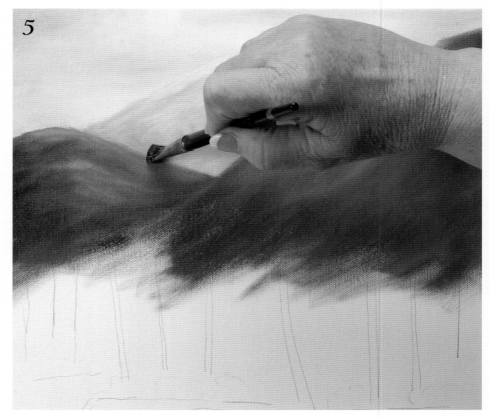

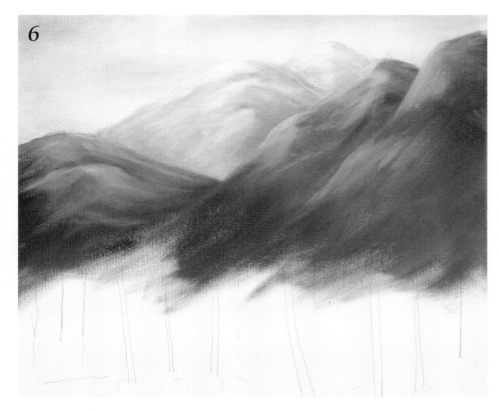

6

Step 6: Mountains Add some highlights to the brown mountains with White Mix + Cadmium Yellow side-loaded on a no. 16 sable bright. Highlight again with White Mix.

The dark shadow against the light highlights separates the mountains.

Mop with the Sky-Wash brush over the mountains to set them into the background.

Step 7: Pines Load a no. 4 sable bright with a soft blue-green mix of Prussian Blue + Burnt Umber + White Mix. Hold the brush almost flat to the canvas and tap in a suggestion of trees. Keep the strokes hazy and soft and vary the heights. Brush some of this color behind the tall pines.

You can add a speck of Cadmium Yellow to change the green on the closest brown mountain, but keep the color value on the blue side.

On the blue-tone mountain, add a touch more White Mix and a little more Prussian Blue for the most distant trees.

Mop with the Sky-Wash brush to set the trees into the mountains.

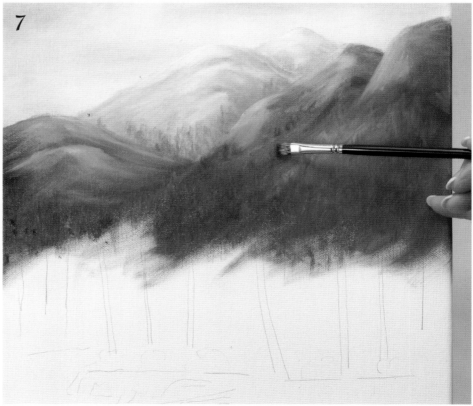

7

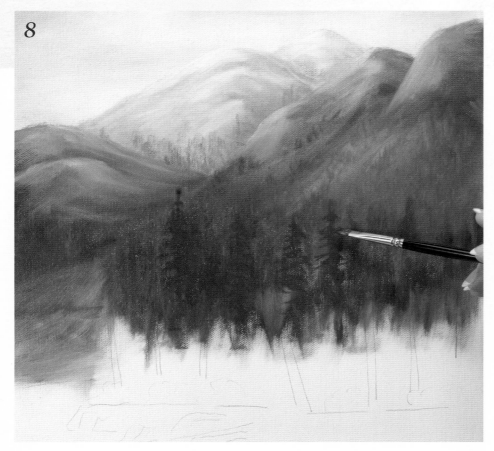

8

Step 8: Distant Pines Corner load a no. 8 sable bright with the same green mix from Step 7 and add a little more of the Prussian Blue + Burnt Umber to deepen the color.

Hold the brush almost flat to the canvas to create suggestions of trees. Add Cadmium Yellow to the mix for some brighter green trees.

Using Prussian Blue + Burnt Umber mixed to a dark green, add a few dark trees on the right and in the dark middle area. Blend these trees by pulling down on the color with a no. 10 bristle flat.

Choose a couple of trees and, using the brush corner, paint in a few more detailed branches with somewhat horizontal strokes.

Step 9: Foreground Pines Paint in the trunks of the closest pines with a no. 4 sable bright double-loaded with Burnt Umber thinned with Blending and Glazing Medium and a dirty white from your palette. Use the chisel edge of the brush and pull the trunks from the top down.

Using a double-loaded brush creates highlights and shadows at the same time.

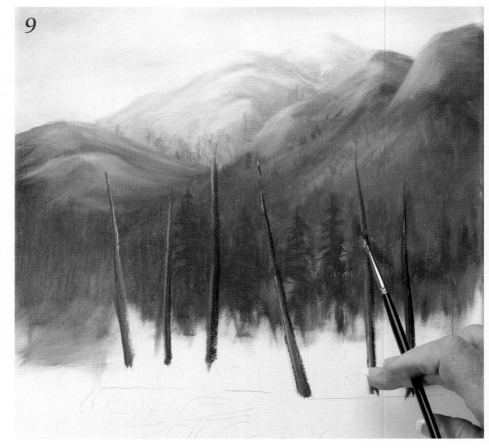

9

10

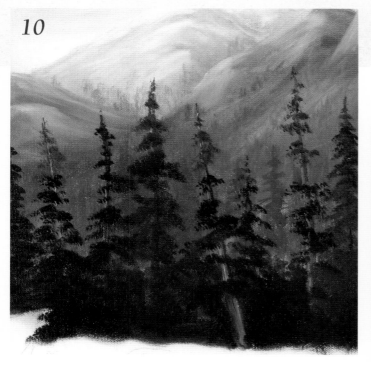

Step 10: Pines Corner load a no. 20 sable bright with dark green mix (see Step 8) to paint the pine branches, letting some of the trunks show. Barely touch with the corner of the brush, leaving the very top of the tree without branches and making the first branches very short.

Vary the colors of the tree branches next to each other to differentiate them.

A bit of the Blending and Glazing Medium helps the colors stick.

11

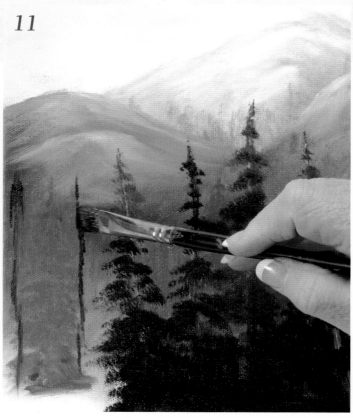

Step 11: Pines You can also add trees where there is no trunk. Start with a vertical line in the branch color. Once the center line is established, you can add branches.

12

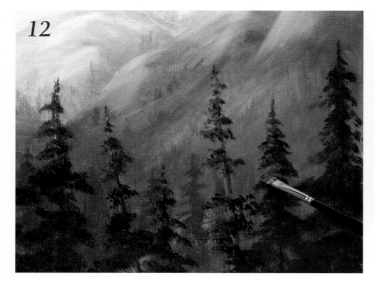

Step 12: Pines Corner load the dirty brush with Cadmium Yellow and tap highlights on some of the trees. For the lightest highlights at the tops of the trees, add a little more Cadmium Yellow + a little White Mix.

13

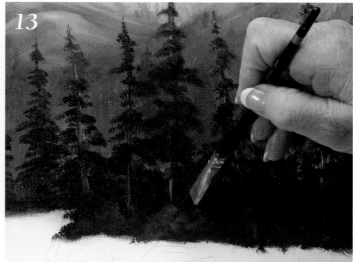

Step 13: Bushes Paint the bushes with a corner-loaded no. 16 sable bright and Prussian Blue + Burnt Umber + Cadmium Yellow + a touch of White Mix. For the brighter highlighted parts, use a bit more Cadmium Yellow and White Mix. Blend the bush edges into the dark trees. As you move close to the right edge of the canvas, add a bit of Prussian Blue and White Mix to the dirty brush.

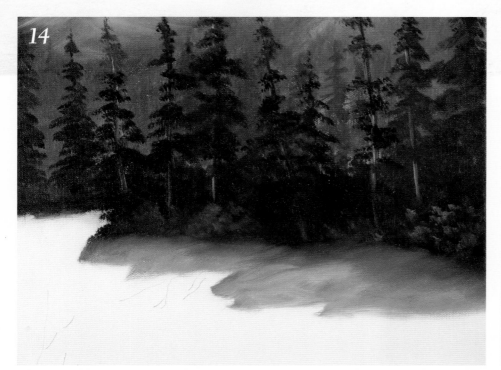

Step 14: Ground Clean the no. 16 sable bright and wash in a base for the ground with Burnt Sienna + White Mix, pulling some of the greens from the bushes and trees into the ground for shadow.

Wipe the brush often and keep the paint thin enough to see the pattern lines.

ADDING HIGHLIGHTS AND SHADOWS

When working with oils, you may have to let the paint dry a bit before adding more highlights or shadows.

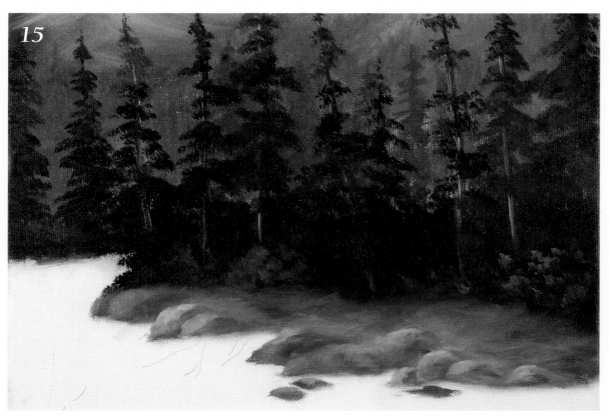

Step 15: Ground With a no. 16 sable bright, add touches of Burnt Umber, Shadow Mix and more Burnt Sienna to the far bank to lay in shadows and form rocks. Pull the brush in the direction of the lay of the land, and occasionally add in some tree color from the canvas or the palette. Go darker on the right side of the canvas.

As you continue, go back and forth between highlighting and shading so you get a good variety of colors. Highlight the rocks and ground with Burnt Sienna + White Mix, sometimes adding touches of Cadmium Red to the mix.

Also use Cadmium Red + Cadmium Yellow + White Mix to highlight some of the rocks.

Use Shadow Mix and some of the blues from the mountains on the darker side of the rocks.

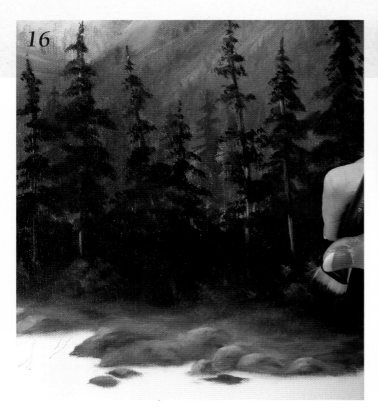

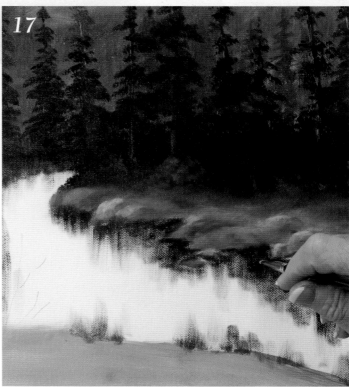

Step 16: Bushes Fluff up the bristles of the no. 10 angular bristle by tapping on the palette. Use some bush highlight colors from step 13 to extend the bushes and blend them into the grass.

Step 17: Water Pull Prussian Blue + Burnt Umber down from the edges of the far bank using a no. 4 sable bright. Pull more and longer areas of these colors on the right edge of the canvas.

Add Shadow Mix under some of the bank areas. Also add some greens from the pines and Burnt Sienna + White Mix from the rocks. Use dry paint without medium.

Add some of the greens, then pull up from the bottom bank into the water. For the dark corner, add a little Shadow Mix. When you pull the color, let it fade out unevenly.

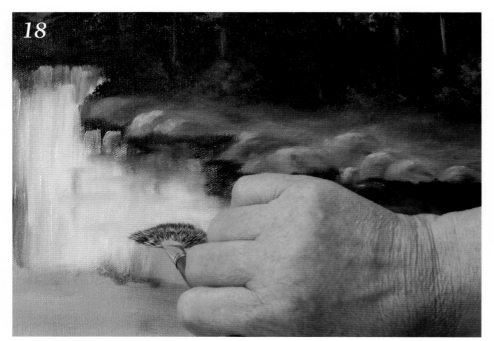

Step 18: Water Clean the brush, then pick up some Blending and Glazing Medium. Fill in the water with thin White Mix + a speck each of Prussian Blue and Ivory Black. Pull up into the dark shadow colors, wiping the brush if you pick up too much color.

After all the colors are applied, take a clean no. 8 fan blender and sweep horizontally across the colors with the chisel edge to blend. Do not over blend — streaks in the water suggest movement.

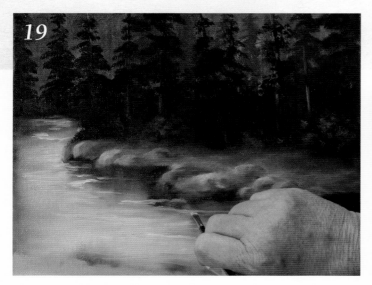

Step 19: Water and Rocks Use a no. 8 sable bright with Burnt Sienna + a bit of White Mix to delineate rock formations. Pull straight down, then, to show water movement, use the chisel to lightly brush horizontally at the base.

You may want to add a few more rocks, rock highlights and rock shadows.

Add water lines with a little White Mix. Load one side of the brush, turn it so the paint is on the top and apply the paint with the chisel edge. If the water lines do not want to stay on the wet paint, let this area tack up and reapply them later.

Step 20: Branch in the Water Paint the branch in the river with a no. 2 liner. Base with Burnt Umber, shade with Ivory Black and highlight with White Mix.

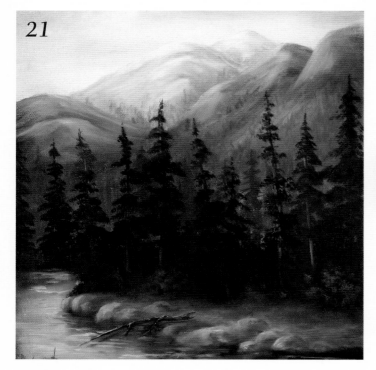

Step 21: Highlight and Shadows When the painting is dry, add brighter snow to the light side of the mountains using White Mix and a no. 4 sable bright.

Use Burnt Umber and glaze a shadow on the ground under the log.
Add brighter water lines to the water.

Step 22: Foreground Shore Paint the foreground shore as you did the rocky shore in step 15, only using darker values. Paint branches of the foreground bushes with thin, inky Burnt Umber and a no. 2 liner.

Tap in a dark green (Prussian Blue + Burnt Umber) from the palette and highlight with a medium green (dark green mix + Cadmium Yellow). Paint bush foliage using the same brush and technique used for the bushes on the rocky shore in step 16. Also tap in some foliage color on the foreground for grasses.

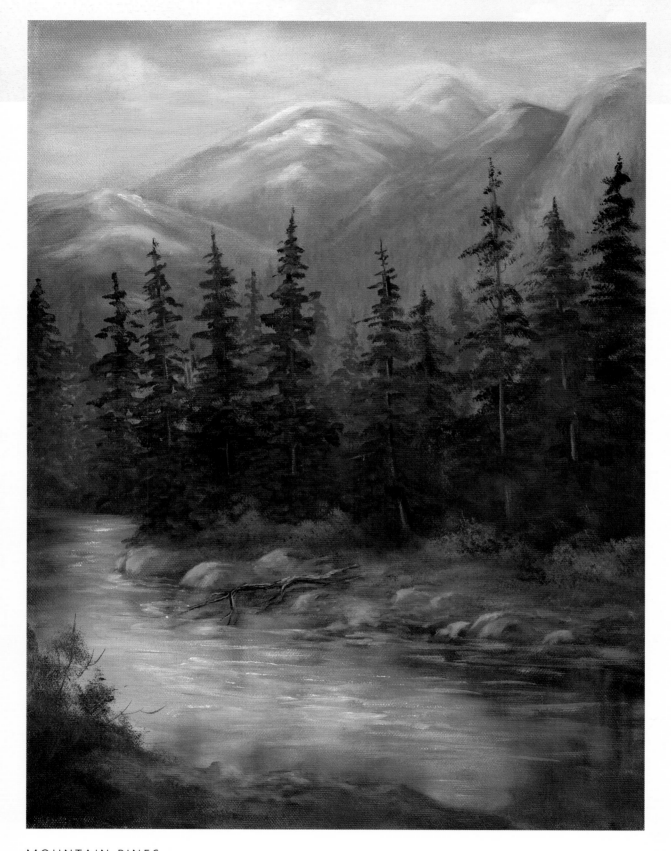

MOUNTAIN PINES

Finishing Touches: Allow the paint to set up a little and then brighten the snow on the lighter side of the mountains with White Mix on a no. 4 sable bright. Add brighter water lines with White Mix loaded on a palette knife. Always check your values and add more shadows by glazing with the Blending and Glazing Medium for darker shadows and apply heavy highlights with dry paint.

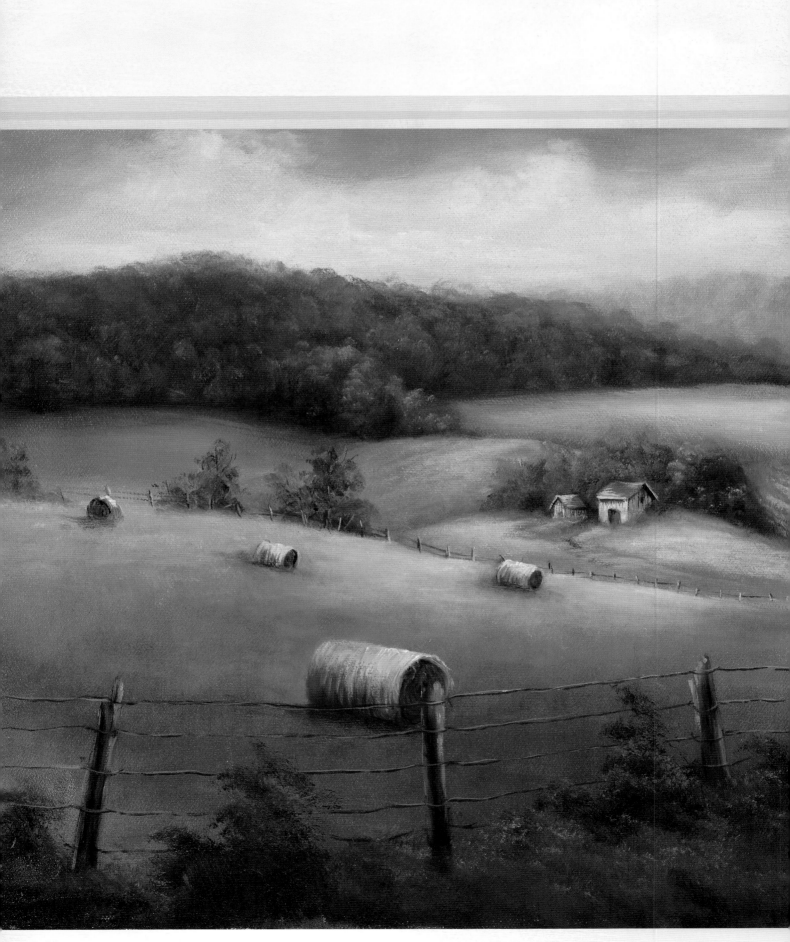

Bales of Hay

The Iowa countryside provides the elements for this composition. As you can see, the scene was composed of two photos. Many times the artist has an idea, but not one photo that fills the bill. Combine photos to make the scene you wish to paint. Not sure if your idea will work? Enlarge your photos, remove areas you want to combine and tape them together. Perspective will have to be corrected in most cases.

This painting teaches a valuable lesson in creating distance with the use of color. The base of the fence was created by double loading the flat sides of a brush.

Keep the buildings simple so you only have to draw a box or cube. Use a T-square to keep the vertical lines on the buildings straight. Use an index card or piece of a card to help you paint the foliage behind the buildings without losing your pattern.

Brushes:

nos. 4 and 10 Supreme bristle flats
nos. 2, 4, 8 and 16 Royal Sable brights

no. 4 bristle filbert
no. 8 Royal Sable fan blender
no. 5/0 Golden Taklon liner
1-inch (25mm) Sky-Wash

Other Materials:

T-square
stylus or pencil
Blending and Glazing Medium
pattern (see page 92)

Surface:

12" × 16" (30cm × 41cm) portrait-grade canvas

Winsor & Newton Artists' Oil Colors

Alizarin Crimson	Burnt Sienna	Burnt Umber	Cadmium Orange	Cadmium Scarlet	Cadmium Yellow	Cadmium Yellow Pale

Ivory Black	Naples Yellow	Prussian Blue	Raw Sienna	**Professional Permalba Oil:**	**Winsor & Newton Alkyd:**
				Brilliant Yellow Light	Titanium White

Yellow Ochre	White Mix	Shadow Mix
	Titanium White + a dot of Cadmium Yellow	Alizarin Crimson + Ivory Black

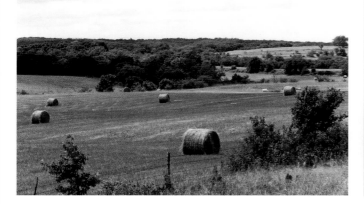 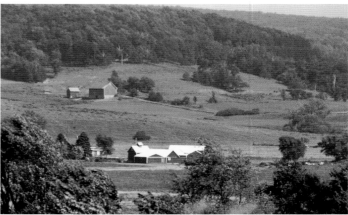

PATTERN

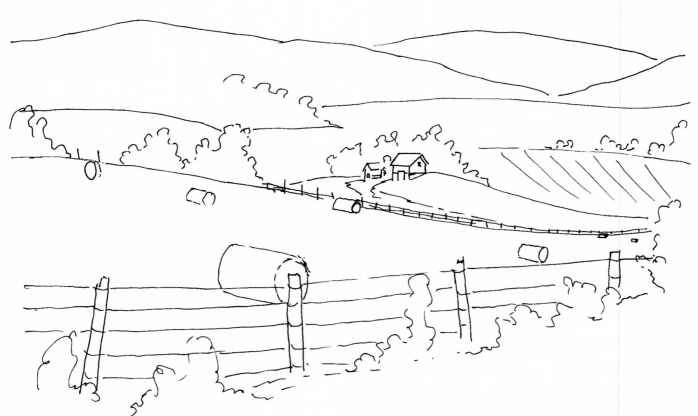

This line drawing may be hand-traced or photocopied for personal use only. Enlarge at 111% to bring it up to full size.

1

Step 1: Sky Corner load a no. 12 bristle flat with White Mix + Prussian Blue and paint across the top and sides of the canvas, adding more White Mix as you paint toward the center of the sky.

Be sure to paint the sky down into the first hill — the colors added later for the hillside trees need to be soft and hazy from mixing with the wet paint.

Clean the brush, dry well, then pick up White Mix and fill in the rest of the sky, fluffing in clouds. Mop with the Sky-Wash brush to set the clouds into the sky.

2

Step 2: Sky Tint some of the clouds with White Mix + Cadmium Yellow. Tint above the hills with White Mix + Cadmium Scarlet. Add White Mix + Prussian Blue + Shadow Mix at the corners and across the top of the sky.

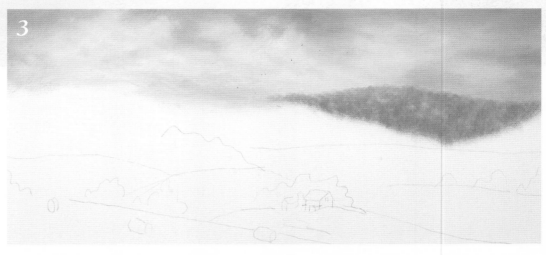

PAINTING HILLS

When painting hills, always pull the brush in the direction of the lay of the land.

Step 3: Hills The farthest hill is painted just slightly darker than the sky with a no. 4 bristle filbert and Prussian Blue + White Mix + a dot of Shadow Mix. Pull with short downward strokes and vary the colors to look like a hillside of trees.

Add a speck of Cadmium Yellow to the mix to create some soft green in places and a bit of Burnt Umber to darken in others.

The right side of the hill is darker than the left. White Mix + Prussian Blue may be tapped over the hill to lighten. Use a no. 8 fan blender to blend across the top of the hill to set the hill and sky together.

Step 4: Hills Using a no. 8 sable bright, base the dark hill with Prussian Blue + Burnt Umber. Vary the amounts of color so some areas have a bit more Burnt Umber and some more Prussian Blue. Pick up a bit of Blending and Glazing Medium if you wish to help the paint move easier.

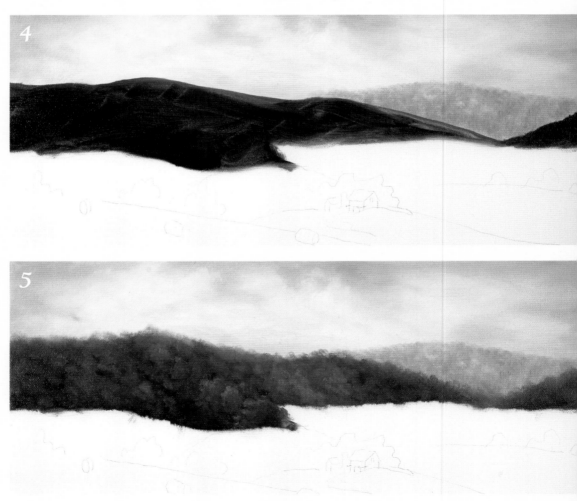

Step 5: Hills With the no. 4 bristle filbert, pull short, downward strokes to form the tops of many trees on the far hill. Used varied colors — Prussian Blue + Burnt Umber + Cadmium Yellow, sky blues from the palette, Shadow Mix + White Mix and a few touches of Burnt Sienna in the dirty brush.

Leave much of the base color showing through for tree separation. Clean the brush, dry well and tap over the top of the hill, pushing up into the sky to lighten the hilltop. Mop with the Sky-Wash if necessary.

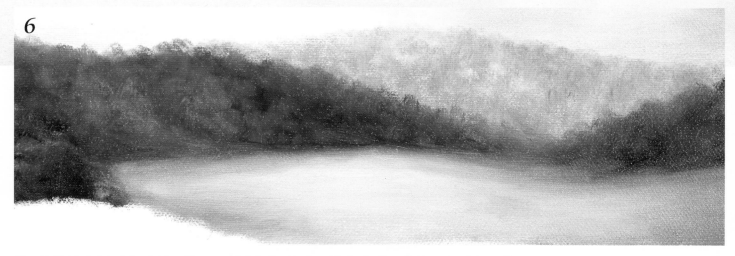

6

Step 6: Fields Paint all the fields with a no. 4 bristle flat. Begin with the farthest field on the right, pulling down some of the tree color. Add some of the blues from the sky + Cadmium Yellow + White Mix, blending into the wet trees. Add more Cadmium Yellow Pale + White Mix in the highlight area and then highlight again with Brilliant Yellow Light.

You will not be able to get your brightest highlights (the brightest area in the reference photo), but you can go back to them when the painting has tacked or dried. Add a little Yellow Ochre to the bottom of the hill.

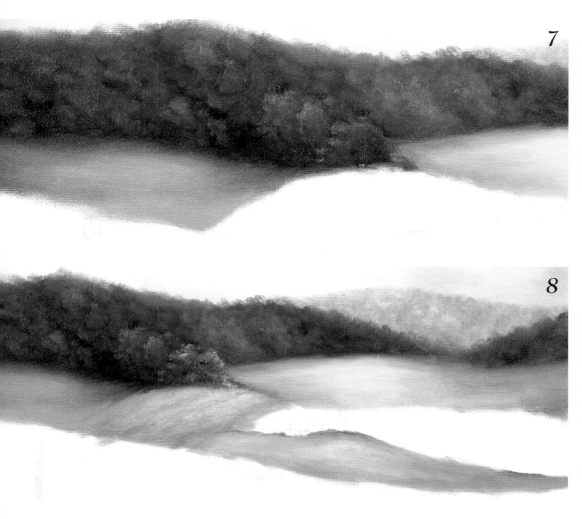

7

8

Step 7: Fields The field to the far left is not catching much light and will remain darker. Pull in more of the tree colors. To the dirty brush add a little Cadmium Yellow + White Mix, adding some Yellow Ochre at the hill base. Highlight with a soft blue value from the sky.

Step 8: Fields The field to the left of the buildings and the field the buildings are sitting in are based with the same colors you've been using, but a little darker than the farthest hill on the right and a little lighter than the back hill on the left.

If the paint gets muddy, add a bit of Cadmium Scarlet to put a slight brown tone in the green. Paint the highlights with Naples Yellow, keeping the brightest colors on the hill with the buildings. Deepen the green where the fields meet by adding a bit of Shadow Mix. Touch up the trees if necessary, and extend them a bit onto the field. At this point you can add Cadmium Yellow Pale highlights to the trees.

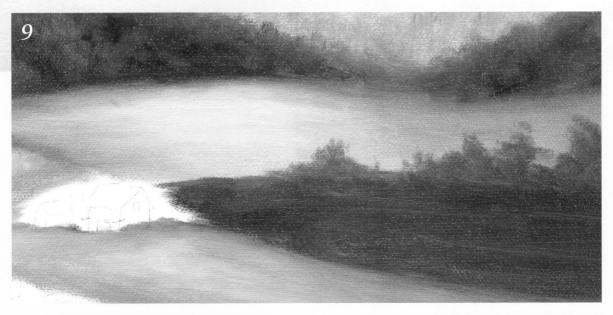

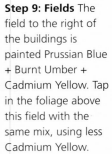

Step 9: Fields The field to the right of the buildings is painted Prussian Blue + Burnt Umber + Cadmium Yellow. Tap in the foliage above this field with the same mix, using less Cadmium Yellow.

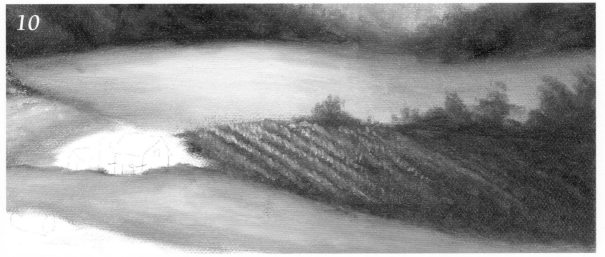

Step 10: Fields To suggest the cornfield, tap on Raw Sienna, Yellow Ochre, Cadmium Yellow + White Mix and Brilliant Yellow Light. Notice the field gets darker toward the edge of the canvas and lower on the hill. You can tap over the field with a Sky-Wash brush to help set the colors together. If necessary, add more highlights when the painting is dry.

Step 11: Trees Still using the no. 4 bristle flat, tap on the trees behind the buildings and in the midground in front of the buildings with a Prussian Blue + Burnt Umber base, followed with lighter areas of Prussian Blue + Burnt Umber + Cadmium Yellow Pale.

Highlight with Cadmium Yellow Pale + White Mix, using a no. 4 sable bright. Using the same brush, add a touch of Burnt Sienna and Burnt Sienna + Cadmium Orange, but be careful you don't make this look like a fall painting.

A little Shadow Mix + White Mix also could be used in this area. Use a no. 5/0 liner and thin Burnt Umber + Shadow Mix to add a few branches.

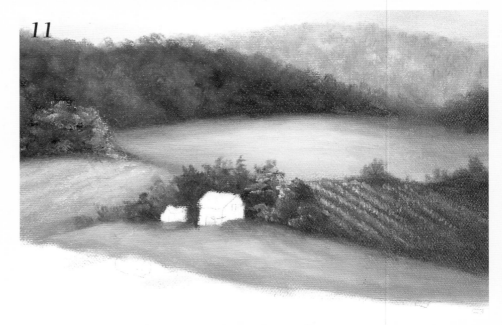

12

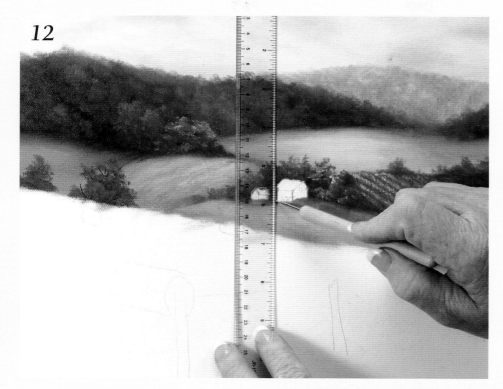

Step 12: Buildings Use a T-square and a pencil or stylus to re-establish the straight sides of the two buildings.

Step 13: Buildings Use a no. 2 sable bright to paint the buildings, sometimes switching to a no. 5/0 liner.

Paint the right sides of the buildings with White Mix + Prussian Blue. Paint the fronts Brilliant Yellow Light. Paint the concrete foundations of the buildings with Yellow Ochre on the dark sides and Yellow Ochre + White Mix on the fronts. Shade under the eaves with a touch of Ivory Black, pulling down a bit for board lines. Also shade down the line of the front corners. Above the eaves shading, add a line of Brilliant Yellow Light on the roof edges. The roof of each building is Burnt Sienna, shaded with Burnt Umber and highlighted with Cadmium Orange. Use a no. 4 sable bright and Ivory Black for the doors, pulling through the wet paint, which automatically grays the color. Pick up some tree color and pull out the building shadows. Check straightness of the buildings with a T-square.

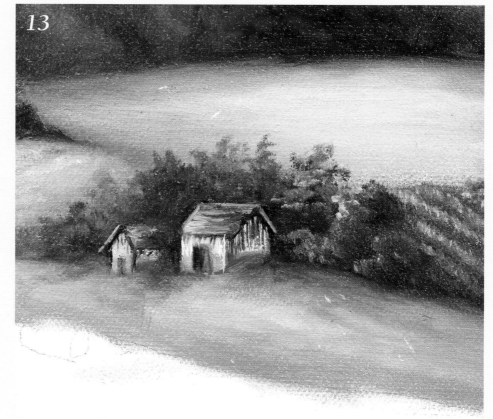

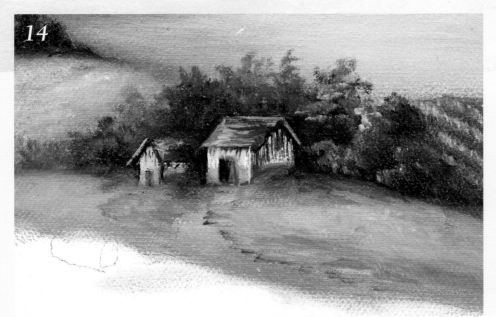

14

BUILDING HIGHLIGHTS

Whenever the paint starts to resist extra layers of color, such as in highlighting, let the paint set up a bit and then go back in with highlights.

Step 14: Paths Using a no. 4 sable bright, paint the paths from the buildings in Raw Sienna; shade the edges with Burnt Umber. If you need to highlight, use White Mix + Cadmium Orange.

Keep the path narrower next to the building and widen it as it comes forward.

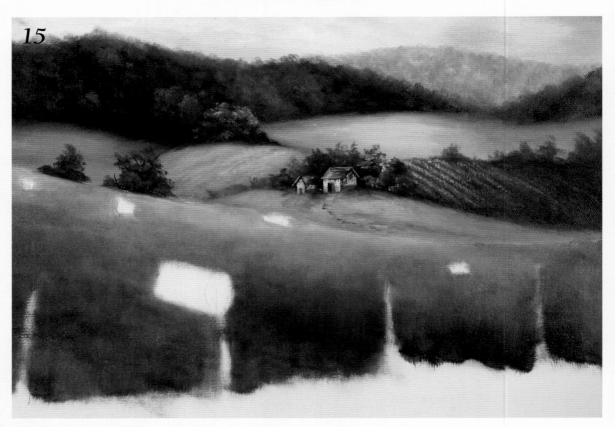

15

Step 15: Fields with Bales You may want to mask the fence posts and hay bales.

Use a no. 16 sable bright to paint the top of the foreground hill with Naples Yellow + White Mix + Prussian Blue + Burnt Umber to make a soft green. You can paint right over the bales.

If you paint out the pattern, etch it back in from your tracing (see page 15). As you move forward and to the right, the field gets darker, so begin to work in Raw Sienna, Yellow Ochre and more Prussian Blue. Eventually add a bit of Raw Sienna.

This field has been mowed and you want a variety of colors for texture, but you don't want to show individual grass blades, so blend your short, downward strokes.

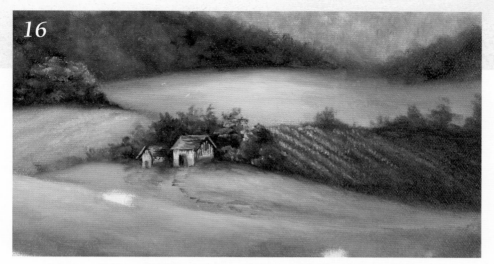

16

Apply shadows with thin paint and highlights with heavy paint.

Step 16: Fields with Bales Tap highlight colors on the top of the hill with the flat side of a no. 16 sable bright. Start with Cadmium Yellow + White Mix. This is the only highlight in the darkest highlight area of the hill on the left.

In the lighter central section, tap Yellow Ochre + White Mix over the first highlight, but don't completely cover. Finish in the lightest areas by laying on Brilliant Yellow Light.

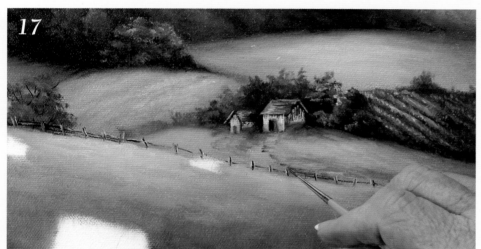

17

Step 17: Fields Using a no. 5/0 liner, add the little fence using Burnt Umber thinned with Blending and Glazing Medium and Shadow Mix.

Make the posts shorter and closer together as they get farther away, and avoid making them all stand straight. The fence wires are the same color skipped along in a non-continuous line between the posts.

Highlight the posts with Brilliant Yellow Light. Notice the highlights differ on the right and left — always facing the light source in the center of the painting. On the more distant posts, add a bit of reflected light on the sides opposite the highlighting with Prussian Blue + White Mix.

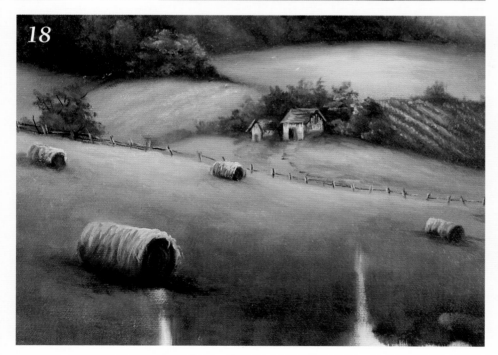

18

Step 18: Bales Using a no. 4 sable bright, base the bottom of the bales with Burnt Umber, pulling up into the bales and stopping irregularly. Fill in the bales with Yellow Ochre. Avoid over blending.

Fill in the bale ends with Burnt Umber. Shade with Shadow Mix to make them look rolled. Wipe the brush and pull shadows from under the bales. Highlight with Cadmium Yellow + Yellow Ochre + White Mix to place sunlight on the bales. Add a highlight of Brilliant Yellow Light.

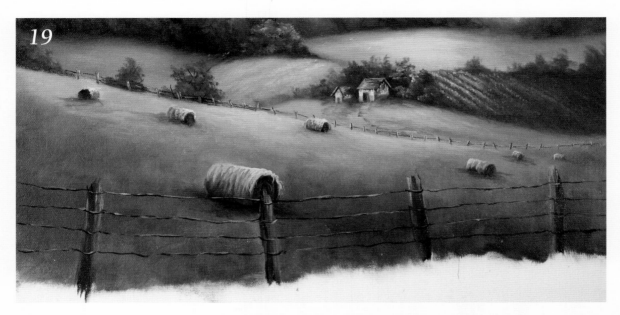

Step 19: Fence Posts Double load a no. 8 sable bright with Burnt Umber + Shadow Mix and Cadmium Orange + White Mix and paint the foreground posts. Notice that the shade side and highlight side reverses for the two posts on the left and the two on the right.

You then can work with the shading and highlighting colors separately to adjust and perfect. Add reflected light of Prussian Blue + White Mix on the dark side of the posts. For the lightest highlights at the tops of the posts use Cadmium Orange + Brilliant Yellow Light. Paint the fence wire with a no. 5/0 liner and thinned Ivory Black. Avoid straight, taut wires. Add highlights with any dirty white off your palette.

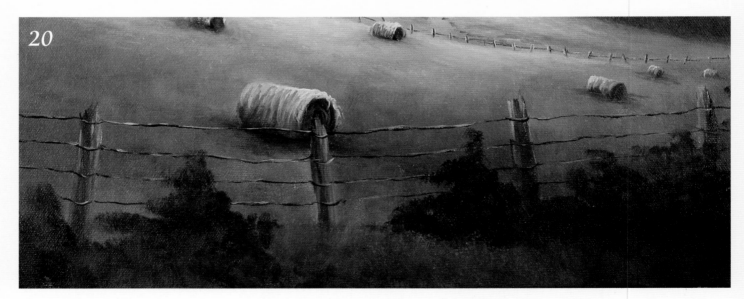

Step 20: Foreground Foliage Using a no. 10 bristle flat, fill in the rest of the canvas foreground with Prussian Blue + Burnt Umber bushes. Add Cadmium Yellow to the mix for the lighter ground in front of the bushes, and apply this mix in quick downward strokes. Pull in some of the color from the bushes for variety. Add a touch of Yellow Ochre + White Mix for lightest values.

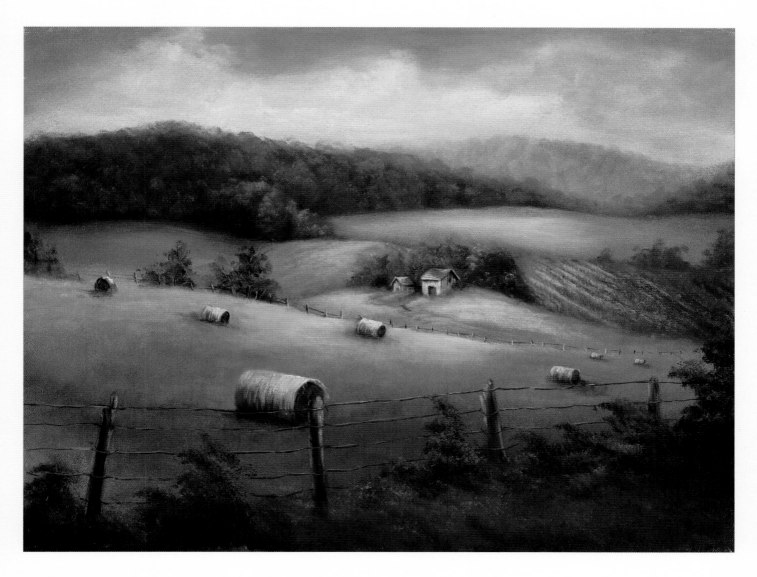

BALES OF HAY

Finishing Touches: Reinforce highlights and add other finishing touches as needed. Let the painting set a day or two. Look at your painting with fresh eyes and if something jumps out at you, it may be an area that needs your attention. Check the values in the painting. If the painting is dry, glaze shadows between the fields, under the bales, and at the cast shadows of the foreground fence posts. Strengthen the highlights in front of the buildings. You may need to add more sunshine to the tops of the bales. Remember, sunshine is not Titanium White, but Titanium White + Cadmium Yellow Pale or Titanium White + Cadmium Orange. White by itself is chalky and does not suggest sunlight.

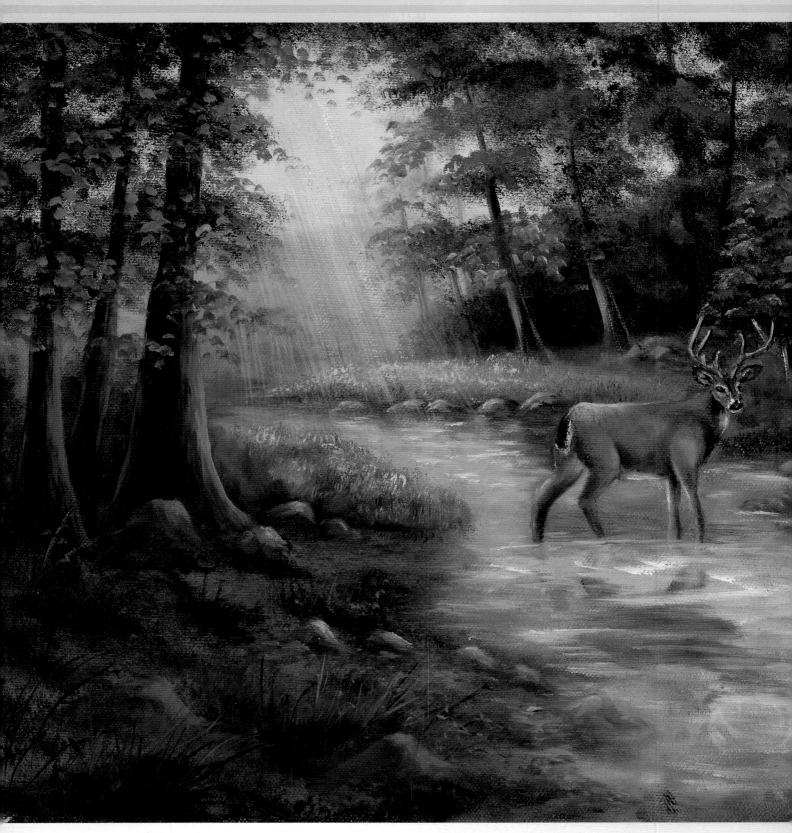

Cooling Off

Adding animals and people to your scene makes the painting more interesting. This scene was originally painted with a cow in the stream; however, deer appeal to a wider market and thus the final painting. It's important to know your market.

I must have several hundred photos of deer, but no large buck. I enlarged a photo of a doe with the stance I wanted and then added antlers. The photo was enlarged on my copier, and then I drew the deer by hand on a piece of tracing paper.

I applied masking fluid to the deer and reflection, which allowed me to paint all the background without worrying about losing the pattern. This technique is commonly used with watercolors, but it also works well with acrylics and oils. Remove the masking fluid with a kneaded eraser or the tip of a palette knife. This painting is a good example of using masking medium, creating sunrays and painting an animal.

Brushes:

nos. 4, 10 and 12 Supreme bristle flat

nos. 4, 8 and 16 Royal Sable brights

no. 10 angular bristle

no. 4 Aqualon filbert

no. 6 bristle fan blender

no. 8 Royal Sable fan blender

no. 2 Golden Taklon liner

1/2-inch (13mm) oval rake filbert comb

no. 5/0 liner

Other Materials:

masking fluid

Blending & Glazing Medium

kneaded eraser

stylus

palette knife

pattern (see page 104)

Surface:

11" × 14" (28cm × 36cm) portrait-grade canvas

Winsor & Newton Artists' Oil Colors:

| Alizarin Crimson | Burnt Sienna | Burnt Umber | Cadmium Red | Cadmium Yellow | Cadmium Yellow Pale | Cerulean Blue |

| Ivory Black | Naples Yellow | Raw Sienna | French Ultramarine | **Winsor & Newton Alkyd:** | **Professional Permalba Oil Color:** |

| Yellow Ochre | White Mix | Shadow Mix | | Titanium White | Brilliant Yellow Light |

White Mix: Titanium White + a dot of Cadmium Yellow

Shadow Mix: Alizarin Crimson + Ivory Black

PATTERN

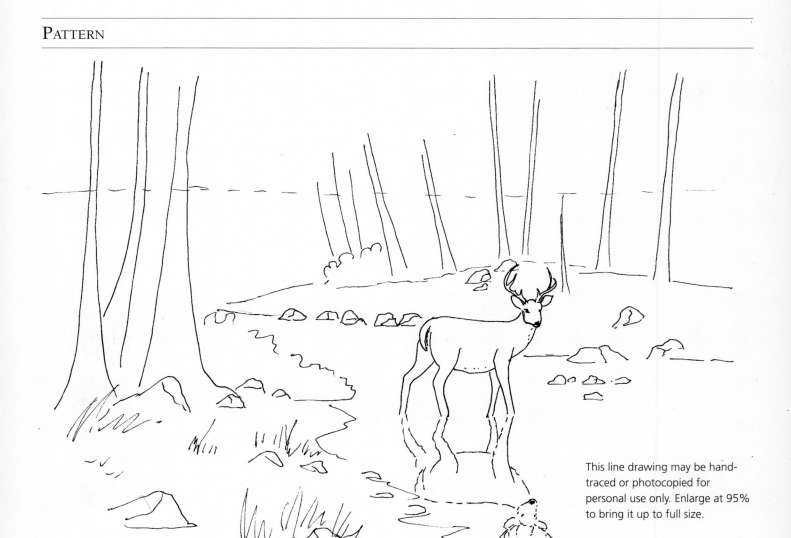

This line drawing may be hand-traced or photocopied for personal use only. Enlarge at 95% to bring it up to full size.

Step 1: Sky Brush masking fluid on the deer and the deer's reflection with an old brush. Use a no. 12 bristle flat to base the sky with White Mix + Cadmium Yellow. You can pick up a bit more White Mix here and there to vary the color a bit. Then pick up Cadmium Yellow + a touch of Cadmium Red and tint the sky on the left.

Step 2: Background Field Use a no. 10 bristle flat and French Ultramarine + a dot of Ivory Black + Cadmium Yellow + White Mix to paint the background field with short, downward strokes.

Add Cerulean Blue to the mix for a blue-green tone across the top, giving a light, hazy look near the sky. Deepen the color as you paint forward toward the creek and feather the bottom and right edges.

3

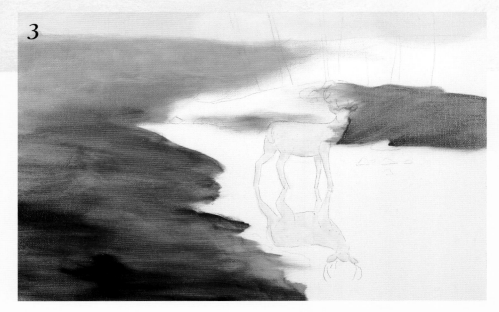

Step 3: Background Field Use a no. 16 sable bright to base the banks with Burnt Sienna + Burnt Umber. You may want to use Blending and Glazing Medium to make the paint wash in smoothly. Paint right into the deer and field, and feather off the edges.

As you paint into the foreground, darken the ground colors, using Burnt Sienna + Shadow Mix. Go right over the rock area.

Step 4: Background Trees Base the background trees on the right and left with a corner-loaded no. 16 sable bright and Cerulean Blue + Burnt Sienna + Ivory Black. (Use plenty of Cerulean Blue.)

Since you are going over the wet sky color, the colors for the trees will lighten and become a soft blue-gray. Much of this background will be covered when the dark foliage is painted—this step simply establishes soft shadow leaves.

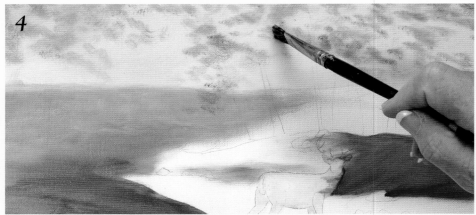

4

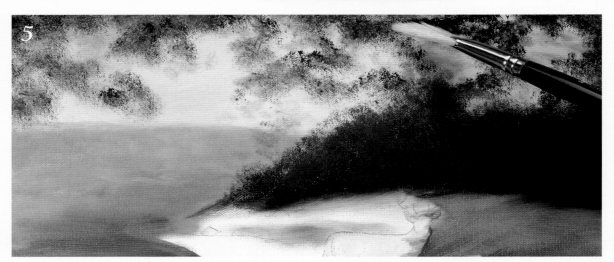

5

Step 5: Background Field Use the corner of a no. 6 fan blender to paint the background foliage with French Ultramarine + a little Cadmium Yellow and a touch of Ivory Black. You may want to add a touch of Blending and Glazing Medium.

Avoid completely covering the sky or earlier foliage. Darken the color as you approach the right bank with French Ultramarine and more Ivory Black.

Feather the bottom of the area with a no. 16 sable bright.

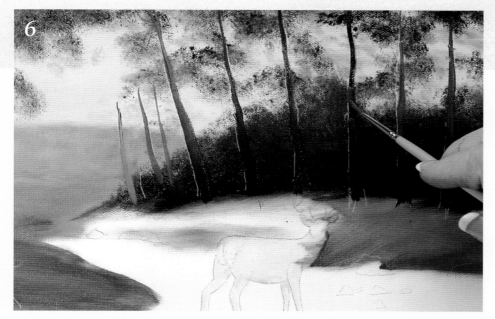

Step 6: Tree Trunks Etch the pattern lines of the trunks and the larger rocks on the shore into the wet paint (see page 15). Paint the tree trunks in the light area with thinned Shadow Mix + a dirty white from your palette + a touch of Burnt Umber on a no. 2 liner.

Starting at the top of the tree, pull down and press on the liner to widen the trunk. The trunks become lighter as you move toward the light spot in the center of the painting.

Step 7: Background Foliage Corner load a no. 6 bristle fan blender with French Ultramarine + Ivory Black + Cadmium Yellow, and tap on more darks to the right background foliage. Add more Cadmium Yellow to the mix for middle values in this same area. Paint the foliage clumps in an umbrella shape, and be sure you go over the trunks.

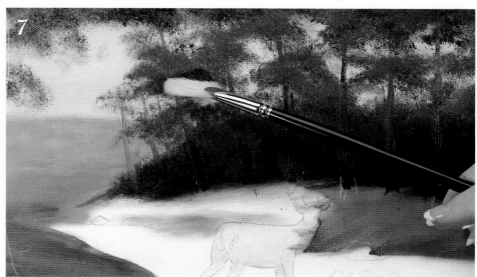

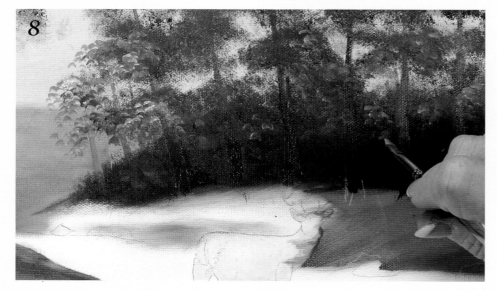

Step 8: Background Trees With a no. 4 filbert, pick up some of the green from step 7 + Cadmium Yellow Pale and add highlights to the two or three trees just to the right of the sunny spot. Add some White Mix for the brightest highlights on the left of the clumps. Load the brush with plenty of paint and dot the color straight in with the tip.

Add Cerulean Blue + a touch of White Mix to this foliage mix and place some cool-value touches to the leaves of the trees in the darker area on the right side of the painting.

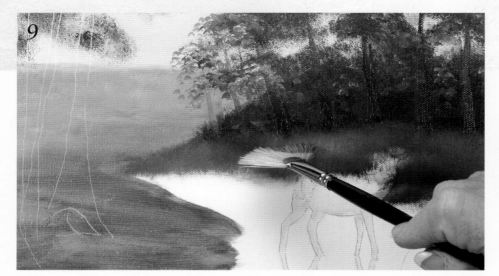

Step 9: Grass Using a no. 6 fan blender, pick up French Ultramarine + Cadmium Yellow + a touch of Ivory Black and paint the darkest areas of the grass in short, downward strokes. Vary the green. In the sunlit area, add Cadmium Yellow Pale. Pull foliage color into the grass for shading.

Step 10: Grass Mix the dirty brush from step 9 with a touch of White Mix. Highlight the grass by touching the canvas with a few brush hairs. The brightest highlights can be added at the very end of the painting.

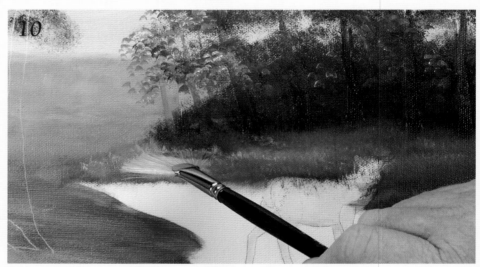

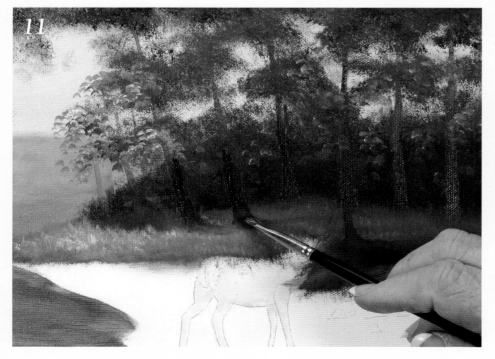

Step 11: More Trees Using the same brush and color mix you used for the trunks in step 6, bring the three front tree trunks into the ground and add a trunk in the middle of the grass. With a no. 4 sable bright, extend the trunk color at the bottom of these same trees to the right and into the grass.

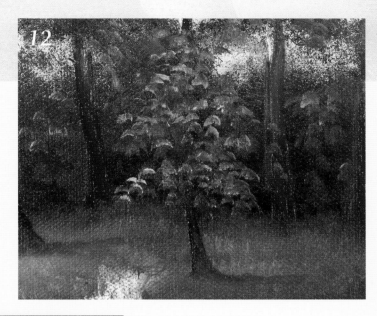

Step 12: More Trees Paint the foliage of the newly added tree with a no. 4 filbert and French Ultramarine + Cadmium Yellow + a touch of Ivory Black. If this is too dark, add a bit of Cadmium Yellow Pale. Highlight the left side with Cadmium Yellow Pale in the dirty brush. Highlight the right with Cerulean Blue on the dirty brush.

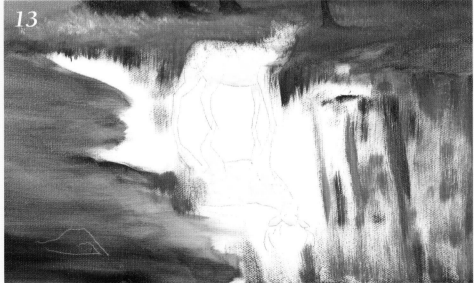

Step 13: Water Using a no. 4 bristle flat, pull straight down under the banks on the right with French Ultramarine + a dark color (Burnt Umber, Shadow Mix, Ivory Black), varying the mix. Do the same pulling up from the canvas bottom. Continue, adding tree greens. Include some trunk reflections with Shadow Mix + White Mix.

Step 14: Water Clean the brush and fill in the rest of the water with a dirty white from the palette. Pull straight down, always starting in a clean area and blend into the painted areas. When the color gets too muddy, wipe off the brush and reload.

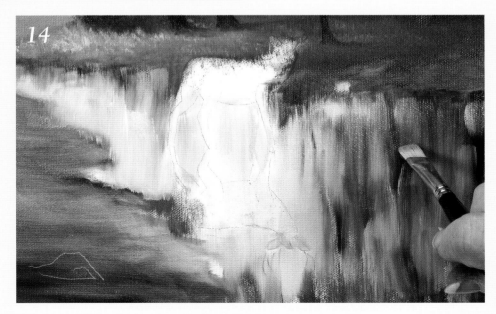

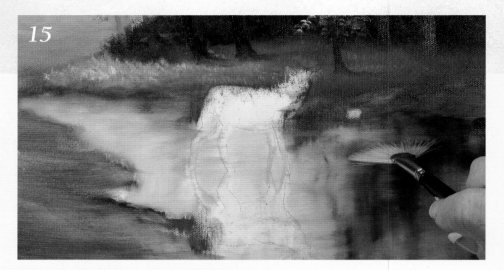

Step 15: Water Blend horizontally back and forth with a no. 6 fan blender to form ripples. Avoid over blending. Let the water tack up so the highlights can be applied later.

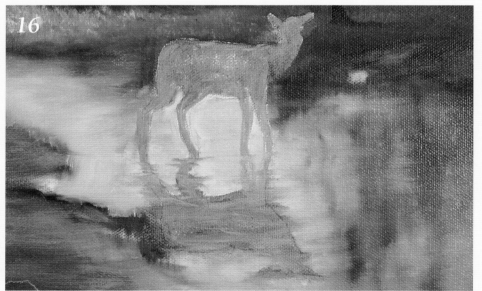

Step 16: Deer Remove the masking medium with a kneaded eraser (you may have to touch up the water afterwards). Base the deer and its reflection in Raw Sienna using a no. 4 sable bright. Pull the brush in the direction of the hair. Be sure to keep the edges of the deer's reflection hazy, and distort the reflection with horizontal strokes.

Step 17: Deer With the no. 4 sable bright, shade the deer and its reflection with Burnt Umber and perhaps a touch of Ivory Black in the darker areas and dirty White Mix in the lighter body areas. Make the reflection colors lighter than the deer. Paint the tail Ivory Black with French Ultramarine + White Mix highlighting.

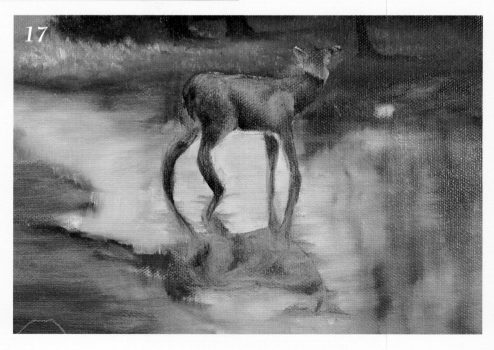

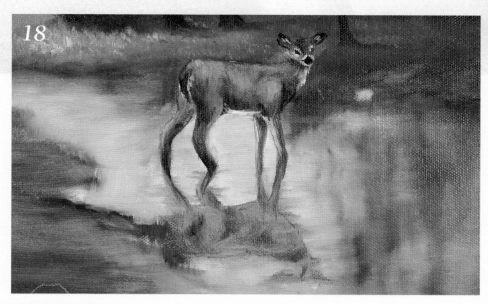

Step 18: Deer Still using the no. 4 sable bright, add Yellow Ochre highlights. Build the highlights with Naples Yellow. Then highlight with Brilliant Yellow Light across the back and a touch on the hind legs.

Switch to a no. 2 liner and paint the nose, eyes and rims of the ears Ivory Black. Add Titanium White details on the stomach, chest, legs and around the eyes and nose and on the tail edges.

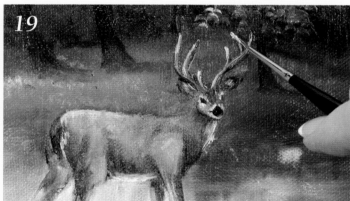

Step 19: Deer Etch in the antler pattern lines (see page 15). Base the antlers with slightly thinned Naples Yellow and a no. 5/0 liner. Shade with Burnt Sienna and Burnt Umber. Highlight with Brilliant Yellow Light and then White Mix.

If the antlers get too thick, you can thin them by applying grass color on the edges.

Step 20: Trees Use a no. 8 sable bright to base the trunks on the near shore with Burnt Umber + Shadow Mix, keeping the trunks darker on the left. Add some dark background foliage with French Ultramarine + Ivory Black on a no. 8 fan blender.

With the dirty brush, add grass with French Ultramarine + Ivory Black + Cadmium Yellow. Brush into the water. With the same color, tap in foliage between the trunks with a no. 4 sable bright.

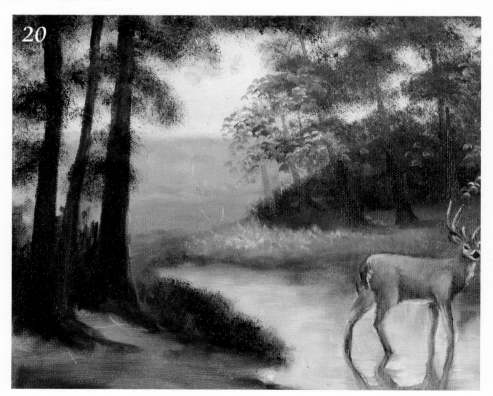

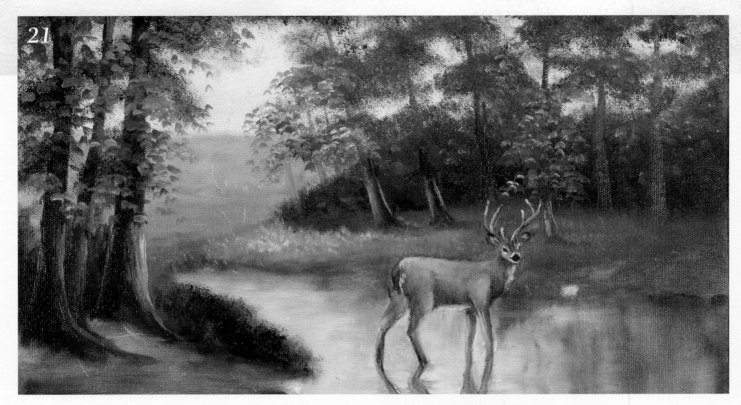

Step 21: Trees on the Left All foliage highlights are applied with a no. 4 filbert and a blue-green of Cerulean Blue + French Ultramarine + Brilliant Yellow Light. You may need an occasional touch of White Mix.

Switching to a no. 2 liner, highlight the trunks on the near bank with Cadmium Yellow + Cadmium Red + White Mix. The tree trunks on the far bank near the light are highlighted with the same colors and then highlighted again with Cadmium Yellow + White Mix.

The trees on the far right have little to no highlighting. All the highlighted trees have some blue reflected light (French Ultramarine + White Mix) on the trunks, opposite the highlighted side.

Step 22: Near Bank Lay a paper towel over the deer and water. Using a no. 8 fan blender and a palette knife, spatter (see page 18) the ground with thinned Burnt Sienna, Burnt Umber, Shadow Mix, and Naples Yellow + White Mix.

Step 23: Near Bank Barely touching the surface, brush over the spatters with a no. 8 fan blender.

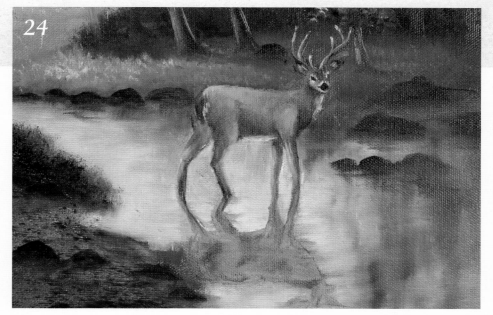

Step 24: Rocks and Bank Use a no. 8 sable bright to base the rocks on the banks, in the water and on the lawn with Shadow Mix, Ivory Black and Burnt Umber, using different combinations. For rocks in the water, brush down from the base into the water to form reflections. Then use light, horizontal brush strokes to distort a bit. For rocks on the ground, blur the bases into the ground.

Step 25: Rocks and Bank Add a middle value on the highlight area of all the rocks with a no. 8 sable bright and White Mix + Cadmium Yellow + Cadmium Red. Then go back and highlight with Naples Yellow and Yellow Ochre.

As you come further to the foreground, make the color richer. Some of the spatters can be highlighted with Naples Yellow to give the appearance of gravel or small rocks. Then add brightest highlights with Brilliant Yellow Light.

Add a bit of reflected light on the rocks with French Ultramarine + White Mix and Shadow Mix + White Mix.

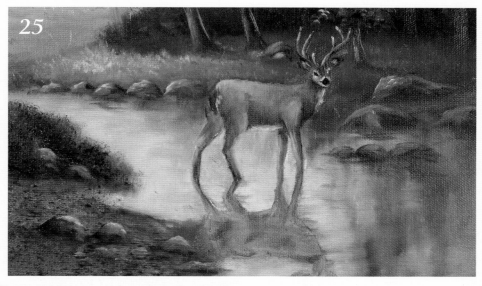

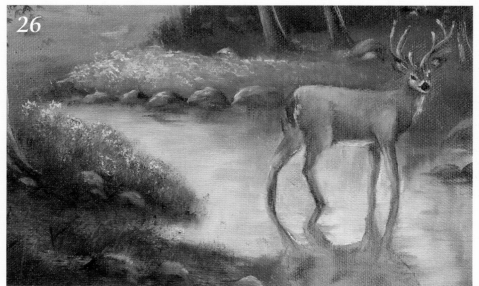

Step 26: Grass on Shore Paint the scrubby grass on the near shore with a no. 8 fan blender and French Ultramarine + Ivory Black + a touch of Cadmium Yellow. Vary the color proportions. Add a little around the rocks on the far shore.

Pull up a few blades with a no. 2 liner, using any greens or blue-greens from the palette, thinned to an inky consistency.

Stipple (see page 18) on highlights using a no. 10 angular bristle and Cadmium Yellow Pale + Brilliant Yellow Light + White Mix.

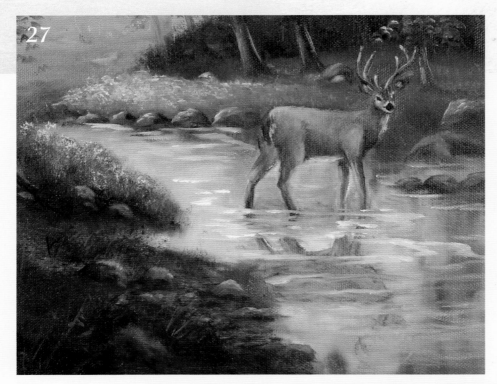

Step 27: Deer Shadow Paint the shadow of the deer in the water with a no. 8 sable bright and Shadow Mix + any dark green on the palette. Then add White Mix water lines.

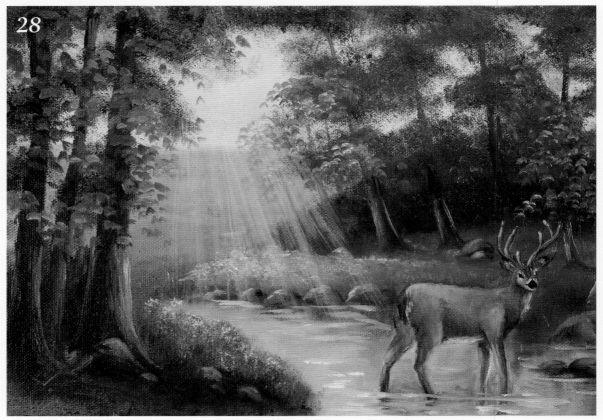

Step 28: Light Rays The light rays are added when the canvas is dry. Using a 1/2-inch (13mm) oval rake, press the bristles into Brilliant Yellow Light thinned with Blending and Glazing Medium. Actually make the bristles splay on the palette. Lightly stroke sunbeams downward. Then run the dirty brush through thinned White Mix and stroke again. If the color is too intense, mop lightly with a no. 8 fan blender, but don't lose the streaks.

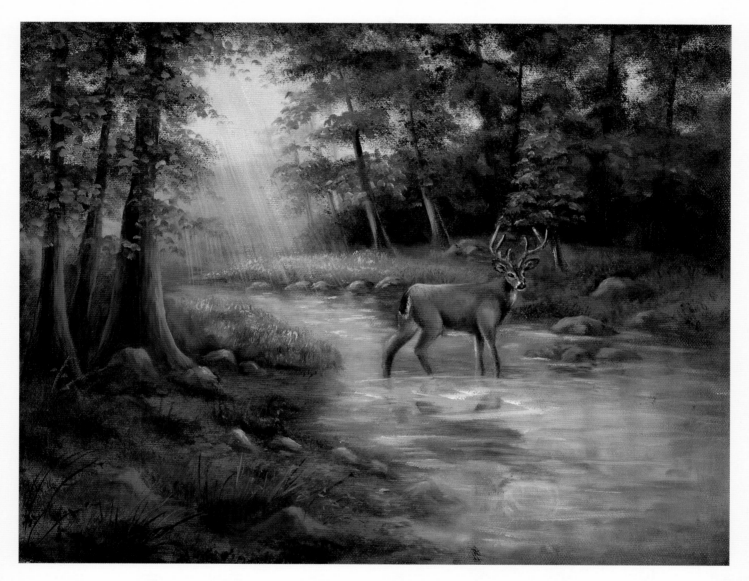

COOLING OFF

Finishing Touches: Reinforce highlights and add other finishing touches as needed. Check your values with the red acetate. I recommend you continue to add highlights and shadows to the deer. Sometimes you may thin the paint to make the light rays so much that the rays become very weak. You may need to strengthen them if they dry too pale.

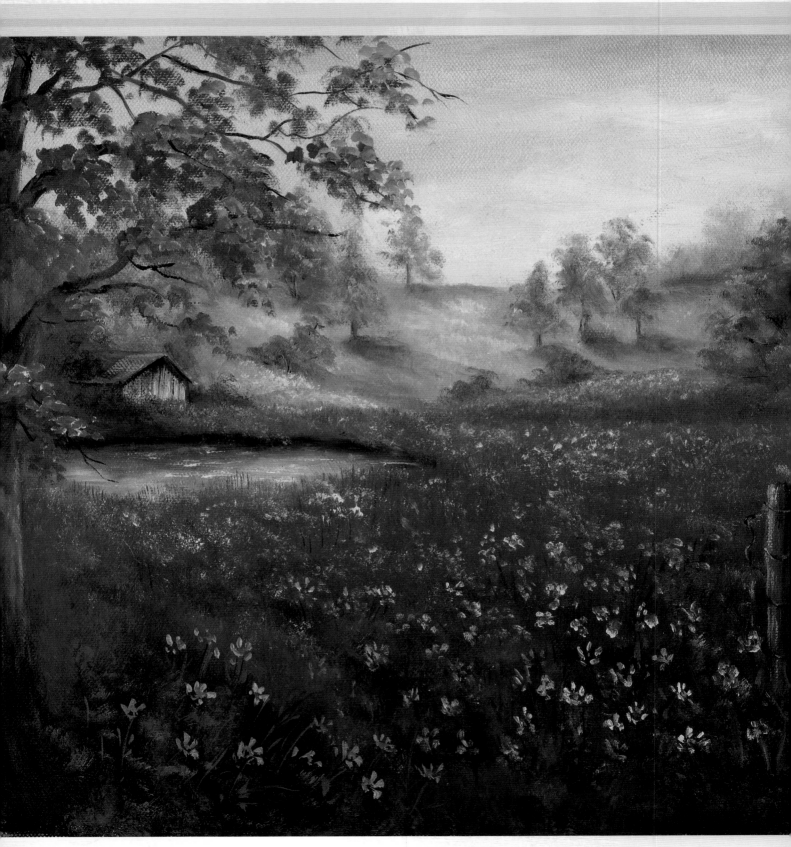

The Daisy Field

This was a true photo day on a little stretch of country road. I must have taken at least six views of this small scene. Painting the light fields with the shadows can be challenging for me as I paint with lots of color and tend to use deeper jewel tones. As you create your own paintings, you also will begin to establish a standard palette of colors that you find easy to work with and understand.

You could change the daisies in this field to any other wildflower. Try painting this scene without the large tree and add more fence in the foreground. The field with the daisies and water could be painted with lighter values near the top of the rise. Experiment. Should you not like what you paint, sand the canvas and try again. Be creative — it's a good thing.

Brushes:

nos. 8 and 10 Supreme bristle flats

nos. 6, 8 and 16 Royal Sable brights

no. 10 angular bristle

nos. 2 and 4 Aqualon filberts
no. 8 Royal Sable fan blender
no. 5/0 Aqualon liner
no. 2 Golden Taklon liner

Other Materials:

Blending and Glazing Medium

pattern (see page 118)

Surface:

11" × 14" (28cm × 36cm) portrait-grade canvas

Winsor & Newton Artists' Oil Colors:

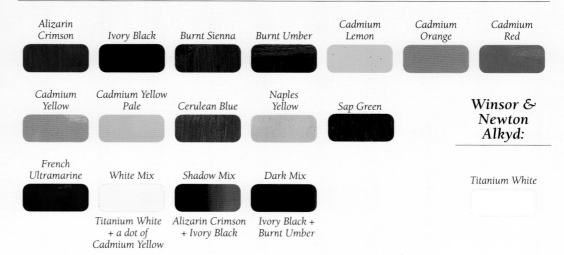

| Alizarin Crimson | Ivory Black | Burnt Sienna | Burnt Umber | Cadmium Lemon | Cadmium Orange | Cadmium Red |

| Cadmium Yellow | Cadmium Yellow Pale | Cerulean Blue | Naples Yellow | Sap Green | **Winsor & Newton Alkyd:** |

| French Ultramarine | White Mix | Shadow Mix | Dark Mix | | Titanium White |

White Mix: Titanium White + a dot of Cadmium Yellow

Shadow Mix: Alizarin Crimson + Ivory Black

Dark Mix: Ivory Black + Burnt Umber

REFERENCE PHOTOS

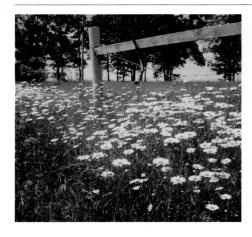

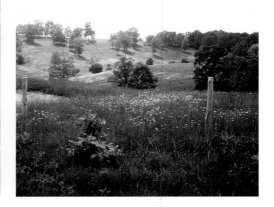

PATTERN

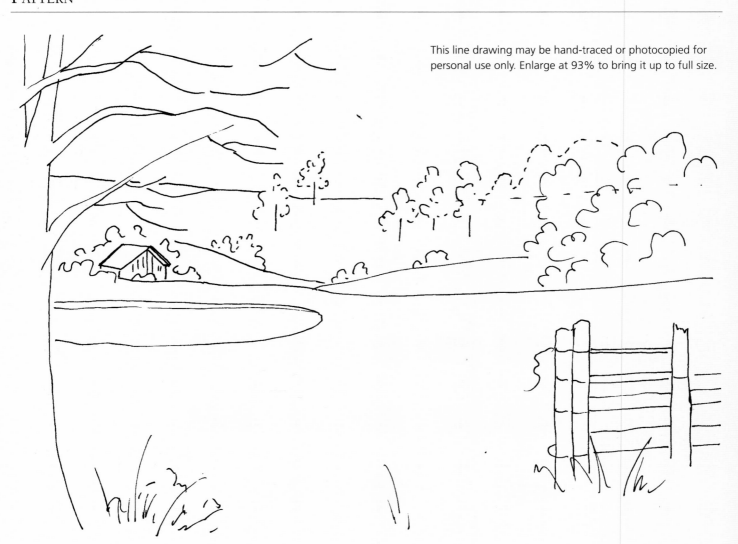

This line drawing may be hand-traced or photocopied for personal use only. Enlarge at 93% to bring it up to full size.

Step 1: Sky and Distant Trees Paint the sky with a no. 10 bristle flat and Cerulean Blue + White Mix in varying proportions. Use horizontal strokes. Add Shadow Mix to the sky-blue mix and apply at the top of the canvas and the right corner.

Using the same brush and the sky colors + White Mix + Sap Green, paint the distant trees. Deepen as you move downward with Sap Green + Cerulean Blue + a dot of Shadow Mix.

Step 2: Field Next to Trees Using a no. 16 sable bright and White Mix + Cerulean Blue + Sap Green + Cadmium Lemon, stroke in the back field. Vary the color proportions, keeping the center lightest and shading darker at the base of the hill.

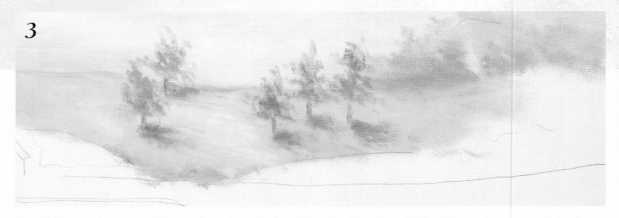

3

Step 3: Trees Using a no. 5/0 liner and very light Shadow Mix + Cerulean Blue + White Mix, paint the trunks in the far field. Switching to a no. 8 sable bright and Cerulean Blue + Sap Green + Shadow Mix, tap in loose tree foliage, varying the color proportions. The wet paint helps to keep the values from getting too dark. Be sure you vary the heights and widths of the trees. With darker foliage colors, tap in tree shadows, making them darker closer to the trunks. Also, shadows at the top of the hill are darker than shadows toward the bottom. Blend a bit if necessary.

Going back to the no. 16 sable bright, tap in grass highlights in the bright, center area with White Mix + Cadmium Yellow.

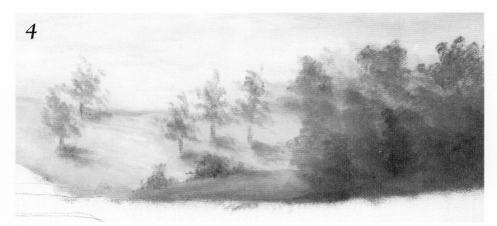

4

Step 4: Small Field and Trees The next small field needs to be a little darker. Use a no. 16 sable bright and White Mix + French Ultramarine + Sap Green + a bit of Shadow Mix. For trees and bushes in that row, use the same brush, corner-loaded with French Ultramarine + Sap Green + White Mix in varying proportion. Shadow Mix + a dot of Cadmium Red helps gray the greens. Tap on the color and make this foliage darker at the base.

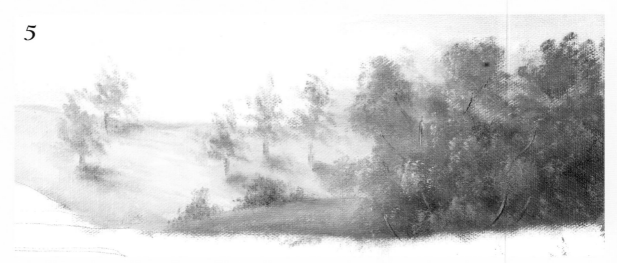

5

Step 5: Trees Tap highlighting on the trees with a no. 10 angular bristle and French Ultramarine + Cadmium Lemon. Pick up more Cadmium Lemon + a touch of White Mix for the final highlights. On the shadow side of the trees, tap in French Ultramarine + White Mix. Thread in a few branches with a no. 5/0 liner and Shadow Mix. Highlight with Cadmium Orange + White Mix. If the branches are too prominent, tap over them with a bit of foliage.

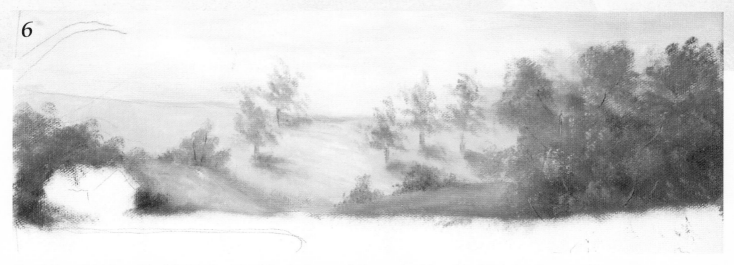

Step 6: Trees Paint the patch of field to the right of the shed as you did in step 4, adding a bit of Cadmium Orange. Add the little tree on the hilltop in that area as you did those in steps 3 and 5, adding a bit of Cadmium Orange and Naples Yellow in the foliage. Also paint the foliage around the building, but don't highlight it.

Step 7: Shed Base the shed with a no. 6 sable bright and a thin layer of White Mix. Shade with Shadow Mix + French Ultramarine on the left and beneath the overhang of the roof. Add Ivory Black directly below the overhang and a few lines pulled down with the brush chisel to show the texture of the boards on the shed front. Highlight with White Mix + Cadmium Yellow Pale and Cadmium Orange.

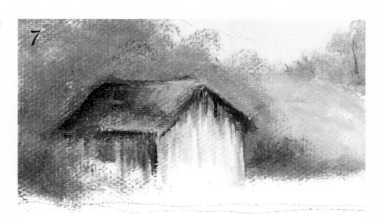

Base the roof with Burnt Sienna. Shade with Burnt Umber and highlight with Cadmium Orange + White Mix. Add a second highlight on the roof peak with Naples Yellow.

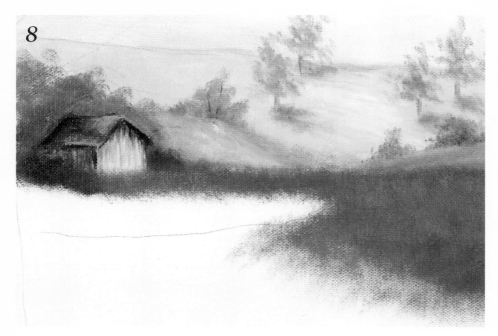

Step 8: Grass in Foreground and Pond
You may wish to mask the fence posts. Load a no. 8 fan blender with Sap Green and then add in French Ultramarine + Cadmium Yellow + White Mix and a touch of Cadmium Red. Tap in the grass. Pick up Burnt Sienna at times, varying the values of the greens and darkening them around the shed and as you move into the foreground. Paint the pond (see step 9) before finishing the grass.

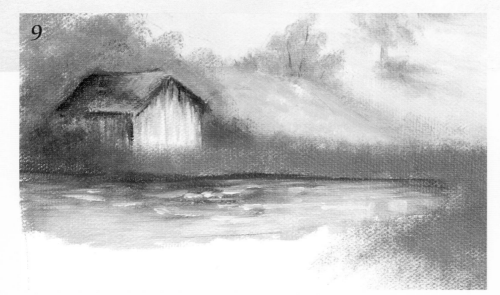

Step 9: Pond Using a no. 8 sable bright, paint inside the pond's far bank with Dark Mix + French Ultramarine + Shadow Mix + Burnt Sienna. Then pull that color down into the pond. Fill the pond with vertical strokes, using thin White Mix + French Ultramarine and White Mix + Cerulean Blue. Blend horizontally.

Add White Mix water lines with the brush chisel.

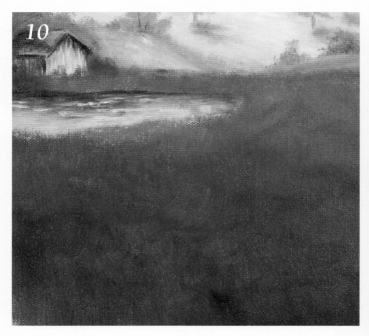

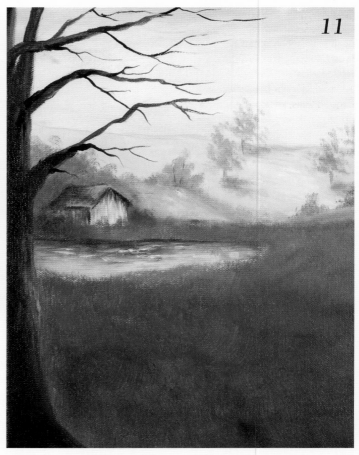

Step 10: Grass Finish the grass using the same brush and colors used in step 8. Remember to get darker and richer as you move into the foreground. Blend the brush strokes into one another.

Step 11: Foreground Trees Base the tree trunk with a no. 8 bristle flat and Dark Mix + Burnt Umber. Shade the left side and the base of the tree with Shadow Mix. Highlight the right side with Cadmium Orange + White Mix. Paint the limbs with the same colors, using the chisel edge of a no. 6 sable bright.

For finest branches, use a no. 2 liner. Before adding foliage, let the paint tack up while you paint the daisies.

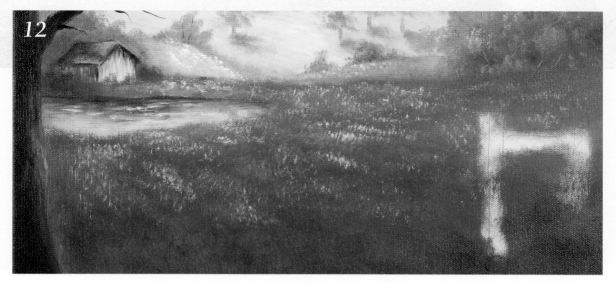

Step 12: Daisies

Paint most of the daisies with a no. 8 fan blender and White Mix. Use heavy paint on the brush corner. Barely touch and tug down quickly for those farthest back. Touch with more pressure as you move forward.

Step 13: Daisies

In the left corner by the tree base and under the fence post, use the fan to flick in some vague dark foliage with Shadow Mix + White Mix. For the larger daisies, switch to a no. 2 filbert and just stroke in the petals. For those under the tree, add a touch of French Ultramarine to the White Mix. Touch in a few daisy centers with Cadmium Yellow on the tip of the no. 2 filbert.

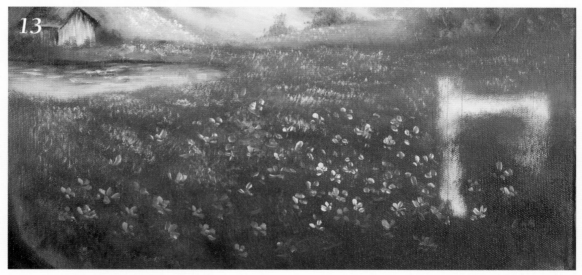

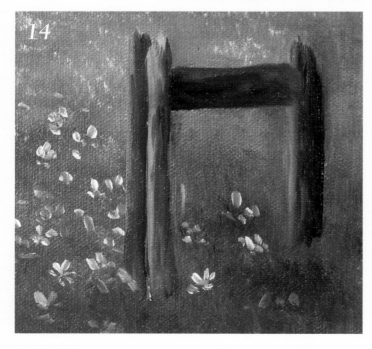

Step 14: Fence

To paint the fence post, double load a no. 8 bristle flat with Dark Mix + a bit of Blending and Glazing Medium and the Cadmium Orange + White Mix already on your palette. With the Cadmium Orange + White Mix on the left side of the brush, pull down on the post. The double load allows you to highlight and base the fence at the same time. For the two posts on the left, paint the far left one first, which will give you better delineation between the two posts. Add darks and lights as needed for a textured effect. Highlight with the Cadmium Orange + White Mix.

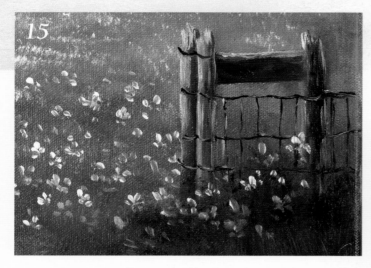

Step 15: Fence Using the no. 8 fan blender and French Ultramarine + Sap Green + Shadow Mix, darken the grass at the base of the fence posts. Paint the wire with a no. 5/0 liner and Ivory Black and highlight it with French Ultramarine + White Mix.

With the same color, chop in some reflected light on the backs of the posts. Apply the fence's final highlights with Naples Yellow, chopping it on roughly for a textured look. Add daisies over the posts and wire.

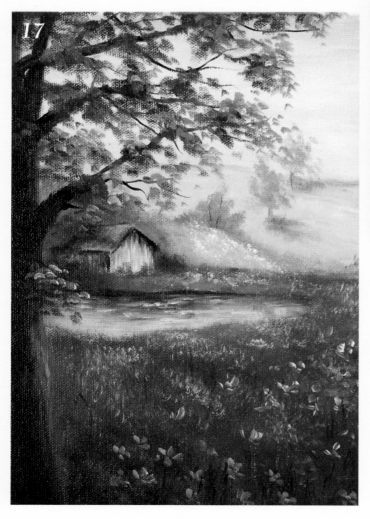

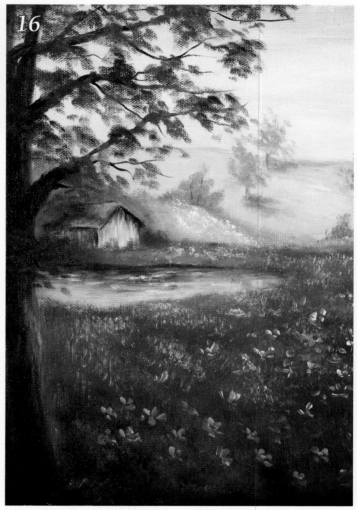

Step 16: Foreground Tree Apply the shadow foliage on the foreground tree with the bottom corner of a no. 8 sable bright and Shadow Mix + White. Add mid-values with French Ultramarine + Sap Green + a bit of Cadmium Yellow. Don't cover all the shadow leaves.

Step 17: Foreground Tree Begin highlights with a no. 4 filbert and the mid-value foliage color + more Cadmium Yellow. Pick up Cadmium Yellow Pale in the dirty brush for brighter highlights. Add a touch of White Mix to the mix for a few brightest highlights. Use a no. 5/0 liner and thinned French Ultramarine + Sap Green to add a few hit-and-miss tall grasses and stems. As you come to the foreground, add a bit of Shadow Mix. Let dry.

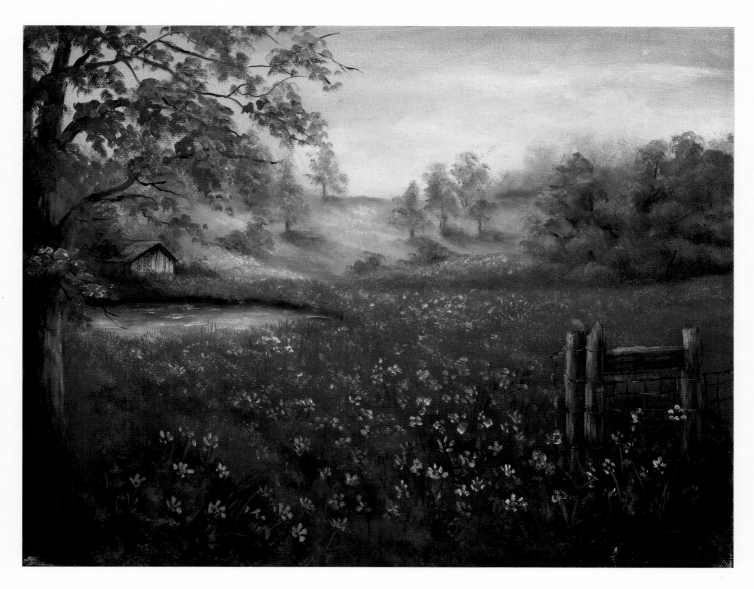

THE DAISY FIELD

Finishing Touches: Glaze as explained on page 21. Use Cadmium Orange + Burnt Sienna along top of the first hill. Use French Ultramarine + Ivory Black behind the first hill and for shadows in foreground. You can add more glazes to build shadows as you feel necessary.

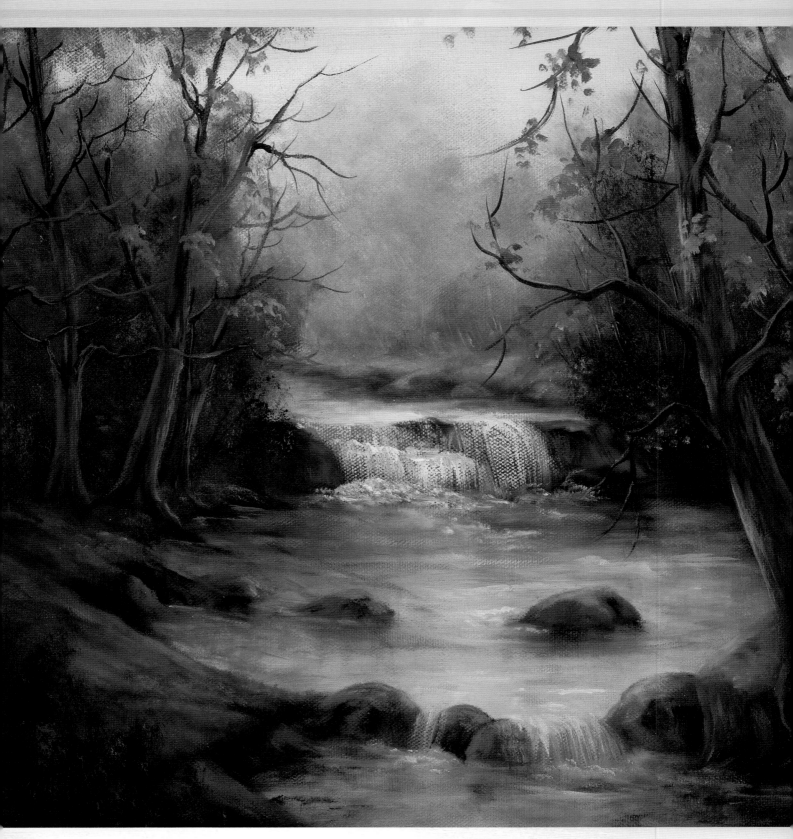

The Basin

This lovely, tranquil scene was photographed when we were vacationing in Maine. It was early fall, and we had anticipated all the gorgeous fall colors. Not! We were several weeks too early. When I decided to paint this scene, I changed the colors to the wonderful rich colors I had hoped to see. Don't be afraid to change the season of your photos — remember, you are telling a story and setting a mood with your painting. The scene was loosely sketched onto the canvas with a liner brush and Burnt Sienna thinned with oil brush cleaner. The details will happen as you paint. As you paint this scene, concentrate on the rushing water and the two large trees on the left side. The undercoat of black acrylic allows the artist to complete the waterfall without waiting for the canvas to tack or dry. I like to basecoat some of my paintings with acrylic and then detail, shade and highlight with oils — it's the best of two worlds.

Brushes:

3/4-inch (19mm) Aqualon wash

nos. 4 and 12 Supreme bristle flat

nos. 4, 6, and 16 Royal Sable bright

no. 10 angular bristle

no. 8 Royal Sable fan blender

nos. 5/0, 2, 4 and 6 Aqualon liner

no. 6 Aqualon filbert

no. 6 Royal Sable round

Other Materials:

stylus

pattern (see page 128)

Surface:

12" × 16" (30cm × 41cm) portrait-grade canvas

Winsor & Newton Artist's Oil Colors

| Alizarin Crimson | Burnt Sienna | Burnt Umber | Cadmium Orange | Cadmium Red | Cadmium Yellow | Ivory Black |

| Lemon Yellow Hue | Naples Yellow | Raw Sienna | French Ultramarine | **Winsor & Newton Alkyd:** | **DecoArt Americana Acrylic:** |

| | | | | Titanium White | Lamp Black |

| Yellow Ochre | White Mix | Shadow Mix | Dark Mix |

| | Titanium White + a dot of Cadmium Yellow | Alizarin Crimson + Ivory Black | Ivory Black + Burnt Umber |

REFERENCE PHOTOS

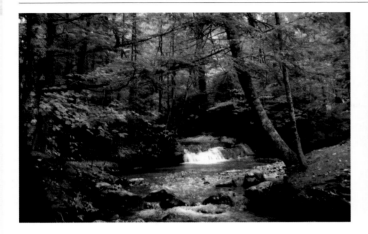 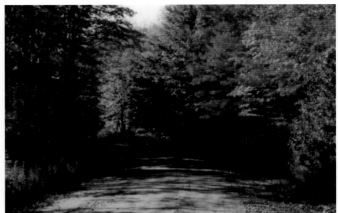

PATTERN

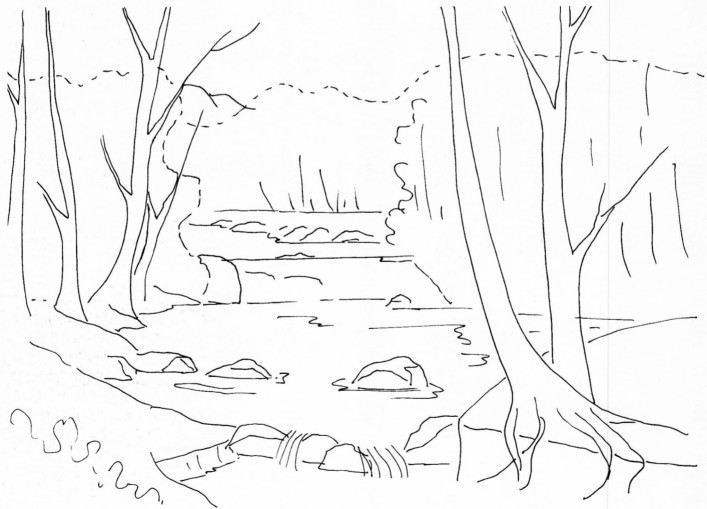

This line drawing may be hand-traced or photocopied for personal use only.
Enlarge at 100% to bring it up to full size.

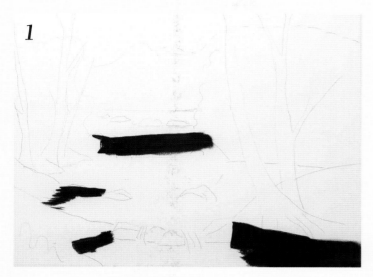

1

2

Step 1: Undercoat With the 3/4-inch (19mm) wash, undercoat the fall area and the bottom of the bank on the right with Lamp Black acrylic. You can use oil paint instead, but you must let the paint dry before continuing. Acrylic paint dries faster.

Step 2: Sky Begin to lay in the sky with a no. 12 bristle flat and White Mix + Cadmium Orange + Lemon Yellow Hue. Keep the sky very light and paint down to the horizon line and deeply into the large tree area. Add White Mix + French Ultramarine to the top and edges, keeping this a very soft color.

3

Step 3: Background Trees Still using the no. 12 bristle flat, load with Shadow Mix and tap over the wet sky in the middle of the painting. Then tap in very light French Ultramarine. Tap in a tiny bit of Dark Mix by the horizon line. Keep this very light and mute with a no. 8 fan blender if necessary.

4

Step 4: Background Trees With the no. 12 bristle flat, tap in some autumn highlight colors. With White Mix in the brush, pick up some Cadmium Orange, Cadmium Orange + Cadmium Red, Yellow Ochre, Yellow Ochre + Lemon Yellow Hue, and even French Ultramarine. If the colors get bright and heavy, lightly mop with a no. 8 fan blender.

5

Step 5: Background Trees Take some White Mix on your no. 5/0 liner and add a few tree trunks.

6

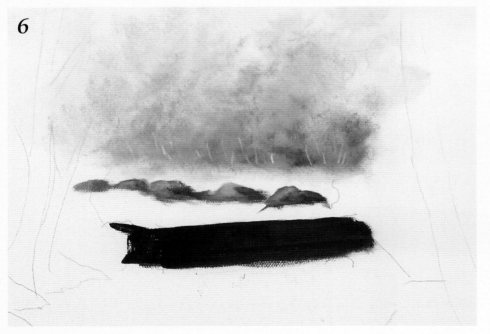

Step 6: Rocks Paint the distant rocks with a no. 6 sable bright and Dark Mix + White Mix. Scuff in the paint lightly. Clean the brush, and add in highlighting colors to give the rocks shape. You can use Burnt Umber, Naples Yellow and Cadmium Orange + White Mix. Keep the rocks a bit blurred — no sharp edges.

7

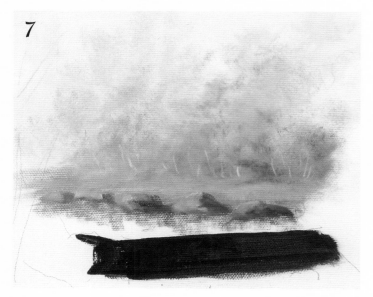

8

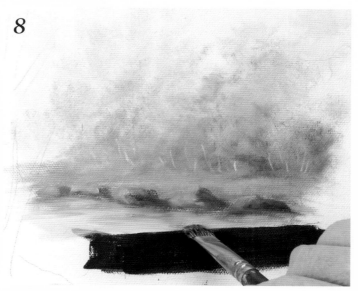

Step 7: Grass Using a no. 16 sable bright, add grass above the bank with Yellow Ochre. Add to the dirty brush a tiny bit of French Ultramarine. You can add a bit of Cadmium Yellow if the color is too dull. Pull some tree color into the grass for shadows. Highlight with Lemon Yellow Hue + White Mix.

Reinstate the rock highlights if necessary. Pull down rock color into the water for reflections. You may want to add in a bit of the grass greens and some French Ultramarine.

Step 8: Water Above the Falls With the same brush and thin White Mix, lay in the water above the falls vertically and then stroke across horizontally to distort the water a bit.

9

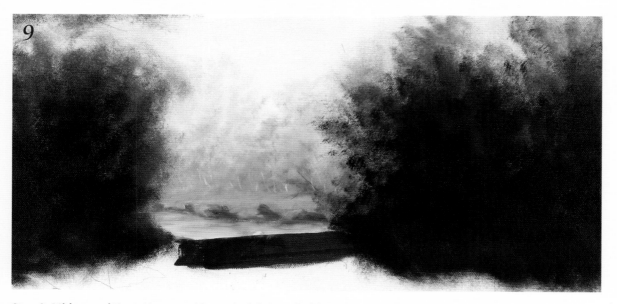

Step 9: Midground Trees Use a no. 10 angular bristle and add Titanium White to Dark Mix to create a purple-gray color. Begin tapping in the foliage on either side of the bright area. Begin slightly below the area of the sky colors.

Mop with the no. 8 fan blender to set the background into the sky. Use more paint and darken with Dark Mix as the foliage moves farther from the bright center of the painting. The left side has the darkest darks. You can add a bit of Ivory Black to the Dark Mix for this far area.

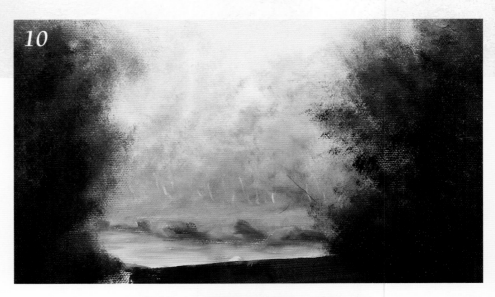

Step 10: Midground Trees Highlight the dark foliage with a no. 10 angular bristle. Pick up a bit of Yellow Ochre + Cadmium Yellow. Touch in lightly, keeping the colors muted. With the dirty brush, pick up French Ultramarine. Continue to pick up colors such as Burnt Sienna, Alizarin Crimson, Cadmium Orange, Burnt Umber, Raw Sienna and Cadmium Red. Do not use White Mix. Remember to keep the colors muted, and highlight more on the right than the left.

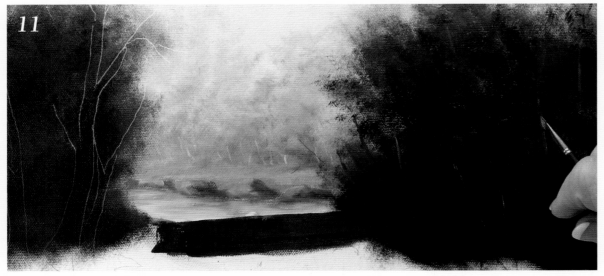

Step 11: Midground Trees Etch in the pattern lines of the left tree trunks (see page 15). Then brush mix some Cadmium Orange + White Mix on the palette to create a highlight color. Double load a no. 6 sable bright with Dark Mix and the highlight color. Stroke in the muted trunks on the right with the lighter colors toward the center of the painting. The bottoms of the trunks should disappear into the foliage.

Step 12: Midground Water Using a no. 8 bristle flat with Shadow Mix + French Ultramarine, stroke in the water shadows. Use color from the banks to create shadows for the rocks. Sometimes use Dark Mix + French Ultramarine. Do not paint the closest pool of water yet.

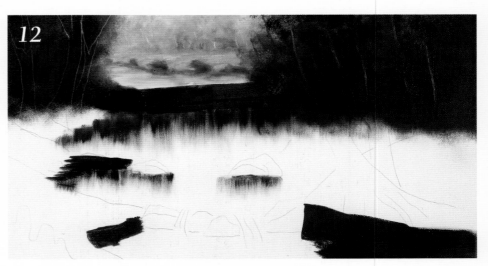

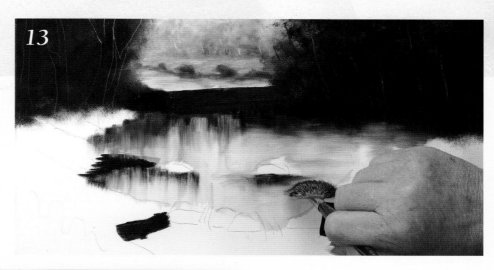

Step 13: Midground Water Clean your brush and fill in the water with thinned White Mix + French Ultramarine or White Mix + any green from your palette. Stroke vertically, and go down to the lower falls. Then distort lightly with a no. 8 fan blender, stroking horizontally, as you see on the right of the photo. The water on the left has not been distorted yet.

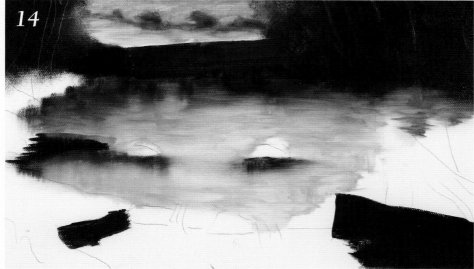

Step 14: Midground Water Using a no. 6 sable bright, lay in touches of foliage color in the water. Start with the greens and move on to the blues. You can continue with any colors used in the trees, but keep them very muted. The brightest colors are over the lower waterfall. Darkest colors are under the upper falls and under the left trees. Remember to stroke in vertically and then distort horizontally.

Step 15: Mid- and Foreground Banks
Base all the foreground banks with Burnt Sienna on a no. 16 sable bright. Pick up Burnt Umber and Dark Mix and work the colors together. Use thin paint.

Be sure to pull some of the foliage colors into the banks to blend the areas. Work the colors in the direction of the lay of the land. The right bank is lighter and has more highlighting than the left.

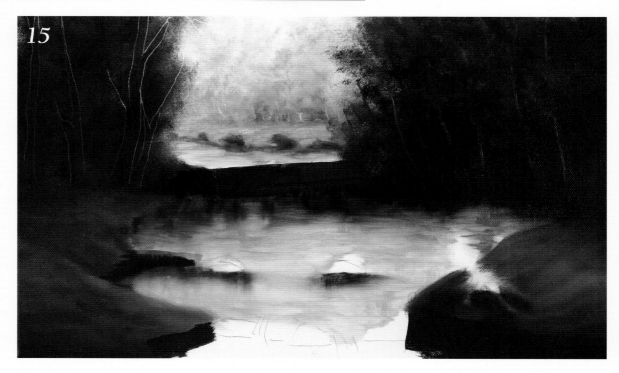

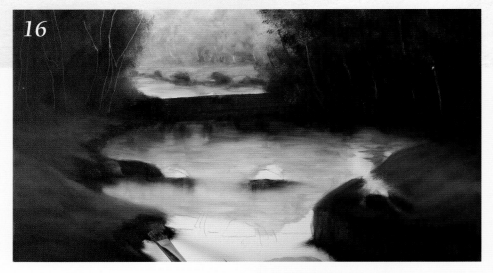

Step 16: Mid- and Foreground Banks Paint the left bank edges with a no. 16 sable bright and Dark Mix, French Ultramarine and Shadow Mix, varying colors and mixes. Blend the tops of the banks into the edges and vary the height of the edges. Stroke in the direction of the lay of the ground. Also lay in a very thin coat of Shadow Mix on the right bank edge. Highlight all the bank edges with French Ultramarine + White Mix, keeping the right bank darker.

Step 17: Remaining Tree Trunks If you wish, you can etch in the pattern lines of the midground and foreground tree trunks again. Use a no. 4 bristle flat and Burnt Umber + Ivory Black + a tiny bit of White Mix to paint the trunks. Extend the roots. Trees closest to the center have a touch more White Mix. Trunks farthest from the center have less White Mix and more Ivory Black. Paint some of the bigger limbs with the brush chisel.

Step 18: Remaining Tree Limbs Start with a no. 6 liner for the thicker limbs and move down to a no. 4 liner and perhaps a no. 2 as they get thinner. Load Burnt Umber + Ivory Black, start the branches within the trunks and pull outward. The topmost branches should go right off the edge of the canvas.

Step 19: Undercoat Rocks Undercoat the rocks in the water with a no. 4 bristle flat and Shadow Mix and Dark Mix. Pull the bottoms into the water areas for reflections.

Step 20: Highlight Banks Using a no. 16 sable bright, start highlighting the banks with Yellow Ochre. The right bank has the most highlighting. Chop in a little Naples Yellow for a lighter highlight on the right. Use Naples Yellow + Yellow Ochre on the left.

Step 21: Highlight Banks Load the no. 16 sable bright with French Ultramarine + Lemon Yellow Hue + Dark Mix and paint the moss on the left bank with short, dabby strokes. Add Cadmium Yellow + White Mix to the dirty brush for highlights.

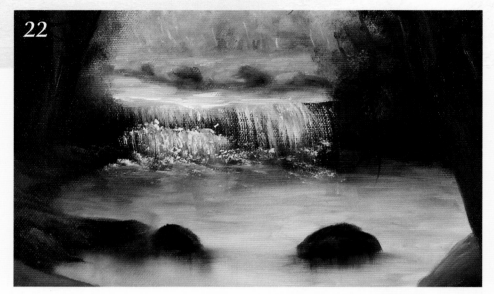

Step 22: Upper Falls Corner load a no. 8 fan with White Mix + green from palette, turn the brush over and pull the water in from the top of the falls down. To make the water appear to be falling over rock tiers, pull down part way and then start over. After you've established the fall, repeat with White Mix.

To create foam within the fall, turn the brush on the chisel. For foam at the bottom of the falls, use the brush corner. Use a no. 6 sable bright to pull White Mix horizontally at the top of the fall, eliminating or softening the black edge.

Step 23: Upper Falls Using a no. 6 sable bright and French Ultramarine + White Mix, stroke in horizontal water lines.

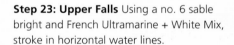

Step 24: Trees With the same brush and Burnt Sienna and Burnt Sienna + Cadmium Orange, begin the highlights on the larger trunks and branches. Build to brighter highlights with Naples Yellow on the dirty brush. Final highlights are Cadmium Orange, Cadmium Red and Naples Yellow in various mixes applied with a no. 6 round. For reflected light opposite the highlights use French Ultramarine + White Mix.

25

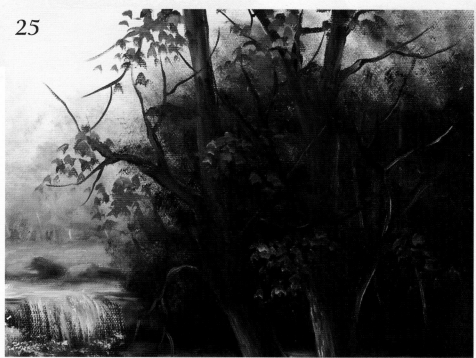

Step 25: Tree Foliage Using a no. 6 filbert and Burnt Sienna, begin tapping in fall foliage on the right foreground trees. Pick up Cadmium Orange + Cadmium Red for more leaves. Then use Cadmium Orange + Cadmium Yellow for the lightest foliage. Finally, add a bit of Yellow Ochre + Cadmium Yellow. Use more of the brighter colors toward the left. You can throw in some of these colors on the ground to suggest fallen leaves.

26

Step 26: Tree Foliage Paint the fall foliage on the left French Ultramarine + Yellow Ochre + a bit of White Mix in varying proportions. Occasionally throw in touches of Cadmium Yellow and Cadmium Orange on the dirty brush.

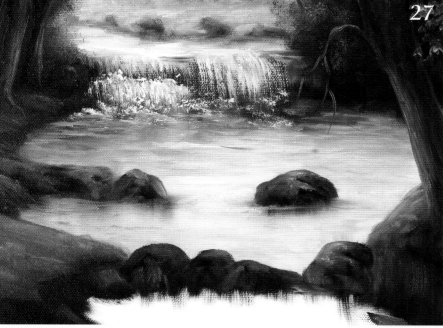

Step 27: Rocks and Lower Water Highlight rocks with a no. 4 sable bright and Cadmium Orange + Cadmium Red + Naples Yellow in varying proportions. Paint back highlights with French Ultramarine and White Mix.

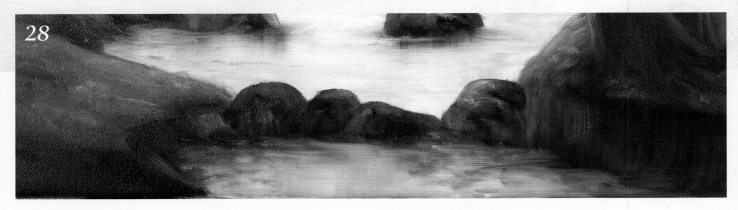

Step 28: Rocks and Lower Water Using a no. 4 bristle flat and Shadow Mix + Dark Mix + French Ultramarine, pull down shadows from the rocks into the bottom water. Clean the brush and then pick up foliage or moss green from the palette + White Mix and fill in the water with downward strokes. This water is darker than the water above. Stroke horizontally for distortion. Stroke in a few fall foliage colors for reflections of fallen leaves.

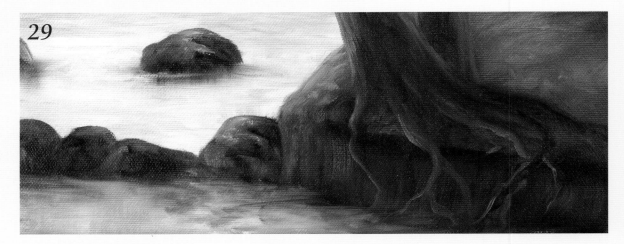

Step 29: Rocks and Lower Water Pick up Shadow Mix on the no. 10 angular bristle and tap in some dark foliage in the lower left. Switch to a no. 6 sable bright double-loaded with Shadow Mix and French Ultramarine + White Mix, and use the chisel edge to pull out tree roots from the tree on the right into the water. Be sure the lighter color is on the left side of the brush. Make the root lines wiggle a bit and occasionally cross each other.

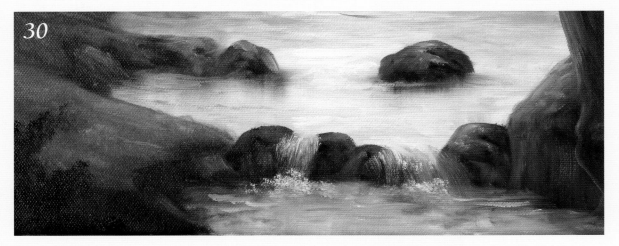

Step 30: Lower Falls Use the corner of the no. 8 fan blender and French Ultramarine + White Mix and pull water over the bottom row of rocks for the lower falls. Clean the brush and pick up White Mix for highlights. Tap with the brush for foam. Switch to a no. 4 sable bright for water lines of foliage green + White Mix.

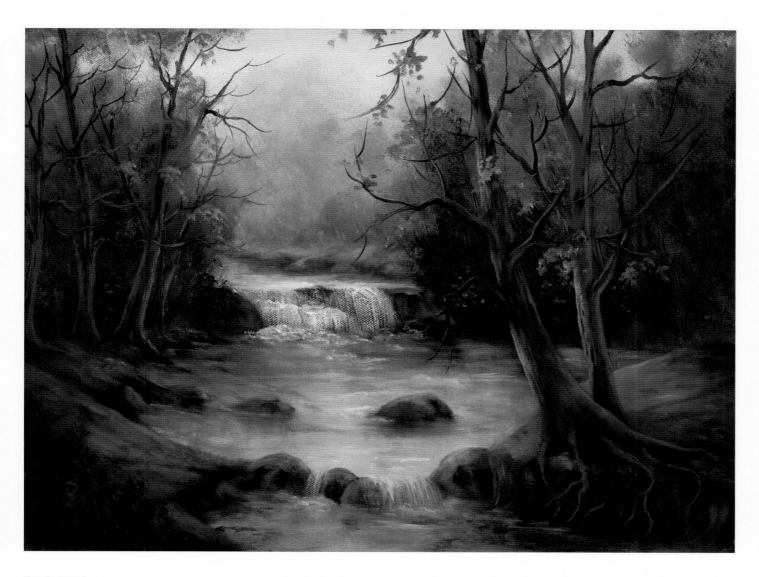

THE BASIN

Finishing Touches: Reinforce highlights and add other finishing touches as needed.

ACRYLIC/OIL COLORS CONVERSION CHART

DecoArt Americana Acrylic		Winsor & Newton Artists' Oil Color
Snow (Titanium) White DA01	=	Titanium White
Lamp (Ebony) Black DA067	=	Ivory Black
Soft Black DA155	=	Ivory Black + Burnt Umber
Grey Sky DA11	=	Titanium White + Ivory Black 3:1
Payne's Grey DA167	=	Payne's Gray
Ultra Blue Deep DA100	=	French Ultramarine
Deep Midnight Blue DA166	=	Prussian Blue + Ivory Black + Titanium White
Blue Mist DA178	=	Titanium White + French Ultramarine + Prussian Blue + Cadmium Yellow Pale
Salem Blue DA043	=	Cerulean Blue
Soft Blue DA210	=	Titanium White + Cerulean Blue + Ivory Black
Blue Haze DA115	=	Cerulean Blue
Cerulean Blue DA224	=	Cerulean Blue
Sand DA04	=	Titanium White + Yellow Ochre
Burnt Sienna DA063	=	Burnt Sienna
Dark Chocolate DA065	=	Burnt Umber
Burnt Umber DA064	=	Burnt Umber
Khaki Tan DA173	=	Titanium White + Burnt Umber + French Ultramarine Blue + Raw Sienna
Light Cinnamon DA114	=	Titanium White + Burnt Sienna + Burnt Umber + Bright Red
Light Buttermilk DA164	=	Titanium White + (Professional Permalba Oil color) Brilliant Yellow Light 1:1
Yellow Ochre DA08	=	Naples Yellow
True Ochre DA143	=	Yellow Ochre Pale
Cadmium Yellow DA010	=	Cadmium Yellow
Raw Sienna DA093	=	Raw Sienna
Camel DA191	=	Yellow Ochre + Titanium White

DecoArt Americana Acrylic		Winsor & Newton Artists' Oil Color
Lemon Yellow DA011	=	Cadmium Yellow Pale
Russet DA080	=	Burnt Sienna + Alizarin Crimson
Black Plum DA172	=	Alizarin Crimson + Ivory Black
Alizarin Crimson DA179	=	Alizarin Crimson + Ivory Black
Cadmium Red DA015	=	Cadmium Scarlet
Oxblood DA139	=	Terra Rosa
Base Flesh DA136	=	Titanium White + Cadmium Yellow + Cadmium Red
Shading Flesh DA137	=	Titanium White + Cadmium Yellow + Cadmium Red + Burnt Sienna
Hi-Lite Flesh DA024	=	Base Flesh Mix + Titanium White
Cadmium Orange DA014	=	Cadmium Orange
Black Forest Green DA083	=	Prussian Blue + Sap Green + Olive Green
Avocado DA052	=	Cadmium Yellow Pale + Ivory Black + Titanium White
Black Green DA157	=	Raw Umber + Burnt Umber + French Ultramarine + Titanium White + Sap Green
Hauser Medium Green DA132	=	Sap Green + French Ultramarine
Hauser Light Green DA131	=	Sap Green + French Ultramarine + Cadmium Yellow Pale + Titanium White
Hauser Dark Green DA133	=	Sap Green + French Ultramarine
Plantation Pine DA113	=	French Ultramarine + Payne's Gray + Cadmium Yellow Pale + Dot of Cadmium Red
Midnite Green DA084	=	Cerulean Blue + French Ultramarine + Cadmium Yellow Pale + Dot of Titanium White + Dot of Cadmium Red
Evergreen DA082	=	French Ultramarine + Payne's Gray + Cadmium Yellow Pale + speck of Titanium White
Jade Green DA057	=	Titanium White + Sap Green + Burnt Umber + Ivory Black
Arbor Green DA209	=	Titanium White + Yellow Ochre + Prussian Blue
Dioxazine Purple DA101	=	Dioxazine Purple (available in Griffin Alkyd by Winsor & Newton)

RESOURCES

SUPPLIERS

DecoArt Americana Acrylic Paints
P.O. Box 360
Stanford, KY 40484
606-365-3193
www.decoart.com

Royal Langnickle Brushes
6707 Broadway
Merrillville, IN 46410
800-247-2211
www.royalbrush.com

Fredrix Canvas
P.O. Box 646
Lawrenceville, GA 30046
www.fredrixartistcanvas.com

Winsor & Newton Oil Paints
P.O. Box 1396
Piscataway, NJ 08855
www.winsorandnewton.com

CANADIAN RETAILERS

Crafts Canada
120 North Archibald St.
Thunder Bay, ON P7C 3X8
888-482-5978
www.craftscanada.ca

Folk Art Enterprises
P.O. Box 1088
Ridgetown, ON N0P 2C0
800-265-9434

MacPherson Arts & Crafts
91 Queen St. E.
P.O. Box 1810
St. Mary's ON, N4X 1C2
800-238-6663
www.macphersoncrafts.com

Maureen McNaughton Enterprises
RR #2
Belwood, ON N0B 1J0
519-843-5648
www.maureenmcnaughton.com

U.K. RETAILERS

Atlantis Art Materials
7-9 Plumber's Row
London E1 1EQ
020 7377 8855
www.atlantisart.co.uk

Crafts World (head office)
No. 8 North Street
Guildford
Surrey GU1 4 AF
07000 757070

Green & Stone
259 Kings Road
London SW3 5EL
020 7352 0837
www.greenandstone.com

Help Desk
HobbyCraft Superstore
The Peel Centre
St. Ann Way
Gloucester
Gloucestershire GL1 5SF
01452 424999
www.hobbycraft.co.uk

INDEX

The best in painting instruction and inspiration is from NORTH LIGHT BOOKS!

Painting With Brenda Harris, Volume 3: Lovely Landscapes

Popular TV Instructor Brenda Harris' acrylic painting method produces realistic, startling results in just a few hours, even for the most inexperienced painters. As in her previous volumes, Brenda proves her gift for teaching is just as effective on the page as it is on TV. Lovely Landscapes provides you with 10 easy-to-follow step-by-steps that result in beautiful acrylic paintings, instruction that requires no prior knowledge of art, and project patterns that reduce the fear of making mistakes. ISBN-13: 978-1-58180-739-4; ISBN-10: 1-58180-739-2, paperback, 112 pages, #33416.

Painter's Quick Reference: Landscapes

The latest addition to the popular *Painter's Quick Reference* series tackles a perennially favorite subject matter—landscapes. With instruction for watercolor, acrylic and oil painters, this guide gives you countless ideas for gorgeous landscape elements, from the perfect trees and shrubs to clouds, skies, hills, mountains, flowers, water and more. It offers quick success through more than 40 easy demonstrations and features inspiring samples and variations from such top artist as Claudia Nice, Lian Zhen, Kerry Trout and Hugh Greer. With ideas for difference seasons, times of day and weather conditions, this fun, flippable book is the perfect creative boost for any landscape artist!
ISBN-13: 978-1-58180-814-8; ISBN-10: 1-58180-814-3, paperback, 128 pages, #33495

Painting Landscapes Filled with Light

Capture the rich, elusive properties of light! In 10 step-by-step projects, Dorothy Dent shares her easy-to-master techniques for painting light-filled landscapes in different seasons, weather conditions and times of day. Dorothy's projects include oil and acrylic painting demos, with advice for adapting the technique used for one medium to that of the other. Prepare to be amazed by the landscapes you create!
ISBN-13: 978-1-58180-736-3; ISBN-10: 1-58180-736-8, paperback, 144 pages, #33412

Robert Warren's Guide to Painting Water Scenes

Painting water effects can be a challenging task for any artist. This book allows everyone—from those taking their first "plunge" to seasoned painters—to create light-filled water scenes in a matter of hours! Renowned artist and teacher Robert Warren shares his own "special secrets" for capturing crashing waves to placid lake reflections by starting with an acrylic underpainting and finishing with oils.
ISBN-13: 978-1-58180-851-3; ISBN-10: 1-58180-851-8, paperback, 128 pages, #Z0054

These books and other fine North Light titles are available at your local arts and crafts retailer and bookstore or from online suppliers.